The War Against Women

Critical South

The publication of this series is supported by the International Consortium of Critical Theory Programs funded by the Andrew W. Mellon Foundation.

Series editors: Natalia Brizuela, Victoria J. Collis-Buthelezi and Leticia Sabsay

The War Against Women

Rita Segato

Translated by Ramsey McGlazer

polity

First published in Spanish as *La Guerra contra las mujeres* by Traficantes de Sueños, 2016.
Copyright © Rita Laura Segato 2016, 2025

This English translation © Polity Press, 2025

Polity Press
65 Bridge Street
Cambridge CB2 1UR, UK

Polity Press
111 River Street
Hoboken, NJ 07030, USA

ISBN-13: 978-1-5095-6212-1 – hardback
ISBN-13: 978-1-5095-6213-8 – paperback

A catalogue record for this book is available from the British Library.

Library of Congress Control Number: 2024934469

Typeset in 10 on 12pt Sabon
by Fakenham Prepress Solutions, Fakenham, Norfolk NR21 8NL
Printed and bound in Great Britain by CPI Group (UK) Ltd, Croydon

The publisher has used its best endeavours to ensure that the URLs for external websites referred to in this book are correct and active at the time of going to press. However, the publisher has no responsibility for the websites and can make no guarantee that a site will remain live or that the content is or will remain appropriate.

Every effort has been made to trace all copyright holders, but if any have been overlooked the publisher will be pleased to include any necessary credits in any subsequent reprint or edition.

For further information on Polity, visit our website:
politybooks.com

Contents

I dedicate this book to the students and recent collaborators in whose generous company, and thanks to whose conversation, I wrote the following pages: Aída Esther Bueno Sarduy, Paulina Alvarez, Marcelo Tadvald, Livia Vitenti, Elaine Moreira, Vicenzo Lauriola, Luciana Santos, Cesar Baldi, Luciana Oliveira, Larissa da Silva Araujo, Mariana Holanda, Daniela Gontijo, Wanderson Flor do Nascimento, Elisa Matos, Juliana Watson, Saúl Hernández, Aline Guedes, Irina Bacci, Priscila Godoy, Vanessa Rodrigues, Tarsila Flores, Nailah Veleci, Ariadne Oliveira, Lourival de Carvalho, Douglas Fernandes, Larissa Vieira Patrocinio de Araújo, Paulo Victor, Silva Pacheco, and Alejandra Rocío del Bello Urrego. I learned with all of them, and they inspired me, provoked me, and nourished my hope.

Foreword

The War Against Women first came out in 2016 as *La guerra contra las mujeres*. The #NiUnaMenos campaign – or #NotOneLess, similar to what came to be known as the #MeToo movement – was well underway in various Latin American cities following particularly high-profile and visible acts of violence against women. Feminist activism was reeling both on- and offline. Facebook pages and WhatsApp groups gathered thousands of supporters in mere hours across Buenos Aires, Mexico City, Bogotá, and Lima, collecting country- and city-specific testimony of women telling of their experiences with sexual harassment and gendered violence. Women shared names and places, and men in all kinds of professions were dragged before the courts of public opinion, and some before the judiciary. Segato's book rode this global feminist wave of indignation and calls for justice. Her work was also an inspiration to the Chilean activist group LasTesis, who in late 2019 gained global visibility with a collective street performance, *A Rapist in Your Path* – since then performed in dozens of countries, languages, and contexts.

In Latin America, Rita Segato is a highly influential, widely known, and revered feminist theorist. I learned about Segato's stardom in Latin American feminism in 2019 at Lima's annual International Book Fair, where she was a guest of honor. Her appearance attracted hundreds of fans, young and old, activists and scholars alike, too many to fit into the room. Segato drew on her

expertise to speak to the specificities of the Peruvian context, and a panel of Peruvian feminist activists and intellectuals responded. The mood was celebratory as well as rebellious; it felt like a new feminist era had arrived.

Segato's work had of course been circulating widely before, mostly as PDFs shared among researchers, students, and activists alike. Paper copies of books don't circulate much in Latin America, as distribution of books is often limited and prices are too high for the studious. This has never prevented anyone from reading, though; before online circulation, books were photocopied and circulated, pirated, and sold in street stalls. My first copy of *La guerra contra las mujeres* arrived in my inbox as a PDF in 2017, via a friend who drew solace from the theoretical clarity articulated in Segato's work.

Clarity of thought, and a clear activist standpoint, are what make the work of Rita Segato so compelling and timely. In addition, Segato holds a systemic vision, theorizing how patriarchal violence is at the center of struggles for power over resources, votes, territory, and (racial, ethnic, class) status. Lastly, Segato connects different contexts and violences across Latin America with a keen eye for contemporary developments and contextual differences. Ultimately, she is a broad-stroke feminist theorist with a deep understanding of persistent colonial structures.

Segato was born in Buenos Aires in 1951. She trained and worked in ethnomusicology in Caracas in the 1970s, after which she continued in anthropology at Queens University Belfast, where she was awarded a Ph.D. in 1984. Her doctoral work focused on mythology and religion in Afro-Brazilian communities in Brazil. From Northern Ireland, she moved to Brazil, where she taught anthropology at the University of Brasília, and where she was first confronted with the issue of violence against women as the subject of research. It was in Brasília where she turned her gaze upon gender violence, and from an unusual starting point: in the mid-1990s, she did a series of interviews with convicted and imprisoned rapists. This research propelled her into the subject matter of patriarchal violence, her focus ever since.

The work with prisoners let Segato to understand sexual violence not as sex crimes, nor as individual crimes of certain men against certain women. Rather, she argued in the resulting book, *Las estructuras elementales de la violencia* (Segato 2003a; in English: The Elementary Structures of Violence), that sexual violence serves to produce and reproduce hierarchies between men; that is, that these

are an integral part of the structures of power in contemporary society. Her understanding of sexual violence, then, focused (a) on its performative and public aspects, and (b) on power as its main driver. Considering the persistent attempts of media, politicians, and society at large to privatize gender violence as incidental and individual, more often than not blaming the victim rather than the perpetrator, Segato's analysis was a welcome and necessary protest against mainstream understandings of violence against women.

While violence against women was and is a central theme in women's lives throughout the continent, if not the world, in the 1990s much attention was focused on the astonishing scale and impunity of the rape and killing of young women on the Mexico–US border, in particular in and around Ciudad Juárez. Many young women of *mestiza*[1] descent migrated to Ciudad Juárez, attracted by the city's labor opportunities in so-called *maquiladoras* (sweatshops), which erupted after the signing of the North American Free Trade Agreement (NAFTA) with the United States and Canada in 1994. These workers were low paid, with no benefits or social protection or urban infrastructure. This is the context in which women's precarious lives became disposable, to be used and abused by the powers that be (Monárrez Fragoso 2010).

The South African-US scholar and activist Diana Russell coined and mainstreamed the term "femicide," later translated and popularized in Mexico as *feminicido*, and in recent decades included in criminal codes across the Americas (Lagarde y de los Ríos 2010: xv). In Latin America, Ciudad Juárez is the center of what seems to be a very persistent increase in femicides. Together with family members of murdered women, Mexican feminists set up ongoing campaigns and protests to fight impunity and identify people and institutions to hold to account, and structures that might help explain these continuing atrocities (Fregoso and Bejarano 2010). None of this has resolved the femicides, though, and Ciudad Juárez continues to be one of the most dangerous places for women to live and work.

Segato visited Ciudad Juárez in 2004, and has written extensively about her observations since, including in *The War Against Women*. Theorizing the femicides in Ciudad Juárez affirmed Segato's argument that these crimes were crimes of power rather than crimes of sex or intimacy, which is often the excuse that the authorities would give after another tortured and raped body was found. Crimes of power, in Segato's view, link capital accumulation

and dispossession in borderlands with criminal violence, institutional corruption, and the continual need to reproduce violent masculinities to hold onto power. In such a context, no perpetrators can be identified, as a complicit system closes its ranks and obscures all accountability, a system where violence has become a logic in itself.

Segato's observations, leading from the femicides in Ciudad Juárez to the increasing levels of violence against women, femicides, and other forms of chronic violence and impunity in the region, led her to argue that there is a "parallel state," a "second state," which is the system behind the cycles of violence we observe when studying violence against women in Latin America. From this perspective, an illegal economy of territory for construction, extractive industries, and coca growing and drug production with strong links to politics and the legitimate economy through investment and capital for votes, arms, and political allies has completely undermined any serious institutional control. This "parastate," or "second state," can exist, Segato argues, because of the control over populations and land that criminal gangs and paramilitaries exercise, deploying gender violence as their tool. Thus, violence against women is an integral part of the functioning of a corrupt and violent system that benefits a few at the expense of the many. The (largely) young men who become victimizers are not necessarily the ones who benefit; they are cogs in a spiraling fight over power and control directed by an obscure parastate. Drawn from marginalized and impoverished masses, these young men are often the first to die, victims of, in Segato's terms, the "mandate" of a violent masculinity.

From this perspective, criminal gangs – from Salvadoran *maras* to similar phenomena in urban centers across Central and South America, or paramilitaries serving urban and rural corporate and political interests – have become the tools by which contemporary violence, dispossession, and death are reproduced daily. It is here, in these all-male environments, that the norms of a violent masculinity are learned and enforced, breeding grounds for misogyny and cruelty in a context of precarity while others maintain power and produce wealth and misery. This analysis draws back to Segato's work with Brazilian convicts, in which she saw that sexual violence was largely a performative exercise in determining a pecking order among men (with women being disposable therein), while these men seemed to be mandated to act this way by a system that functions only via a violent patriarchal logic.

The analysis of all-male environments that exacerbate and cultivate violent masculinities draws parallels to (para)militaries. Just like urban gangs, the frontlines of (para)militaries are largely made up of marginalized young men, who are trained to be and act as violent machos, where sex is a tool to show physical domination. In *The War Against Women*, Segato thus firmly argues that rape is not about sexual desire but about power, locating herself in a feminist tradition that has argued that rape is about power and domination, not about sex (Brownmiller 1975).[2]

Is there a war against women? Or are new wars raging that draw on colonial-patriarchal scripts of conquest of territory via the appropriation of bodies? The Argentinian feminist sociologist Veronica Gago (2020: 75) follows Segato when she argues that the war is not about women, but about property. Property lends authority, and it is the feminized body-territory that has become the battlefield. Segato's analysis of the femicides in Ciudad Juárez leads her to speak of a "pedagogy of cruelty" via "expressive violence": a war over power and control over territory that is played out via messages on the bodies of women. The phrase "women's bodies are battlefields" springs to mind.

Segato was asked to act as an expert witness in the groundbreaking trial against two former military commanders accused of sexual slavery of fifteen indigenous women in Guatemala's dirty war, which culminated in lengthy convictions in 2016. Segato, as an expert on the dynamics of male violence against women, argued that rape was used as a military strategy to subordinate and ultimately destroy the indigenous communities whose lands were being appropriated. Her statement affirmed that women's bodies were used as the larger social body of the communities they were seen to represent (Abbott and Hartviksen 2016). This statement was incredibly important in the context of the trial and helped de-individualize the crimes committed against women's bodies.

One of the things that Segato's performance before the human rights court in Guatemala shows is her importance as a *transnational* expert: Segato never seems to keep to boundaries, either of places, disciplines, or intellectual conventions. This makes her work very accessible, and applicable across cases and contexts. Ultimately, her work is that of a scholar-activist, someone who theorizes based on sharp observation and making connections between persistent phenomena and processes, such as capitalism, democracy, patriarchy, extractivism, and colonialism.

Thinking through the ongoing consequences of colonialism has been part of Segato's work since the beginning; after all, she started her career looking at religion in Afro-Brazilian communities, tracing customs and norms across time and space, and inequalities across histories of oppressions. Since then, as she narrates in *The War Against Women*, Segato has continued to work with Brazilian indigenous communities in what she calls the *mundo aldea* (village-world), the world of dispersed indigenous communities colonized, dispossessed, and re-colonized under post-dictatorship democratic rule. Segato's gender analysis of the Latin American indigenous world is grounded in the difference between duality and binarism: whereas in contemporary (colonial) Western understandings gender is a hierarchical binary, in indigenous duality, gender roles are perceived as complementary. Hence, gendered hierarchies exist and existed in precolonial indigenous societies, albeit according to different logics than the racialized binary of Western gender regimes.

For Segato, this position allows for an indigenous feminism that may fight for women's rights as well as indigenous rights. Not everyone agrees. For the Argentinian scholar María Lugones, whose work is more widely known among English-speaking audiences than Segato's as she was located in the Global North, Segato's position was not critical enough. In 2020, Lugones published a critique of Segato's work in which she argued that Segato fails to properly decolonize her own biases: according to Lugones, even using a duality of gender and the framework of patriarchal inequality in discussing indigenous peoples is an imposition of colonial terminology, and hence structures. While Segato advocates for alliances between feminisms across ethnic and class divides, Lugones suggests we work "toward the recuperation of resistant historical tapestries that weave understandings of relations to and of the universe, of realities that are resistant to the logic of modernity and show us alternatives that enable a communal sense of the self in relation to what there is." She proposes that we build on a "long memory" to return to precolonial values and practices of communal living, hence, an undoing of colonial histories, or of "Eurocentric modernity" (Lugones 2020: 37).

While theoretically interesting, it may be impossible to "return to" a way of perceiving the self and the collective that erases the influence of five hundred years of colonial and postcolonial history. We cannot know how indigenous gender relations, sexualities, and ways of communal living would have developed without

the influence of colonial, capitalist, and patriarchal structures of oppression and struggles for liberation. Five hundred years is a long time. In that sense, it might not be that useful to focus on precolonial gender regimes as characteristics of today's indigenous women's struggles.

Contemporary feminist struggles for liberation in Latin America are multiple and diverse, and they intersect with struggles for land and environmental recuperation, for LGTBQ+ rights, and against racisms and class prejudice. Everyday violence, in both public and private spheres, is real and widespread, and comes from within communities as well as beyond. Arguably, many of the struggles of contemporary indigenous feminisms show similarities with the struggles of Westernized Latin American feminisms. The everyday violence in homes and communities in the rural Andes, or in the indigenous Amazon, or in mixed urban migrant communities in the neighborhoods and slums of Lima, Santiago, or Caracas, is not all embroiled in a parastate type of corruption and control; much of it is mundane, and related to everyday privilege and poverty, patriarchy, and institutional neglect. As Kimberlé Crenshaw (1990) has taught us, in their intersection, struggles of race and gender often clash and can leave women's rights stuck between loyalty to the racialized community and the racism of white feminist movements. Therefore, white and/or Westernized[3] feminist intentions of genuine alliance and collaboration and support for the struggle both for women's rights and for indigenous rights might still work as a unifying factor. Indeed, much of contemporary Latin American feminist activism works explicitly from a horizontal democratic perspective, or "in assembly," bridging divides through – sometimes endless or contentious – debate.

While Segato is mainly interested in understanding and explaining violence against women, her strength lies in her capacity to see the big picture, to link different systemic processes of dispossession over recent decades to explain the disconnect between the increase in laws, programs, and reporting mechanisms for violence against women, and the simultaneous increase in prevalence and cruelty of the same. The systemic links between different phenomena, culminating in heightened levels of violence, corruption, and dispossession across the continent, are what lead her to conclude that violence against women is the act not of an individual but of higher powers, of the state, the Church, the big international corporations – mafias that contrive to maintain and reproduce their power base.

Or, in the words of LasTesis from *A Rapist in Your Path*, "It wasn't my fault, neither where I was nor how I was dressed. The rapist is you: the judges, the police, the state, the president."

Segato's theoretically rich and sharp perspective on the nature and purpose of contemporary violence against women in Latin America has inspired and fueled a diverse and theoretically rich feminist movement throughout Latin America; her work underpins much of our current understanding of the persistent increase, visibility, and cruelty with which violence and death are inflicted upon women throughout the continent, for the sole reason that they are women.

Jelke Boesten

Translator's Preface

In this book, Rita Segato studies the emergence of what she calls "new forms of war." Unlike conventional wars, Segato argues in chapter 2, contemporary wars "are not guided by ends, and their aim is not the achievement of peace in any of that word's senses. Today, for those who administer it, war is a long-term project without victories or conclusive defeats. We could almost say that, in many world regions, the plan is to make war into a way of life." That claim, which has lost none of its relevance since Segato first made it in 2014, has important implications for her argument about violence against women. Repeatedly, Segato takes pains to emphasize that this violence is not only "instrumental" but also "expressive." This means that women are not only the victims and targets of today's lethal wars. They are also "surfaces" for inscription, such that feminine and feminized bodies become the bearers of messages addressed to entire communities and even, Segato insists, to "humanity as a whole."

It follows that the femicides in Ciudad Juárez, for instance, are not matters of local or regional concern. On the contrary, they are, Segato writes pointedly at the end of chapter 1, "addressed to us," even attacks "launched against us." Here her "us" is inclusive, expansive. "The murders are designed to display *before us* the capacity to kill, an expertise in cruelty and sovereign domination. ... We have to become their interlocutors and antagonists, critics of the crimes, at odds with them." Notice what the careful wording of that

last sentence implies: that we can only be the crimes' antagonists if we are also their interlocutors, in other words, that in order to oppose the crimes, we have to allow ourselves to be interpellated by them, enter into painful dialogue with them. In this sense, the book's original title, *La guerra contra las mujeres*, was already somewhat misleading, because, for Segato, the war was being waged against almost everyone.

The title that Segato and I had proposed for this translation was *The War on Women*. To my ear, that title, with its echo of the US "War on Drugs" or the "War on Terror," now an integral part of what is called the "American way of life," came closer to naming the ambient condition of diffuse and open-ended conflict that the book seeks to describe. By contrast, in my view, *The War Against Women* risks suggesting that the forms of violence discussed in this book have an objective, an aim. It risks treating violence against women as war's end rather than the means by which war is fought at a moment when, according to Segato, women's bodies have become the "documents" of domination and the very medium of armed conflict. The phrase "the war against women" also has a history of use among Anglophone feminists and thus activates associations that, as a translator, I had hoped to avoid. Although these associations are now unavoidable, I hope the translation that follows will let readers hear the call that Segato receives and make sense of the messages that she works to decipher.

Ramsey McGlazer

Prologue to the Second Edition

I have added two new chapters, written between 2017 and 2018, to this second edition. The first, chapter 8, "From Anti-Punitivist Feminism to Feminist Anti-Punitivism," brings together the anti-punitivist argument that I made publicly before the National Senate of Argentina and a feminist argument that identifies and reveals the limits of legal education. It thus allows me to include in this volume a set of critical reflections on two sets of efforts in the legal field, punitivist and anti-punitivist, that seek to limit the damage done by a misunderstanding of gender and the violence that derives from it, an uncontained violence that is spreading throughout the Americas.

The chapter responds, first, to the attempt to make women, as victims of sexual and femicidal violence, responsible for justifying a governmental project that seeks to expand the construction of the concentration camps for poor and non-white people that are prisons. But the replication of a problem has never been a solution to it. The only real solution is understanding the roots of the problem. Without this understanding, it is impossible to act efficaciously. Without examining the problem deliberately and profoundly, we will not achieve the goal of containing the truly catastrophic forms of gender violence that are assailing us.

I decided to include, in the second part of the chapter, my response to a text by Eugenio Raúl Zaffaroni published in *Página 12* on May 18, 2017, a text on what he calls the "epidemic of femicides," because this text shows a surprising superficiality that

I thought should be publicly contested and corrected. It is worth noting that what Zaffaroni, a distinguished jurist, ventures to say about femicide is glaringly wrong; this text of his has nothing of the acuteness or sophistication that characterize his writings on the selective application of criminal law along the axes of class and race (see, e.g., Zaffaroni 1993, 2006). When he thinks of femicide and sexual and gender crime, Zaffaroni finds himself caught in common sense. For this reason, in my critique of his work, writing with some impatience, I take the opportunity to clarify my positions on these questions. Conflict and tense conversation allow me to think with greater clarity, and force me to refine my vocabulary.

Chapter 9, "By Way of Conclusion: A Blueprint for Reading Gender Violence in Our Times," is also newly added to this second edition. In this chapter, I elaborate and explain the categories that make up my analytic model throughout the book. This brief text is thus a compendium of the arguments that I have brought to bear on the analysis of gender violence during the last twenty-five years.

Introduction

Theme One: The Centrality of the Question of Gender

I write this introduction in a state of amazement. This volume gathers essays and lectures from the last decade (2006–16). Despite what I argue in these texts, the recent maneuvers of the powerful in the Americas – with their conservative return to moral discourse, used as a prop for their anti-democratic politics – have not ceased to surprise me. In 2016: Macri in Argentina, Temer in Brazil, the Uribe- and corporate-backed "No" vote in Colombia, the dismantling of citizens' power in Mexico, and Trump in the United States. These figures and developments have irrefutably demonstrated the validity of the wager that runs through the following pages and gives coherence to the argument I make in them. The force of the familialist and patriarchal onslaught that is these figures' strategy attests to this. Indeed, throughout the Americas, an emphasis on the ideal of the family, defined as the subject of rights to be defended at all costs, has galvanized efforts to demonize and punish what is called "the ideology of gender" or "gender ideology."[1] The spokesmen of the historical project of capital thus offer proof that, far from being residual, minor, or marginal, the question of gender is the cornerstone of and the center of gravity for all forms of power. Brazil is the country where the role of this moral discourse in the politics

of the ruling class has become clearest, since the impeachment of Dilma Rousseff, the democratically elected president, took place in that country's National Congress, with a majority of votes made "in the name of God" or "of Jesus" or "for the sake of the family." It is our enemies in history, then, who have ended up proving this book's central thesis, by making the demonization of "the ideology of gender" the focal point of their discourse.

I have referred to a "conservative return to moral discourse" here, because we have seen a retreat from the bourgeois discourse of the post-Cold War period, characterized as it was by an "anodyne multiculturalism" that, as I have argued elsewhere (Segato 2007a), replaced the anti-systemic discourse of the preceding period with the inclusive discourse of human rights, at a time when Latin American post-dictatorship "democracies" were being constructed. The question that emerges now is: Why, and on the basis of what evidence, did the think tanks of the geopolitical North conclude that the current phase calls for a reorientation, a turn away from the path followed during the previous decade? During that decade, they supported a multiculturalism destined to create minority elites – black elites, women elites, Hispanic elites, LGBT elites, and so forth – without changing the processes that generate wealth or the patterns of accumulation or concentration. This multiculturalism thus left unaddressed the growing abyss separating the poor from the rich throughout the world. In other words, the benign decade of "multicultural democracy" did not alter the workings of the capitalist machine, but rather produced new elites and new consumers. But if this was the case, then why was it necessary to abolish this democracy and decree a new era of Christian, familialist moralism, dubiously aligned with the militarisms imposed by fundamentalist monotheisms in other parts of the world? Probably because, although multiculturalism did not erode the bases of capitalist accumulation, it did threaten to wear away at the foundation of gender relations, and the enemies of our historical project discovered, even before many of us did, that the pillar, cement, and pedagogy of *all power* is patriarchy.

Drawing on my work as an anthropologist and on the practice and methods of ethnographic listening, these pages constitute an ethnography of power in its foundational and persistent form: patriarchy. The masculine mandate emerges here as the first pedagogy of expropriation, a primal and persistent pedagogy that teaches the expropriation of value and the exercise of domination. But how to

write an ethnography of power, given that the pact of silence – an agreement among peers that rarely fails in any of its iterations – is power's classic strategy and one that appears in nearly every patriarchal, racial, imperial, or metropolitan context? We can only come to understand power by observing the recurrence and regularity of its effects, which allow us to approach the task of discerning where its *historical project* is headed (Segato 2015a/Eng.: Segato 2022). Patriarchal violence – that is, the misogynist, homophobic, and transphobic violence of our late modernity, our era of human rights and of the UN – is thus precisely a symptom of patriarchy's unfettered expansion, even despite the significant victories that we have won in the intellectual realm, the field of discourse. This violence perfectly expresses the ascendancy of a world of ownership, or indeed one of lordship, a new form of domination resulting from the acceleration of the concentration and expansion of a parastate sphere of control over life (which I address in the second chapter included in this volume). In these crimes, capital in its contemporary form expresses the existence of an order ruled by arbitrary patriarchal impulse and exhibits the spectacle of inevitable institutional failure in the face of unprecedented levels of concentration of wealth. Observing the speed with which this phase of capital leads to increases in the concentration of wealth, I suggest in chapter 3 that it is no longer sufficient to refer to "inequality," as we used to do in militant discourses in the context of the anti-systemic struggles of the Cold War. The problem today, again, has become one of ownership or lordship.

It has not been easy, after a period of multicultural sloganeering – a period when multicultural slogans seemed powerful – to understand why it has been so important, even indispensable, for the historical project of the owners to preach and reinstate a militaristic patriarchal fanaticism – one that seemed to be gone forever. In Latin America, the phrase "the ideology of gender" has appeared recently, a category in the service of accusations. In Brazil, there have even been several legislative proposals put forward by a movement called the Programa Escola sem Partido, or Program for a School without Party, or Non-Partisan School. One of these proposed laws, awaiting a vote in Brazil's National Congress and already in force in some states, including the state of Alagoas, for example, seeks to prohibit "the application of the postulates of the theory or ideology of gender" in education, as well as "any practice that could compromise, hasten, or misguide the maturation and development

of gender in harmony with the student's biological sexual identity."
The extraordinary engagement with the field of "gender" on the part
of the new right, represented by the most conservative factions in all
churches – factions that are themselves representative of the recalci-
trant interests of extractivist agribusiness and mining – is, at the very
least, enigmatic. What is at stake in this effort to ensure obedience
to a conservative morality of gender? Where is this strategy headed?
After an episode involving attacks and threats against me when I
took part in a conference at the Pontifícia Universidade Católica de
Minas Gerais – attacks and threats made by a far-right group based
in Spain[2] – I suddenly understood with alarm that the truculent
style and spirit of their arguments came close to something that I
already knew, because they recalled the patrolling and persecutory
avidity of Islamic fundamentalism, which I have discussed elsewhere
(Segato 2008); that is, precisely the most Westernized version of
Islam, one that emulates the modern West in its identitarian and
racializing essentialism.

I then started to wonder: Are we not witnessing the intent
to impose and spread a religious war like the one that has been
destroying the Middle East, exactly at a time when, as I suggest in
the second chapter, the political and economic decline of empire
makes war its only terrain of uncontestable superiority?

Theme Two: Patriarchal Pedagogy, Cruelty, and War Today

In this volume, my initial formulations on gender and violence remain
(Segato 2003a): (1) The phrase "sexual violence" is misleading,
because although aggression is exercised *by sexual means*, the ends
of this kind of violence are not of a sexual nature but rather are
related to the order of power. (2) These are not acts of aggression
that originate in a libidinal drive or a desire for sexual satisfaction.
Here instead the libido seeks power and is guided by a mandate
delivered by peers, by the members of a masculine fraternity that
demands proof of belonging to the group. (3) What confirms one's
belonging to the group is the taking, the extortion, of a tribute,
one that is transferred from the feminine to the masculine position
and that constructs the latter in and through this transfer. (4) The
hierarchically organized structure of the masculine mandate is
analogous to the order of gangs. (5) Through this kind of violence,

power expresses itself, displays itself, and consolidates itself in a truculent form. It exhibits itself to the public, and this violence is more expressive than instrumental.

Another feature of my work that remains relevant here, despite the recent debates on this issue, is the conviction that patriarchy, or a structure of gender relations based on inequality, is the most archaic and persistent of humanity's political structures. This structure shapes the relations between positions in all differential configurations of prestige and power. It is captured, radically aggravated, and transformed in a colonial-modern order that is lethal for women, an order that has its beginnings in the process of conquest, which transforms *low-intensity* or *low-impact patriarchy*. The phrase "patriarchal-colonial modernity" describes the priority of patriarchy as an appropriator of women's bodies and their status as the first colonies. The conquest itself would have been an impossible undertaking without the prior existence of this low-intensity patriarchy, which makes men docile before the example of triumphant, imperial masculinity. The men of the conquered communities would thus come to function as hinges between two worlds, divided in their loyalties: loyal to their people, on the one hand, and to the masculine mandate, on the other. In this analysis, gender is the basic historical form or configuration of all power in our species and, therefore, of all violence, since power is the result of an inevitably violent expropriation. Dismantling this structure very gradually will thus be the condition of possibility for any and every process capable of reorienting history in a direction that is in keeping with an *ethics of dissatisfaction* (Segato 2006a). Elsewhere (Segato 2003a), I have described this archaic, crystallized time, a deep and very slow time that is nevertheless fully historical, as *the patriarchal prehistory of humanity*. My claim for the precedence and universality of patriarchy is supported by the existence of myths, dispersed throughout the planet, that narrate a moment – certainly a historical moment, since if it were not historical it would not appear today in the form of a narrative – in which women are conquered, dominated, and disciplined, placed in a subordinate, obedient position. Not only the biblical story of Genesis but also countless indigenous origin myths recount the same recognizable story. In the case of Adam and Eve, the act of eating the apple led to their removal from the Edenic playground of unrestricted and incestuous pleasures, condemning them both ... to conjugality. Myths found on all continents, among the Xerente, Ona, Baruya, Masai, and others – including the

Lacanian claim that woman "is" the phallus that man "has," read here as a history compressed into myth – speak to us of an event that is foundational, primal, common to numerous peoples (Segato 2003a). This may mark the transition to humanity, a moment in the phase when humanity as such is still emerging and still one, a moment prior to the dispersal of lineages and the proliferation of peoples. This would have been a moment during the era when the muscular prominence of males was transformed into political prominence: a moment during the long transition from the natural to the cultural – that is, the historical. Deep time has distilled what might be a historical account into a mythical synthesis.

This leads me to conclude that as long as we do not dismantle the patriarchal structure that founds all inequalities, underwrites all expropriations of value, and sustains the edifice of all forms of power – economic, political, intellectual, artistic, and so on – as long as we do not produce a definitive break in the hard rock crystal that has stabilized the patriarchal prehistory of humanity, no significant change in the structure of society will be possible. For this reason, the question of gender relations – of their structure, which has been nothing other than the structure of patriarchy founded in the beginning of history – has become more dramatic and more urgent than ever before, despite all the efforts that have been made in the modern legal and institutional fields. This leads us to the question of how this structure changed under colonization and how Latin America's Creole-republican states remain colonial.

With the process of conquest and colonization, a change exacerbated gender hierarchies. I address this process in the fourth chapter of this volume especially. Lower-case man, with his particular role and space in the tribal world, became upper-case Man, synonymous with and paradigmatic of Humanity, subject of the colonial-modern public sphere. In keeping with the decolonial turn made in Aníbal Quijano's contributions to sociology and history, I use the term "colonial-modern" to underscore that the "discovery" of America was the condition of possibility for modernity as well as capitalism (Segato 2015b/Eng.: Segato 2022). With this historical change in the structure of gender, the masculine subject became the model of the human and paradigmatic subject of speech in the public sphere; that is, he became paradigmatic of anyone and anything endowed with political capacity, general interest, and universal value. At the same time, women's spaces, like everything related to the domestic sphere, were emptied of politics, deprived of bonds of solidarity,

alliance, and cooperation that characterized communal life, recast as marginal, as the remainders of politics. The domestic sphere thus became associated with intimacy and privacy in a way that it had not been previously and still is not in communal contexts. As a result of this change, women's lives acquire the fragility that we know today. Their vulnerability, once established, increases into the present.

Seen through this lens, the state discloses its masculine DNA; it can be seen as a product of the transformation of a particular space for men and for the performance of their specific role – *politics* in the communal and inter-communal context, and later at the colonial front and in the national state – into a sphere that encompasses all of reality and hijacks everything that aspires to be political. The genealogy of this all-encompassing "universal and public" sphere begins in a particular and specific space that belonged to men. This space was transformed through the imposition and expansion of colonial modernity. The dual matrix ruled by mutual reciprocity changes into the binary modern matrix, in which all alterity is a function of the One, and every Other has to be assimilated into a framework of universal reference.

This change in hierarchical relations between masculine and feminine is accompanied by a transformation in the field and meaning of sexuality, as I have argued previously (Segato 2015c/Eng.: Segato 2022) and as I argue in the third chapter of this book. Sexual access enters the universe of damage and cruelty and is contaminated; it becomes not only the appropriation of bodies and their annexation *as territories*, but also their condemnation, their *damnation*. Conquest, pillage, and rape are associated not just as forms of appropriation, but as forms of damnation, and their association persists. Their correlation continued after the founding of the republics, and it continues in the present. Masculine pedagogy and the masculine mandate become a *pedagogy of cruelty* that encourages expropriating greed through the repetition of violent scenes that normalize acts of cruelty. This pedagogy thus diminishes people's capacity for empathy, and this is indispensable to predatory projects. As Andy Warhol said in one of his celebrated quips: "The more you look at the same exact thing, the more the meaning goes away, and the better and emptier you feel." Habitual cruelty is directly proportional to the isolation of citizens through desensitization.

As I argue in the third chapter of this book, the current, apocalyptic phase of capital, characterized by a great acceleration in the

concentration of wealth, brings about the collapse of the institutional fictions that previously offered a stable grammar for social life. More than *inequality*, it is the idea of *lordship* that has the last common spaces left on the planet in its grip, in a *re-feudalization* of immense territories. And it is precisely the association of sexuality with injury that provides a language for the lucrative pacts hidden in what, in chapter 2, I call a *second reality*. Because the masculine mandate, if it does not legitimate, definitely safeguards and conceals all the other forms of domination and abuse that proliferate in its breeding grounds. What I have said about Ciudad Juárez is thus also applicable to the logic of sexual trafficking and the reduction of women to the status of sexual slaves elsewhere: in this bleak, asphyxiating atmosphere, the corporate state seals pacts of complicity with corporate organized crime, and keeps all the secrets that sustain accumulation today.

Trafficking and sexual slavery in our time – different in several ways from the traffic of women to countries with large male immigrant populations during the first decades of the twentieth century – illustrate this idea, because their efficacy does not follow from the rate of material profit that is derived from them, but rather from what they obscure, from the pacts of silence and complicity that are sealed in their shadow. These are at once material and symbolic economies, in which women's bodies are a bridge between profit and the capacity to exercise jurisdictional domination. Sexual access secures the collusion of the owners and safeguards their right to injure with impunity. In trafficking and in femicides[3] – and *femigenocides* – perpetrated by organized crime and in the parastate sphere that is expanding throughout the Americas, it is not just the materiality of women's bodies that is dominated and sold, but also their functional role in sustaining the agreements of those in power. It is for this reason that the trade in women, material and symbolic, is so difficult to abolish.

Undoubtedly, this plays a role in today's informal wars, in their "feminization" and the use of profanation, identified by various authors as a key method for waging the new forms of combat. As part of my work as an anthropologist expert witness in the case of Sepur Zarco, Guatemala, where a group of Q'eqchi' Maya women had been subjected to sexual and domestic slavery, I showed how such a method for the destruction of the social through the profanation of the feminine body played an important role in the genocidal war waged by the authoritarian state in the 1980s (Segato

2016). This strategy was indeed derived from the instructions in a war manual, a strategy that therefore had nothing to do with the hierarchical order of the low-intensity patriarchy proper to indigenous and peasant homes. The expressive power of this morally lethal war – which targeted women's bodies in a deliberate program, planned by strategists in their laboratories and surgically carried out through a series of orders – was evident. It sheds light on the role of the feminine position in gang wars and repressive wars, which expand the parastate's sphere of control over populations.

In times of functional and pedagogical cruelty, it is the woman's – or the child's – body that cruelty targets and treats as a surface for inscription, because in the archaic imaginary, women and children are not the armed adversaries in war, but rather war's third parties and "innocent" bystanders. This is why they serve as sacrificial victims, over whose dead bodies pacts of complicity are finalized, and power's exhibitionist will is spectacularized. In the fifth chapter of this book, I propose the term *femigenocide* as a name for this kind of femicidal violence, which should not be conflated with intimate conflicts or referred to the realm of relationships. I would add here that, in order to acknowledge the intersections of various existing forms of oppression and discrimination, we could create a compound, combining femigenocide with the category of *africanidade*, proposed by the great, now-deceased black Brazilian thinker Lélia Gonzalez (1988), in order to refer to *Amefricafemigenocide*. We could also draw on the category *juvenicide*, used by Rossana Reguillo and other Mexican scholars (Reguillo 2015; Valenzuela Arce 2015), which would then give us *Amefricajuvenifemigenocide*, a term with which to designate a cruel and sacrificial form of execution, not utilitarian but rather expressive of sovereignty, an act in which power exhibits its will and its jurisdictional sovereignty.

To summarize, then, the crimes of patriarchy express contemporary forms of power, property owners' power over life, as well as the power of a persistent, violating, and expropriating *conquestiality*. This term is more accurate than *coloniality*, given that examples ranging from the repressive war in Guatemala, the situation on the Pacific coast of Colombia, or the killing of the Kaiowa Guaraní people in Mato Grosso, Brazil, among other places on the continent, prove that it is wrong to assume that the Conquest simply ended one day.

To the question of how to end war, in the context of the informal wars that are spreading today throughout Latin America, I have

responded: by dismantling the masculine mandate, with the collabo-
ration of men and for their benefit, too. This means dismantling the
patriarchy, because it is the pedagogy of masculinity that makes war
possible, and without peace at the level of gender there will never
be any true peace.

Theme Three: What Hides the Role of Patriarchy as the Pillar That Sustains All Powers

What hides the centrality of relations of gender in history is
precisely the binary character of the structure in which the public
sphere encompasses, totalizes, and engulfs its residual other: the
domain of the private, the personal. I am referring, in other words,
to the binarism that separates the political and the extra-political
in colonial modernity. This binarism leads to the existence of
a universe whose truths are endowed with universal value and
general interest, and whose discourse is thought to emanate from a
masculine figure, whereas this figure's *others* are endowed with only
particular, marginal, and minor significance. The immeasurable gap
between the *universal and central*, on the one hand, and the residual
and *minoritized*, on the other, creates a binary structure that is
oppressive and inherently violent in a way that other hierarchical
orders are not. I argue in the fifth chapter that it is precisely because
of this mechanics of minoritization in the binary structure of
modernity that crimes against women and the feminine position in
the patriarchal, colonial-modern imaginary have not been addressed
by the law and have never been fully recognized as public.

 In this sense, we could even venture the idea that the burning
of witches in medieval Europe is not equivalent to contemporary
femicides, but rather has a genealogical relation to these killings: the
earlier executions represented a public form of gendered punishment,
while contemporary femicides, although they take place in the midst
of the uproar, spectacle, and settling of scores that characterize
parastate wars, never manage to emerge from the private realm in
which they are confined in the imaginary of judges, prosecutors, the
media, and public opinion in general.

 This is why I argue that modernity is an enormous machine for
producing minoritizing anomalies of every kind, anomalies that
then have to be filtered in the sense of being processed through the
grid of universal reference and, in the language of multiculturalism,

reduced, typified, and classified in terms of *iconized political identities*, in order to be reintroduced into the public sphere in this form – and only in this form (Segato 2007a). Everything that cannot be adapted to this exercise or charade, that cannot be made to fit into the matrix of the existent – which works like a great digestive process – becomes a placeless anomaly and is subject to expulsion, banished from politics. It is in this way that modernity, with its state born from a patriarchal genealogy, offers a remedy for the evils that it has itself introduced: it gives back with one hand, and in a degraded form, what it has taken with the other, and at the same time it revokes what it seems to offer. In this context, radical difference, which can neither be typified nor be made to serve the colonial-modern-capitalist pact, cannot be negotiated with, whereas it is, in fact, constantly negotiated with in the communitarian worlds of the Amefrican peoples of the Americas.

With its colonial preconditions and its patriarchal public sphere, modernity is a machine for producing anomalies and organizing purges: it stabilizes norms, quantifies punishments, catalogs pain, privatizes culture, archives experience, monumentalizes memory, essentializes identities, commodifies life, mercantilizes the earth, and levels temporalities. (For a related set of critiques, see Gorbach and Rufer 2016.)

We must expose the binarism that emerges from the colonial-modern matrix, in order to undo it. This binarism is replicated in so many others, with the gender binary being the most often cited. We must give up our faith in a state that cannot be expected to break with its constitution; that is, with its tendency to capture politics, with its plurality of worlds and styles. This is especially true in Latin America, where the republican states founded by Creole elites represented not a break with the period of colonial administration, as the mythic historical narrative has made us believe, but rather a continuation, in which the government, now geographically proximate, set itself up to inherit the territories, goods, and people that had previously belonged to overseas administrative powers. So-called "independence" was thus nothing but the passing of these goods from there to here, while a fundamental aspect of the colonial state remained: the attitude or sentiment of the administrators was still external to what they administered. This exteriority, so typical of the colonial relation, persisted and led to an increase in the public sphere's distance from the people. The governed became inexorably marginal and

remote, separated by a gap from the state's administration and thus rendered fragile.

Our states were designed so that the riches reclaimed from colonial powers could be appropriated by elite founders. Still today, this susceptibility to appropriation remains the state's most characteristic feature, so that when someone who does not belong to the elites enters into the orbit of the state, they become a member of the elite, and this is an inexorable effect of being part of an administrative apparatus that is always exterior to and imposed on populations. The crisis of civic faith thus becomes inevitable. In fact, the founding subject of our republics – that is, the *criollo* – is not the champion of democracy and sovereignty that history advertises, but rather a subject with five characteristics that secure his separation from the people and from life: he is racist, misogynist, homophobic, transphobic, and speciesist.

The argument of chapter 4 leads me to propose an inversion of the celebrated human rights formula, a formula for inclusion: "different but equal." Noting the explicitly hierarchical structure of communal worlds, I offer an alternative formula: "unequal but different." Here I also argue for a shift in our way of understanding the feminist slogan of the 1970s: "the personal is political." The path I propose in chapter 3 is not a translation of the domestic into the terms or the grammar of the public, the metabolization of the private so that it acquires a degree of politicality. Instead, I propose the opposite: a "domestication of politics," a de-bureaucratization and humanization, a transposition of politics into a domestic key, a repoliticization of the domestic. The constant failures of the strategy of taking state power, whether by force or through elections, in order to redirect history show that this cannot be the answer. We have never managed to reach our destination through the seizure of the state, because state power has ultimately imposed its rationality on those who wield it. It has remained the site of an administrative elite that retains its colonial lineage. We should instead recognize and reclaim the plurality of spaces and the politics of different styles offered by communal life – in the village, between villages, and at the colonial front – remaining mindful of their differences from patri-archal politics. In the meantime, the way forward is amphibious, involving work inside and outside the state realm, work in both intra- and extra-state politics, reconstructing communities that are under attack and that have been dismembered by the colonial and state interventions called "modernization."

While dismantling the public–private binary, we must also recover the domestic politics, *oikonomies* (Segato 2007b), and styles of negotiation, representation, and management developed and accumulated in women's experiences throughout history, given our status as a differentiated group within the species, beginning with the social division of labor. There were defeats in this history, undoubtedly. But our contemporary defeat by the owners is greater, and we are on our way toward the catastrophe that their hostility to life is precipitating. This is not a matter of essentialism, but rather an idea of histories in the plural, or what I have called *historical pluralism*: an understanding that societies of different kinds have organized projects in which goals for happiness and wellbeing and forms of action in the feminine have been differentiated. Women can recover this politics in a feminine key, and men can join us and learn to think and practice politics in a different way. This could be the beginning of a new era, one that, in reality, is already showing signs of appearing: the start of a new paradigm for politics, perhaps the beginning of the end of what I have elsewhere called "the patriarchal prehistory of humanity" (Segato 2003a).

Throughout the history of our movement, feminists have sought to recreate sisterhoods, understood as protective shields for our spaces. They have forgotten or perhaps not recognized that these shields always existed in the communal world, until they were dislodged when association, representation, and the work of management were captured by a public sphere that totalized politics. They were thus remade "in the image and likeness" of the institutions proper to the world of men. The history of men is audible; it can be heard. But women's histories were erased, censored, and lost in the transition from the village-world to colonial modernity.

The idea of a *totalitarianism of the public sphere*, to use the phrase I adopt in chapter 4, and the crisis of faith in the state that results, lead to a problem that is worth mentioning briefly in this context, a problem related to the fatal mistake of placing faith in the state. I am referring to what I choose to describe as an *authoritarianism of utopia*, knowing full well that this phrase touches on entrenched sensibilities, sensibilities formed by the long history of both Christian monotheism and socialist conviction. (We must not forget that "the road to hell is paved with good intentions.") Conceptions of a perfect future society, guided by a vision of an effective appropriation of the state by progressive sectors that leads us triumphantly to social perfection, have always become

authoritarian. No utopia can avoid having an authoritarian effect. As I have argued elsewhere (Segato 2007a), the better alternative is to look away from abstract utopias, which are evolutionist and Eurocentric, projected into a future whose real indeterminacy and uncertainty are presumed to be controllable. We should instead look toward the concrete experiences of those peoples who are still today communally and collectively organized. We should put into practice among ourselves their inter-communal ways of limiting uncontrolled accumulation and preventing the formation of gaps of inequality among their members. The only inspiration possible is not to be found in the illusion of a future designed *a priori* by the neurosis of control that characterizes European civilization. It is instead the concrete experience of those who, after five hundred years of constant genocide, deliberated and enigmatically decided to persist in their historical effort to continue to be *peoples*, despite living in a continent of deserters, like ours – a continent claimed by those who have deserted their non-white ancestry and their belonging to an Amefrican, human, and historical landscape. (On societies that decided not to store surplus and not to allow for the emergence of idle classes, see Sahlins 1972; on societies that decided to work against the emergence of the state as a structure of control, see Clastres 1987.) Even in the largest Latin American metropolises, we can learn the lessons of those who persist in weaving communities.

Theme Four: Toward Politics in a Feminine Key

To look for inspiration in communal experience is to try to avoid the recurring strategic error of thinking of history as a project to be realized by the state. This search represents an alternative to all of the experiments that have failed throughout history. To reconstitute community on the basis of the existing fragments: this, then, would be our slogan. This also means recovering a type of politics that was erased when political speech was captured by the public sphere. This capture resulted in the minoritization and marginalization of those groups whose members did not conform to the image and likeness of the "manly" subject of the public sphere, the transformation of these groups into the remainders or the residue of politics. This style of politics is not part of the history of bureaucratic administration or modern rationalism. Instead it starts from *domestic reason*, which has its own technologies of sociability and management.

Masculine historical experience is marked by the distant routes required for hunting, for deliberations governed by protocol, for ritual parliaments, and for military enterprises and negotiations, first between villages and later at the colonial front. Women's history instead lays stress on roots and relations of nearness. We must recover this way of practicing politics in intimate spaces, places of close bodily contact and few formal protocols. We must recover a political style that was cornered and abandoned when the empire of the state and public sphere was imposed. This is an altogether different way of practicing politics, a politics of bonds, a management of intimacy, of nearness and not of the distances of protocol and bureaucratic abstraction. We need not only to restore the ties of memory – by looking in the mirror, appreciating our racialized embodiment, and undoing the myths of *mestizaje*, as I have argued elsewhere (Segato 2015d/Eng.: Segato 2022) – but also to recover the value and reconnect to the memory of women's proscribed and devalued ways of practicing politics, which were thwarted when domestic space abruptly lost prestige and autonomy in the transition to modernity.

But we must do this without lapsing into voluntarism, because not every small-scale collective that privileges face-to-face relations is a community. This is the mistake made by exercises in economic solidarity and restorative justice, since when a collective is organized to an instrumental end – for example, to the end of fulfilling needs in moments of scarcity or of resolving conflicts – it dissolves as soon as the problem that was to be addressed is settled. We saw this in the case of Argentina after the financial crisis of 2001. In order for there to be a community, two conditions must be fulfilled: there must be symbolic density, which is generally provided by a cosmos or religious system; and there must be a perception on the part of its members that they have a common history. This history, however, need not be one without internal conflicts. On the contrary. A community is a community, then, because it shares a history. In effect, it is not a patrimony of fixed customs that constitutes a community or a people, but rather the project of giving continuity, through consensus and dispute, to a common existence, as a collective subject (Segato 2015d; 2015e/Eng.: Segato 2022).

It is the desire to be in conjunction, in communication, that makes a community, as well as the permanent obligation of reciprocity that makes different types of resources circulate among its members. Neo-Pentecostal and literalist Evangelical churches, whose leaders

influence growing numbers of Latin American populations, have arguably been able to recreate precisely these kinds of communal technologies of sociability and thus to replace the old and exhausted collectivities with new ones, now emptied of their sense of rootedness and history (Segato 2007b).

Reconstituting community means being enlisted in a historical project that diverges from the historical project of capital. Here religion, spirituality, or what I have called the community's own "cosmos," plays an important role. I realized this while teaching on a ship called the SS *Universe*, administered by the University of Pittsburgh. Here North American university students from rich families, many of them destined to occupy roles in public life in the future, enrolled in a "semester at sea," during which they obtained credit in different subjects while touring the world. In 1991, owing to the dangers presented by the Gulf War, the ship was obligated to change course, and I was hired to teach between the ports of Caracas and Salvador, Bahía. My role there was to teach young people who were to land in Salvador on the very first day of Carnaval about what had been the subject of my doctoral thesis in the 1980s: Afro-Brazilian religions (Segato 1995). During one of my classes, an older man in attendance asked to speak. I called on him, and, turning his back to me, he claimed for himself the authority of the teacher. Addressing the students, he said: "It's because of these religions that I say that these countries will not be able to progress, because these religions are *dysfunctional for development*." I was deeply disturbed when I heard him say this. But what an invaluable lesson I learned from him – although, of course, I immediately took from what he said the opposite of what the respectable old man had intended: in the spiritual and communal life of *candomblé* were the seeds of resistance to the historical project of capitalism! I left the class wondering who this enigmatic person could be, this man who so zealously cared about the students' education. I found out that he was a politician who had been elected governor of Colorado three times, and who served as director of the Institute for Public Policy Studies at the University of Denver: left up North, right down South. Ever since then, I have understood that certain cosmologies and spiritualities, far from being "the opium of the people," constitute barriers to market intervention, because they are *dysfunctional for capital*.

We can, somewhat schematically, describe what is functional and dysfunctional for capital in today's world using divergent

designations for two types of historical projects: *the historical project of things* and *the historical project of bonds*. Each seeks a different type of satisfaction; the two projects are in tension and ultimately incompatible. In order to make this idea more vivid, I will refer to documentary images and accounts that circulate in the public domain of the pilgrimages made by Latin American migrants traveling to the United States, crossing through Mexico by train on *La Bestia*. These testimonies are intensely striking; they are available in documentary materials, and I heard them firsthand from their protagonists, during the course of at least three international events on this theme.

The accounts have a recurring structure: the migrants board the train; some of them fall and are severely injured; several lose limbs. Women are inevitably raped: as much a fulfillment of fate as if it were written in stone. Numerous migrants are captured, enslaved, and forced to work, often for years, on farms one or another side of the Great Divide that is the border between the United States and Mexico. At the end of this odyssey, after these extreme ordeals – which also involve the payment of exorbitant sums to *coyotes* or smugglers – migrants are frequently captured or returned to their countries of origin. From here, most of them begin the journey all over again ... The habitual approach is to explain their decision to leave home as a consequence of material scarcity or of expulsion by gang warfare. For my part, after spending several days looking at the images that I have described here, I would make another wager and suggest another way of understanding this strange phenomenon, this compulsion in our times and on our continent. I am not, after all, referring to people who have been forcibly expelled from their countries of origin, as in the wars of the Middle East. I would therefore venture to emphasize the role of attraction over that of expulsion, and I would seek to revise familiar understandings of abundance, lack, and libidinal investment. These are the constructions of a historical epoch and apocalyptic phase of capital with particular characteristics already noted by Gilles Deleuze in his Spinozist critique of Freudianism. Because it is abundance that produces lack, installs and imposes it, destroying what had previously been satisfying and fulfilling. At home, relations of trust and reciprocity are being worn down, discredited, and broken by the effects of interventionist modernization and under the pressure of the supra-regional market. When bonds are broken, a scarcity or lack appears that is not merely material, but rather a whole social

climate, in which the drives are redirected toward what I call "the world of things," the region "where things are." A new type of *cargo cult* is thus imposed: a mysticism that seeks an exuberant paradise of aestheticized commodities. It is the *fetish of the North*, or rather the *fetishism of the North as the kingdom of commodities*, that forcibly enters and intervenes in the plurality of the world's cosmologies. What captures the populations of the Americas, drawing them toward the North, is thus the magnetism of a *fantasy of abundance*, of a *fetishism of the region of abundance*, brought to bear on psyches that vacillate in a void of being, in a space now divested of its own magnetism, poor in the pleasures and obligations of reciprocity. Desire, which is always mimetic, is thus produced by a fetishistic excess, mystified and potent. Psyches are sucked into the *world of things* when the old ties of rootedness fail to retain them. And to complete this picture, let me call to memory a fantastic scene from Rodrigo Reyes's film *Purgatorio: un viaje al corazón de la frontera* (*Purgatorio: A Journey into the Heart of the Border*, 2013). In this scene, we see three migrants drawn as though by electricity to a fence made of metal spikes, the fence dividing two worlds. The migrants are like replicas of the zombies who appear in other recent films: these beings, too, are vacant, alone, without blood of their own, nourished by the imagined vitality of those who dwell in the world of things.

This drive toward the world of things, this movement of subjects ousted from territories where bonds have lost their appeal and their magnetism, shows how desire is produced by an excess that takes the form of a fetish; that is, something mystified and potent. *In this way, the desire for things produces individuals, whereas the desire for rootedness produces community.* The latter desire is dysfunctional for the historical project of capital, because investment in communal bonds that sustain happiness reinforces ties of reciprocity and communal rootedness, and makes subjects less susceptible to the magnetism of things. The world of things can only impose itself on detached and vulnerable subjects: the lessons of things, nature as thing, the body as thing, persons as things, and the pedagogy of cruelty that continues to impose a psychopathic structure, marked by a drive that is not relational but instrumental, as the prototypical personality of our time.

This is why I suggest that the way forward in history will involve reconstituting community and its bonds of rootedness. And this is why I believe that politics will have to be feminine from now on. We

will have to look for strategies and styles, reconstituting the threads of memory and reconnecting the fragments of communal technologies of sociability that remain available, until we can regain the time when the domestic sphere and its forms of interpersonal and inter-corporeal contact had not been displaced and foreclosed by the emergence of the public sphere, with its masculine genealogy, which imposed and universalized its bureaucratic style and distanced mode of management with the advent of colonial modernity. This style of politics and its *raison d'état* is monopolistic and stands in the way of a world in the plural. It imposes on all politics the coherence of the one and assimilates all otherness, filtered through the grid of universal reference. Meanwhile, political practice in the feminine is not *utopian* but rather *topical* and everyday, guided by pragmatics rather than principles, a matter of process and not product.[4]

A world in the plural is probably not republican, but it is more democratic. We need to recover what remained and what still exists in our landscapes after the great shipwreck, in order to devise a new style of politics for the future. In the process, we will have to compose a rhetoric fit for this purpose, a set of words to name and confer value on this feminine and communitarian politics, with its histories and its technologies of sociability. Only such a rhetoric and such a writing will be capable of defending us against the powerful rhetoric centered on the value of goods and commodified life.

Olinda, Pernambuco, November 26, 2016

1

The Writing on the Bodies of Murdered Women in Ciudad Juárez

Territory, Sovereignty, and Crimes of the Second State

Ciudad Juárez, in the state of Chihuahua on the northern border of Mexico, is a place that's emblematic of women's suffering. There, more than anywhere else, the association between women's bodies and the danger of death becomes real. Ciudad Juárez is also, significantly, a place that's emblematic of economic globalization and neoliberalism, with its insatiable hunger for profit.

The sinister shadow that falls over the city and the constant fear that I felt every day and every night of the week during my time there are still with me. In Ciudad Juárez, we can see the intimacy between capital and death, between the deregulated accumulation and concentration of wealth and the sacrifice of poor, brown, *mestiza* women, women who are devoured in a space where monetary and symbolic economies come together, and control over resources converges with the power of death.

I was invited to go to Ciudad Juárez in June 2004 because the year before that two women from the Mexican organizations Epikeia and Nuestras Hijas de Regreso a Casa (May Our Daughters Return Home) had heard me formulate what seemed to me to be the only plausible hypothesis that could account for the enigmatic crimes that were devastating the city: Women who resembled one another physically were being killed in disproportionate numbers, and they had been killed continuously for more than eleven years, with excessive cruelty, their bodies bearing evidence of gang rape and torture. These killings seemed unintelligible. My initial

commitment to spend nine days participating in a forum on the femicides in Juárez was interrupted by a series of events that culminated on the sixth day of my stay. The cable television signal dropped throughout the city when I began to offer my interpretation of the crimes, during an interview with journalist Jaime Pérez Mendoza on local Channel 5. The chilling chronometric precision that made the interruption of the signal and the first word of my response to Pérez Mendoza coincide also made us decide to leave, departing Ciudad Juárez early the following morning, both to protect ourselves and to protest against the censorship that we had suffered. Imagine our response when we found that everyone we talked to confirmed that our decision to leave immediately was wise. We were mindful that, in Ciudad Juárez, it seems that there are no coincidences, and, as I will argue, everything appears to be part of a massive communicative apparatus whose messages are intelligible only to those who, for one reason or another, crack the code. For this reason, the first problem that the horrendous crimes in Ciudad Juárez present for the foreigner, for audiences far away, is a problem of intelligibility. And it is precisely in their unintelligibility that the murders seek refuge, like messages translated into an obscure military code, an argot made up entirely of instances of *acting out*.[1] To give just one example of this logic of signification: the journalist Graciela Atencio, working for the newspaper *La Jornada*, based in Mexico City, also asked in one of her stories on the murdered women in Ciudad Juárez (Atencio 2003) if there might be something more than coincidence at work when, on August 16, 2003, just as the paper published news of a revealing "FBI report describing a possible modus operandi in the kidnapping and disappearance of young people," problems with the postal service prevented the paper's distribution in Ciudad Juárez.

Unfortunately, this was not the only coincidence that appeared significant to us during our stay in the city. On Monday, July 26, after having concluded my first presentation, midway through the forum that brought us to Juárez and exactly four months after the last body was found, another corpse appeared, the corpse of Alma Brisa Molina Baca, who had worked in one of the city's *maquiladoras*. Here I set aside the many irregularities that characterized the police investigation and the local press's coverage of the remains of Alma Brisa. It was, without exaggeration, something that had to be seen to be believed; you had to be there to bear witness to the inconceivable, the incredible. But what I do want to note is that the

body appeared in the same plot of wasteland in the middle of the city where another victim had been found the year before. This other victim was the murdered daughter (killed when she was still a girl) of the very mother whom we had interviewed on the evening of July 26 in the gloomy neighborhood of Lomas de Poleo, located in the unrelenting desert that cuts across the border between Chihuahua and the state of New Mexico, in the neighboring country to the North.[2] Others' general comments pointed to the fact that, the year before, when President Vicente Fox ordered a federal intervention in the state of Chihuahua, another body had been found. The cards had been dealt. The sinister "dialogue" seemed to confirm that we were dealing with a code and that the traces that we were following would lead to our destination.

This is the interpretive approach that I would like to take here, and it is what I was about to share when the cable television signal dropped, early in the morning on July 30, 2004. My comments had to do with how the deaths in the city were related to the illicit consequences of a ferocious form of neoliberalism that has gone global, reaching into the margins of the Great Divide after the North American Free Trade Agreement (NAFTA), and a result of the unregulated accumulation of wealth concentrated in the hands of a few families in Ciudad Juárez. In fact, what is most remarkable when one takes the city's pulse is the vehemence with which public opinion rejects the names of alleged perpetrators that public officials put forward, one after another. This vehemence suggests that people want to look in another direction and hope that the police will take their investigations elsewhere, into the city's rich neighborhoods.[3] The illegal traffic in all kinds of goods across the border includes traffic in commodities produced by the labor extorted from women working in *maquiladoras*; it depends on the excessive surplus value extracted from this labor as well as on the movement of bodies, drugs, and the enormous sums of capital that these businesses generate across the border, to the South of paradise. This illicit traffic resembles a process of unending payment, of unjust taxation, where tribute is paid to a voracious and insatiable authority, a figure who disguises his demands in and through acts of seduction. The border between the miserable poverty of excess and the miserable poverty of lack is an abyss. There are two things that can be said without risk, and that everyone says, in Ciudad Juárez: the police, the Attorney General of the Republic, the special prosecutor, the human rights commissioner, the press, activists, and NGOs. One is

that "the *narcos* are responsible for the crimes," a statement that reminds us who the culprits are and that reaffirms our fear of the margins of social life. The other is that "the motive for these crimes is sexual." On Tuesday, the day after the body of Alma Brisa was found, the newspaper repeated this claim: "Another crime with a sexual motive." And the special prosecutor underscored this idea as well: "It is difficult to curb sexual crimes." Here again, we see a confused handling of the evidence and a discourse that disorients the public by leading them to reason along lines that I believe are mistaken. In this way, the authorities and those who shape public opinion, although they pretend to speak in the name of the law and to defend rights, encourage an indiscriminate perception of the many misogynist crimes that occur in this place, as in any other place in Mexico, Central America, or the world: crimes of passion, domestic violence, sexual abuse, serial rape, the criminal imposition of debt through trafficking, the traffic in women, crimes related to digital pornography, trafficking in organs, and so on. I see this will to indistinction – as well as the allowance in Ciudad Juárez for all of these crimes against women, the sense that the crimes there are "natural" – as an effort to create a *smokescreen*,[4] to prevent the clear perception of a central nucleus with particular characteristics. It is as if the concentric circles formed by these various acts of aggression served to distract from or hide a particular type of crime, not necessarily the most recurrent but the most enigmatic by virtue of its almost bureaucratic features: young women with a physical resemblance to one another, most of them workers or students, are kidnapped, deprived of their freedom for several days, and then subjected to tortures, gang rape (including, as the former chief expert Oscar Máynez would declare in the forum, rape by more than seventeen men in one instance), mutilation, strangulation, and certain death. The forces of law then mix up or misinterpret clues and mishandle evidence. Attacks on lawyers and journalists follow, as does pressure from the authorities to blame scapegoats who are clearly innocent. This pattern has persisted, uninterrupted, from 1993 until today. To this list we can add the fact that no accusation has seemed plausible to the community, and no "avenue of investigation" has led to results.

During these years, the impunity has been shocking. It can be described in three main ways: (1) as involving the absence of any accused perpetrators who have seemed like convincing perpetrators to the public; (2) as entailing a lack of consistent investigations;

and, consequently, (3) as allowing for the endless repetition of these kinds of crimes.

On the other hand, two brave investigative journalists, Diana Washington Valdez, author of *The Killing Fields: Harvest of Women* (Washington Valdez 2006; first published as *Cosecha de mujeres* in 2005), and Sergio González Rodríguez, who wrote *Huesos en el desierto* (Bones in the Desert: González Rodríguez 2002),[5] gathered copious data discarded by the police during the course of many years, generating a list of places and persons related, in one way or another, to the disappearances and killings.

I spoke with Washington on two occasions on the other side of the border (since the FBI would not allow her to cross the bridge into Mexico without an escort), and I read González's book. What emerged was the realization that "honorable" people, powerful landowners, were linked to the deaths. But a crucial link was still missing: what led these respected heads of households, so successful financially, to implicate themselves in these macabre crimes that the evidence suggests were committed collectively? What plausible connection could there be between these gentlemen and the kidnappings and gang rapes? How could this connection be proven so that the crimes could be prosecuted? Here an explanation was missing. And it was precisely here, in the search for such an explanation, that the much-abused idea of "sexual motive" proved insufficient. We need new typologies and reformulated definitions if we want to understand the specificity of these deaths in Juárez; we also have to formulate new legal categories. In particular, we have to say what might appear to be obvious: that no crime committed by "common" or "marginal" criminals is allowed to last and to go unpunished for such a long time, and that no serious police force would speak so lightly of what, in general, can only be arrived at through lengthy investigation: the motive, motivation, or reason for a crime. These elementary truths caused people to shudder in Ciudad Juárez, where they proved unspeakable.

Science and Life

Some time before I heard Ciudad Juárez spoken of for the first time, between 1993 and 1995, I carried out research on the mentality of those who were sentenced for rape, prisoners in the penitentiary of Brasília.[6] My "listening" to the statements of these inmates

– all of them condemned for sexual attacks that took place in the anonymity of the streets and that targeted unknown victims – lent support to the key feminist thesis according to which sexual crimes are not the work of individual deviants, mentally ill men, or social anomalies, but rather the expressions of a deep symbolic structure that organizes our acts and fantasies and makes them intelligible. In other words, the aggressor and the collectivity to which he belongs share a gendered imaginary; they speak the same language and can understand one another. My interviews forcefully demonstrated what Menachem Amir (1971) had already discovered through empirical data and quantitative analysis: that, contrary to our expectations, rapists generally do not act in isolation; that they are not asocial animals who stalk their victims the way solitary hunters pursue their prey. Instead they act together. It is impossible to overstate the importance of this finding or its consequences for understanding rape as an act that is veritably *social*, that is, an act that takes place within a communicative space that can be entered and understood.

Rape is the use and abuse of the other's body without her intentional or willed participation. It seeks the annihilation of the victim's will, a reduction signified by her loss of control over the behavior of her body, its being taken over by the will of the aggressor. The victim is expropriated, robbed of her control over her body-space. This is why we can say that rape is an act that allegorizes Carl Schmitt's definition of sovereignty as legislative control over a territory and over the body of the other, annexed to this territory (Agamben 1998; Schmitt 1986 [1922]). It is an exercise in unrestricted control, an act of sovereign, arbitrary, and discretionary will whose condition of possibility is the annihilation of equivalent powers in others and, above all, the eradication of all indices of alterity or alternative subjectivity. In this sense, rape is linked to the ingestion of the other, an act of cannibalism through which the other perishes as an autonomous being with a will of its own; consumed, the other can only exist if it is appropriated by and included within the body of the one who devours it. The remains of this existence persist only as part of the project of a dominating will.

Why does rape acquire this meaning? Because, owing to the function of sexuality in the world as we know it, rape combines physical and moral domination in a single act. And there is no sovereign power that is only physical. Without the other's psycho-logical and moral subordination, there is only the power of death,

and the power of death, in and of itself, is not sovereign. Total sovereignty in its most extreme form entails "making live or letting die" (Foucault 2003). Without domination over life as life, domination cannot be complete. This is why war that leads to extermination does not entail victory, because only the power to colonize allows the power of death to be displayed to those destined to be kept alive. The sovereign trait *par excellence* is not the power to kill the subjugated person, but rather the power to bring about her psychological and moral defeat, and to effect her transformation into a receptive audience for the display of the aggressor's discretionary exercise of the power of death.

This violence is expressive more than it is instrumental. It seeks to express absolute control over the other's will. This is why the form of aggression that is closest to rape is torture, whether physical or moral. To express that the other's will is in one's hands: this is the *telos* or the end of expressive violence. Domination, sovereignty, and control create its universe of signification. It is worth remembering that these, however, are capacities that can only be exercised before a community of the living and that they have more to do with colonization than extermination. In a sovereign regime, some are destined to death so that sovereign power can leave its mark on their bodies; in this sense, the death of these people, who are chosen to represent the drama of domination, is expressive, not utilitarian. It is nevertheless necessary to understand that all violence, including violence in which the instrumental function is predominant – as in the case of the violence that seeks to appropriate something belonging to someone else – includes an expressive dimension. In this sense, we can affirm what every detective knows: that every act of violence, as a discursive gesture, carries a signature. And it is in this signature that we can recognize the recurring presence of a subject behind the act. Every detective knows that, if and when we recognize the element that recurs in a series of crimes, we can identify this signature, the profile and presence of a recognizable subject behind the act. The aggressor's *modus operandi* is nothing more and nothing less than the mark of a style on his various acts. Identifying the style of a violent act as one would identify the style of a text means casting the perpetrator in the role of author.[7] In this sense, the signature is not a result of deliberation or of will, but rather the result of an automatism in the act of enunciation. It is the recognizable trace that a subject leaves behind, the trace of this subject's position and of his interest in what he says, what he

expresses, whether through words or deeds (Derrida 1982). If rape is, as I argue, a speech act, it is necessarily addressed to one or more interlocutors who are present either physically at the scene of the crime or in the mental landscape of the speaking subject.

It turns out that the rapist transmits his messages along two axes of communication or interlocution, not just one, although rape is generally thought of exclusively in terms of his interaction with the victim. Along the *vertical* axis, he does address the victim, to be sure, and his discourse takes a punitive turn. He casts himself in the role of moralizer, as a champion of social values, because, in the shared imaginary, it is the woman's destiny to be contained, censored, disciplined, subdued in and through the violent act that allows him to embody the sovereign function.

But the discovery of the *horizontal* axis of communication may be the most important result of my research among the inmates in Brasília. Along this axis, the aggressor addresses his peers, and he does so in several ways. From them, he seeks permission to enter their society, and, seen from this perspective, the raped woman serves as a sacrificial victim, burned alive in an initiation ritual. The rapist competes with his peers, showing that, with his aggression and his ability to exercise the power of death, he deserves a place in their virile brotherhood and even a special position in a fraternity that only speaks the language of hierarchy, of a pyramidal organization.

This is because in the extremely long history of gender – a history that is so long that it merges with the history of the human species as a whole – the production of masculinity involves processes that differ from those involved in the production of femininity. Evidence seen from a transcultural perspective indicates that masculinity is a status that must be obtained, and one that must be reconfirmed regularly throughout one's life, where this confirmation involves a process of approval or conquest and, crucially, is contingent on the extraction of tribute from others who, by virtue of their naturalized position within this hierarchical order, are perceived as sources of nourishment, as sustaining virility. While they pay this tribute, these others also produce their own exclusion from the caste they embody. In other words, in order for the subject to earn masculinity, like a kind of title or degree, it is necessary that another subject *not* have it but rather confer it through a long process of persuasion or imposition that can aptly be described as a form of taxation (see Segato 2003b). Under "normal" sociopolitical conditions, where

this hierarchical order obtains, we women are those who pay this tax, this tribute, while men are its recipients and beneficiaries. And the structure that relates these two genders establishes a symbolic order marked by inequality, one that is found in, and that organizes, all the other scenes of social life, governed by a law of hierarchical asymmetry.

In short, understood within this framework, the crime of rape results from a mandate that emerges from the structure of gender itself; it guarantees the payment of tribute, which grants new members access to the virile brotherhood. And it occurred to me that we could locate fundamental features of the long and entrenched cycle of femicides in Ciudad Juárez at the tense cross-roads between these two axes: the vertical axis along which the victim is consumed; and the horizontal axis along which tribute is extracted. In fact, what led me to Ciudad Juárez was my belief that my framework for interpreting rape could shed new light on the enigma of the femicides and allow us to organize the pieces of the puzzle so that a recognizable pattern might emerge.

In keeping with this model, which takes into account and emphasizes the coordinated, horizontal role of communication among members of the fraternity, I tend not to see the femicides in Ciudad Juárez as crimes in which hatred of the victim is the predominant factor.[8] I do not deny that misogyny, in the strict sense of contempt for women, is generalized in the environment where the crimes take place. But I am convinced that the victim is the waste product of this process, treated as a disposable thing, and furthermore that there are constraints and extreme demands required for belonging to the group of peers behind the enigma of Ciudad Juárez. Those who predominate in this scene are other men. It is not the victim who reigns here; her role is to be consumed to allow men to satisfy the demands of their peers. The interlocutors privileged in this scene are equals, whether allies or competitors: the members of the mafia that is the brotherhood of men, who seek to secure their belonging and to celebrate the pact they sign; they are antagonists, who seek to display their power to their competitors in business dealings; they are the local authorities, federal author-ities, activists, academics, and journalists who dare to trespass in the sacred domain; and they are the subaltern relatives – fathers, brothers – and friends of the victims. These demands and forms of exhibitionism are characteristic of the patriarchal regime under a criminal order.

The Femicides in Ciudad Juárez: A Criminological Wager

Here I offer some ideas that, taken together, constitute a constellation or a possible image of the setting, the aims, the ends, the meanings, the occasions, and the conditions of possibility of the femicides. The problem here is that the demonstration can only take the form of a list. Nevertheless, the themes I touch on below make up a sphere of meaning – not a linear succession of elements but a single signifying unit: the world of Ciudad Juárez. It is not necessary that these enter the discursive consciousness of the authors of the crimes, because the facts are fundamentally constitutive of their world. To speak of causes and effects in such a context seems to me inadequate. But to speak of a universe of interconnected and intelligible meanings does make sense.

Setting: The Border, or The Great Divide

Located on the border between excess and lack, North and South, Mars and the Earth, Ciudad Juárez is not a happy place. It is home to many tears and many terrors.

Money has to cross this border to reach the *terra firma* where capital is finally safe and can bear fruit in the form of prestige, safety, comfort, and health. Across this border, where the real banks reside, capital governs morality. Across this border is the most controlled society in the world, its tracking and surveillance systems almost infallible. Beyond this point, this line in the desert sand, any illicit business has to be undertaken stealthily, in the strictest secrecy, among the initiated members of secret societies that are more cohesive and more secretive than those found anywhere else. Their pacts require the seal of a rigorous silence. Along this border, the owners of big businesses live on one side and "work" on the other, and their lands are rapidly expanded and valorized, with plots literally stolen in desert every day, moving ever closer to the Río Bravo. The border is home to the most lucrative traffic in the world: a traffic in drugs and bodies. The border separates one of the most expensive workforces in the world from one of the cheapest. This border is the scene of a massive and prolonged series of attacks on and killings of women, murders committed during what is called "peacetime."

Aims

The extremely long period of legal inertia – the lack of any legal response to the crimes – already calls attention to their enduring subtext: the killings are about impunity. Impunity is their great theme, and, for this reason, it is impunity that can serve as a point of entry into our effort to decipher them. Still, it could be that, although the breeding ground for the killings is the environment that I have just described – an environment characterized by the concentration of economic and political power and therefore by privilege and protection for some groups – we would be mistaken to think of impunity only as a causal factor.

I want to propose that the femicides in Juárez can be better understood if we stop thinking of them as a consequence of impunity and instead imagine that they are productive and reproductive of impunity. This was my first hypothesis, and it's also possible that it was the first aim of the perpetrators when the killings began: to seal, through collective complicity in the horrendous executions, a pact of silence that could guarantee inviolable loyalty to the brotherhood made up of the mafiosi who operate on both sides of the most heavily policed border in the world. To give proof, all at once, of their capacity for cruelty, the power of death that one must wield to take part in dangerous business dealings. The sacrificial, violent, and macabre ritual unites the members of the mafia and renders their bond indissoluble. The sacrificial victim, part of a dominated territory, is forced to pay the tribute or tax that is her body, to support the group's cohesion and sustain its vitality. For her murderers, the stain of her blood is the mark of their occult belonging to the group. In other words, more than a cause, impunity can be understood as a product, as the result, of these crimes, which can be seen as a mechanism for the production and reproduction of impunity: a blood pact, sealed by the blood of the victims.

In this sense, we can already identify a difference between this kind of crime and the kind of gender violence that is perpetrated in intimate domestic spaces and that targets victims within the abusers' circles (daughters, stepdaughters, nieces, wives, and so on). If in the shelter of domestic space a man abuses the women who depend on him because he can – that is, because they are already part of the territory that he controls – an aggressor who appropriates a feminine body in an open, public space does so because he has to in order to demonstrate that he can. In the former case, we are dealing with

the confirmation of a domination that already exists; in the latter, we are dealing with the display of a capacity to dominate, a demonstration that must be repeated regularly and that we can associate with the ritual gestures that serve to renew the vows of virility. Here power is conditioned to display itself publicly, to dramatize itself, often through a predatory act that targets the feminine body. But in fact the production and maintenance of impunity through the sealing of a pact of silence cannot be distinguished from what we could describe as the display of impunity. Sovereign power's classic strategy for reproducing itself as such involves spreading and even spectacularizing the fact that it is beyond the law. We can also understand the crimes in Ciudad Juárez in this way. This suggests that if, on the one hand, they allow for the sealing of an alliance and the making of a criminal pact, on the other hand, they fulfill an exemplifying function and in this way strengthen the disciplinary power of all law. With the important addendum that the association of mafiosi in this instance seems to act as a network with tentacles; its subjects occupy places in official administrations at various levels, forming in this way a "second state" that controls and shapes social life under the mantle of the law.

This is the case because in exercising his capacity to kidnap, torture, and kill repeatedly and with impunity, the author of these crimes demonstrates beyond any doubt the cohesion, vitality, and territorial control wielded by the corporate network he commands. Clearly in order to sustain the continuity of these crimes – their uninterrupted recurrence for many years – copious human and material resources have been required: an extensive network of associates; access to sites for detention and torture; vehicles for transporting victims; access to influence or the power to intimidate – or blackmail – members of the government and public administration at all levels, including the federal level. It is important to note that while this network of allies is brought together by whoever presides over the corporate crimes in Ciudad Juárez, its existence is flagrantly on display in its totalitarian domination of the city.

Meanings

It is precisely in order to fulfill this latter function that the killings come to resemble a system of communication. If we listen attentively to the messages that circulate here, we can also glimpse the face of the subject who sends them, the subject who speaks. Only

after understanding what he says, to whom, and why can we begin to locate the place from which his discourse emerges. This is why I insist that every time the phrase "sexual motive" is repeated thoughtlessly, without being accompanied by a meticulous analysis of what is "said" in these acts of communication, we miss an opportunity to trace the features of the subject hidden behind his bloody "text."

In other words, the femicides are messages that are sent by an author, a subject who can be identified, placed, and described through a "rigorous" practice of listening to the crimes, a process of treating them as communicative acts. We find the subject who speaks in his discourse, and it is in his discourse that the reality of this subject is inscribed, his identity and subjectivity. It is through this discourse that he becomes traceable and recognizable. Likewise, we can find in his statements the trace of his interlocutor, the latter's imprint, left like a negative image. This is true not only in the case of the violent instances of acting out that the police investigate, but in the case of any subject's discourse, as many contemporary philosophers and literary theorists have explained.[9]

If the violent act is understood as a message and the crimes in Juárez are perceived as orchestrated in a way clearly meant to solicit a response, we find ourselves facing a scene in which acts of violence function like a language capable of signifying efficaciously to listeners, addressees, those put on notice, those who understand and who speak the same language even when they do not participate directly in this communicative action. This is why, when a system of communication with a violent alphabet is instated, it is very difficult to dislodge it, to eliminate it. The violence that is constituted and crystallized in the form of a communicative system becomes an established language and comes to function with the automatism that characterizes any language's workings.

To ask, in such a case, why one kills in a certain place is like asking why a certain language is spoken in a certain place (Italian in Italy, Portuguese in Brazil ...). One day, each one of these languages was established through historical processes of conquest, colonization, migration, or territorial unification under the auspices of a nation-state. In this sense, our reasons for speaking a certain language are arbitrary and cannot be explained by a logic of necessity. But it follows that the processes through which a language is abolished or eradicated in a given territory are also historical. The problem of violence as language is further exacerbated when we recognize that

there are some languages that, under certain historical conditions, become lingua francas, spreading beyond the ethnic or national borders that originally sheltered them.

Let us ask, then: Who is speaking? To whom? What is he saying? When? What is the language of femicide? What is the meaning of rape? My wager is that the author of this crime is a subject who values profit and territorial control above all else, including his own personal happiness. He is a subject surrounded by vassals and one who thus makes it absolutely clear that Ciudad Juárez has owners and masters [*dueños*], and that these owners and masters kill women in order to show that that is what they are. "The sovereign is the one with respect to whom all men are potentially *homines sacri*" ("bare life" that can be annihilated with impunity because, as a sort of death penalty under Roman law indicated, the *homo sacer*'s punishment was to be denied any civil or human status), and "*homo sacer* is the one with respect to whom all men act as sovereigns" (Agamben 1998: 84). Does the author of these lines know that, in a certain sense, the notion of bare life can be understood to refer to women, given that, as is clear in places like Ciudad Juárez, their existence can be ended without legal consequence?

Sovereign power cannot assert itself unless it can sow terror. To this end, it addresses other men in the vicinity, the victim's guardians or those responsible for her, those within her domestic circle and those who are charged with protecting her as representatives of the state. It addresses the men belonging to other fraternities, whether they are allies or rivals, in order to demonstrate the many kinds of resources that it commands and the vitality of the network that sustains it. It confirms, for its allies and business associates, that community and group loyalty remain unscathed. It says to them that its control over the territory is total, that its network of alliances is cohesive and trustworthy, and that its resources and contacts are unlimited.

One speaks in this way when consolidating a fraternity, when arranging a business deal threatened with the danger that illicit dealings entail along this patrolled border, when opening the doors of an organization to a new member, when other gangs challenge the group's territorial control, when there are intrusions from outsiders or inspectors make their way into the totalitarian preserve. The language of femicide uses the signifier of the feminine body to point to the position of what can be sacrificed for the sake of a greater good, a collective good, like the constitution of a brotherhood of

mafiosi. The woman's body is the sign *par excellence* of the position that pays tribute, the victim whose sacrifice and consumption are easily absorbed and naturalized by the community.

The victim's customary double victimization is part of this process of digestion, as is the double and triple victimization of her family, represented most often by a sad mother. A nearly uncontrollable mechanism of cognitive defense makes us hate anyone who embodies the inversion, the violation, of the rules of the grammar of sociability, or the distance that separates our expectations for how life will be from how it is in reality. We seek to reduce the dissonance that this distance generates, and in the absence of an easily identifiable aggressor, we look for someone to hold responsible, someone who must be to blame for the collective misery this aggressor has caused.

Just as it is common for a convicted aggressor to recall his victim begrudgingly because he associates her with the endpoint of his destiny and the loss of his freedom, the community descends further and further in a misogynist spiral. Without adequate support to help its members to address their discontent, they cast blame on this victim, holding her responsible for the cruelty with which she was treated. All too easily, we choose to reduce the suffering and intolerable injustice to which we bear witness by concluding that "there must be a reason" for the victim's fate. Thus the murdered women in Ciudad Juárez rapidly become so many prostitutes, liars, party girls, drug addicts – anything that helps us to absolve ourselves of responsibility and free ourselves from the feeling of bitterness that would result from a confrontation with their unjust fate.

In the language of femicide, the feminine body is also the signifier of territory; its etymology is as archaic as the transformations it has undergone are recent. The annexation of the bodies of women as part of the conquered country has been constitutive of the language of tribal and modern wars. Sexuality turned toward this territory comes to express acts of domestication, of appropriation, the simultaneous insemination of the territory and the woman's body. For this reason, the mark of territorial control for the lords of Ciudad Juárez can be inscribed on women's bodies as though they were extensions of the domain that these men claim as their own. Gang rape is, like blood pacts, a mixture of the bodily substances belonging to all who participate; it is the act of sharing intimacy at its most intense, of exposing what is most jealously guarded. Like the voluntary cut from which blood flows, rape is the publication

– the making public – of a fantasy, the transgression of a limit, a gesture of radical commitment.

Rape and sexual domination are also characterized by bringing together physical and moral control of the victim and those associated with her. Moral degradation is a prerequisite for the consummation of this domination. In the world we know, sexuality is pregnant with morality.

What, then, is a femicide? What sense does Ciudad Juárez confer on this word? It is the killing of a generic woman for being a woman and for belonging to this class, just as genocide is a generic and lethal form of aggression aimed at those who belong to an ethnic, racial, linguistic, or ideological group. Both kinds of crimes are addressed to a category, not a specific subject. On the contrary, this subject is depersonalized as subject, because the category to which she belongs comes to predominate, becomes more important than the features of her biography or her personality.

But it seems to me that there is a difference between these two types of crimes that should be examined and discussed further. If in genocide the rhetorical construction of the other leads to this other's elimination, in femicide, the misogyny behind the act is a feeling that comes closer to what hunters feel toward their prey: it resembles a devaluing of their life or the belief that the only value of this life resides in its availability for appropriation.

The crimes in Ciudad Juárez thus appear to attest to a veritable "right of lordship," the right of a bestial baron at once feudal and postmodern. Acting with his group of acolytes, the aggressor expresses his ultimate right to absolute domination over a territory, where his entitlement to the woman's body is an extension of his seigneurial right to the fields. But under contemporary conditions that are worse than terrible – postmodern, neoliberal, post-state, post-democratic – the baron becomes capable of controlling his territory in an almost unrestricted way as a result of the uncontrolled accumulation that is characteristic of the booming border region. These conditions are exacerbated by economic globalization and the current, reigning neoliberal market. Here the only regulating force is greed, leading to the pillaging of competitors' holdings. These competitors are the other barons in the region.

Regional microfascisms and totalitarian forms of control over the area accompany the decline of the order of the nation-state on this side of the Great Divide. They call, more than ever, for the urgent application of internationalist forms of law and regulation. The

mysterious crimes perpetrated against the women of Ciudad Juárez indicate that decentralization, in the context of neoliberalism and de-statification, cannot but lead to the installation of a provincial totalitarianism, a regressive conjunction of postmodernity and feudalism where the feminine body is annexed to a territorial domain.

Conditions of Possibility

The extreme asymmetry made possible by the deregulated extraction of profits by one group is a crucial condition of possibility for establishing a context of impunity. When unequal powers are as extreme as they are under an unfettered neoliberal regime, there can be no separation between licit and illicit business. Inequality is accentuated to such an extent that absolute control over territory at the sub-state level becomes possible; such control can be wielded by groups, with their networks of support and alliance. These networks then install a form of veritable provincial totalitarianism, though which they manage to demarcate and unambiguously express the regime of control that reigns in the region. The crimes against women in Ciudad Juárez seem to me to be a way of signifying this type of territorial dominion. A clear characteristic of totalitarian regimes is enclosure, the representation of totalitarian space as a universe without an outside, an encapsulated and self-sufficient space where a strategy of elite entrenchment prevents inhabitants from gaining access to alternative forms of perception, or to external reality. The nationalist rhetoric that sees the nation as a primordial construction, a national unity (as in the cases of "Mexicanness" in Mexico, "tropical civilization" in Brazil, or ser nacional in Argentina), benefits those who retain territorial control and who monopolize collective speech. Such a metaphysics of the nation based in anti-historical essentialism, as popular and potent as it may seem, depends on the same logical procedures that shelter Nazism. This kind of nationalist ideology can also be found at the regional or provincial level when regional elites consolidate their power over space and legitimate their privileges through a primordialist ideology, that is, by instrumentalizing their identification with an ethnic group or civilizational inheritance. Powerful nativist slogans lead toward the formation of a feeling of loyalty to emblems of territorial unity; for the elite, these emblems are a kind of heraldry. In a totalitarian context, popular culture is

appropriated culture; the people are the inhabitants of a territory under occupation; and the authorities are the owners and masters of discourse, traditional culture, and the riches produced by the people and the territory under totalitarian control. As in national totalitarianism, one of the main strategies of regional or provincial totalitarianism involves preventing the collectivity from engaging in any discourse that might be branded non-autochthonous, not native to the region or marked by the commitment to the cause of regional loyalty. "Foreigner" and "stranger" are turned into accusatory labels, and any possibility of speaking "from without," from elsewhere, is eliminated. This rhetoric privileges the idea of a cultural patrimony that must be defended above all else and the idea of a territorial loyalty that predominates and that excludes all other loyalties: for example, the commitment to complying with the law or to the struggle for the expansion of rights or to the demands of activists and international courts that seek to defend human rights.

This is why, if the production of an "inside" and the use of the media are unmistakable strategies of totalitarian leaders, the "outside" is always the foothold for action in defense of human rights. In a totalitarian environment, the highest value, constantly hammered home, is "us." The concept of "us," or of the "we," becomes defensive, entrenched, and patriotic; whoever violates it is accused of being a traitor. In this type of patriotism, the first victims are the others internal to the nation, the region, or the locality: always women, black and indigenous peoples, and dissidents. These internal others are compelled to sacrifice, silence, and postpone both their complaints and all arguments for their difference; these must be deferred for the sake of sacralized unity and the essence of collectivity.

Brandishing this set of typically totalitarian representations in the region, the media outlets in Juárez disqualify foreign perspectives one by one. When one "listens" to the subtext of the news reports or reads between the lines, one recognizes that the media's discourse is: "Better a murderer of our own than a foreign agent of justice, even if the latter may be in the right." This well-known and elementary propagandistic strategy contributes daily to the construction of a totalitarian wall around Ciudad Juárez, shielding it from any outside gaze. It has also helped, throughout the past several years, to hide the truth from the people and to neutralize the forces of law that might resist local authorities by organizing protests against them.

It is impossible not to think of Ciudad Juárez when we read this in the work of Hannah Arendt:

> The totalitarian movements have been called "secret societies established in broad daylight."[10] Indeed ... the structure of the movements ... reminds one of nothing so much as of certain outstanding traits of secret societies. Secret societies also form hierarchies according to degrees of "initiation," regulate the life of their members according to a secret and fictitious assumption which makes everything look as though it were something else, adopt a strategy of consistent lying to deceive the noninitiated external masses, demand unquestioning obedience from their members who are held together by allegiance to a frequently unknown and always mysterious leader, who himself is surrounded, or supposed to be surrounded, by a small group of initiated who in turn are surrounded by the half-initiated who form a "buffer area" against the hostile profane world. With secret societies, the totalitarian movements also share the dichotomous division of the world between "sworn blood brothers" and an indistinct inarticulate mass of sworn enemies. This distinction [is] based on absolute hostility to the surrounding world
>
> Perhaps the most striking similarity between the secret societies and the totalitarian movements lies in the role of ritual. ... [But] such idolatry is hardly proof ... of pseudoreligious or heretical tendencies. The "idols" are mere organizational devices, familiar from the ritual of secret societies, which also used to frighten their members into secretiveness by means of frightful, awe-inspiring symbols. It is obvious that people are more securely held together through the common experience of a secret ritual than by the common sharing of the secret itself. (Arendt 1958: 376–8)

But what kind of a state is this? What kind of leadership produces this regional totalitarianism? We are dealing with a second state that needs a name, a name that might serve as the basis for a juridical category capable of capturing in law the owners and masters of this second state as well as the networks of complicity that they control.[11] The femicides in Ciudad Juárez are not common crimes or everyday acts of gender violence; they are corporate crimes, and more specifically they are crimes of the second state, of the parallel state. In their phenomenology, they resemble the rituals that cement unity in secret societies and totalitarian regimes. They share an idiosyncratic feature of other abuses of political power: they present themselves as crimes not committed by a person or subject, crimes

against a victim who is also not personalized. They appear as the acts of a secret power, which abducts a certain type of woman and victimizes her in order to reaffirm and revitalize its capacity for control. These are thus more like crimes committed by the state, crimes against humanity, but the parallel state that commits them cannot be held responsible because we lack the legal categories and effective juridical procedures for confronting it. This is why it's necessary to create new legal categories in order to account for the crimes and make them juridically intelligible, classifiable. They are not common crimes: that is, they are not crimes of gender violence, sexually motivated crimes, or crimes arising from a lack of understanding in the domestic sphere, as agents of the law, authorities, and activists frivolously claim. They are crimes that could be called crimes of the second state or corporate crimes, in which the expressive dimension, the assertion of control, predominates. I mean "corporation"[12] here in the sense of a group or network that administers resources, rights, and duties in a way that makes it a parallel state. Such corporations are firmly established in the region of Ciudad Juárez and have tentacles that extend into the highest reaches of the country's power. We can invert the terms momentarily and say that the *telos* or aim of capital, and of the "demands of capitalization," is not a process of accumulation, because this claim would be tautological (the end of accumulation is accumulation; the aim of wealth concentration is wealth concentration), and in making this claim we would be describing a closed cycle, an end in itself. If instead of this we were to posit that the aim of capital is the production of difference through the reproduction and progressive intensification of hierarchy, to the point where extermination becomes an indisputable expression of capital's success, then we would be led to the conclusion that only the death of some people can aptly allegorize and render self-evident the place and position of all of those who are dominated, of the people who are dominated, of the class that is dominated. It is in exclusion – and the destruction of the other that points to this exclusion – that capital is consecrated. And what is more emblematic of the place of submission than the *mestiza* woman's body, the poor woman's body, the body of the daughters of poor *mestizos*?

Could there be any better surface for the inscription of the otherness that is thus produced in order to be conquered? What trophy could serve as a better emblem of the regime, with its business deals made beyond the reach of any regulation or restriction? Here

the woman who is doubly othered emerges as the place where the latest form of totalitarian territorial control – control over bodies and territories, of bodies as parts of territories – is produced and signified through her humiliation and suppression. We thus confront the limitlessness of two kinds of economies, symbolic and material. The depredation and pillage of the environment and the workforce go hand in hand with systematic, corporate rape. We should not forget that pillage, *rapiña* in Spanish, shares a root with the word *rape* in English. If this is so, then we can argue not only that an understanding of the macroeconomic context helps us to shed light on the events in Ciudad Juárez, but also that, at the micro scale and at the local level, the humble women of Juárez should wake us up and lead us to a clearer understanding of the global transformations of our time, a time when the globe is becoming ever more inhospitable and terrifying.

Epilogue[13]

The Deaths and Us

Finally, I need to carefully examine my personal reasons for becoming involved with the case of Ciudad Juárez. As a result of my research, I have come to understand that, although those who suffer most are the victims themselves, their mothers, and their close relatives, the crimes against women in Ciudad Juárez are part of the jurisdiction in which all of us are forced to live, and an inescapable preoccupation for everyone who values justice and collective happiness. This is the case for two reasons. On the one hand, the theoretical, ethical, and legal problem of the femicides is similar to the great problem of the Holocaust, with all its dilemmas; both sets of crimes are the heritage of all of humanity. They offer an education, a lesson for all of us. Their perpetrators do not dwell beyond the shared horizon of the human; nor are their victims endowed with any essential, special qualities that set them apart from the other peoples in history who have been massacred. The historical conditions that make people into monsters or the accomplices of monsters lurk around all of us. The threat of "monstrosity," of our becoming monstrous, hangs over everyone, without exception, just as the threat of victimization does. It is enough to establish a strict and static border between "us" and "others" for the process to get underway.

Likewise, to give another example, the problem of racism is also everyone's problem, not only a problem for those who suffer from it. "The problem of racism is your problem, white people's problem, since you're the ones who produce it," someone said to me once. And anyone who watches while the forward march of racism's reproduction passes by, thinking it has nothing to do with them, will pay the price. While the victim who suffers from it has an opportunity to acquire lucidity and regenerative consciousness, it is the humanity of the one who is supposedly "not affected" that is worn away without their knowing, irremediably. They lapse into an inexorable decadence. Dark times descend, and we cannot make out their cause or figure out why the suffering they cause seems to show itself in others exclusively.

But this is not the only reason we are dealing with a problem that affects everyone. As I have argued, in the particular case of the femicides in Ciudad Juárez, I am convinced that there are other reasons as well, because I understand these as crimes perpetrated against us, for us – Mexican women, all Mexicans, women in other countries, and humanity as a whole. And I believe that we have been deliberately and intentionally made into the recipients of the messages they send. I am not saying this in a general sense but rather in a strict sense: I am convinced that these crimes are addressed to us, launched against us, that they are ways of laying claim to totalitarian sovereignty over this corner of Mexico and this part of the world. In other words, I am not arguing that we are involved simply because the crimes are assaults against us, make us suffer, and offend us, but rather that, in a rigorous, technical sense, they are displays of discretionary domination over the life and death of the inhabitants of this border territory, represented by and inscribed on the bodies of its women. These bodies become a document, an edict, an indisputably sealed decree. The crimes stage an ongoing dialogue with the law and with all of those who seek refuge within it. The murders are designed to display *before us* the capacity to kill, an expertise in cruelty and sovereign domination over a territory. They say to us that this is another's jurisdiction, an occupied land where we cannot interfere. And it is precisely because we do not agree – because we do not believe that Ciudad Juárez is located outside Mexico and beyond our world – that we have to assume the role in which they place us. We have to become their interlocutors and antagonists, critics of the crimes, at odds with them.

What Is To Be Done?

When I felt that I had done the work of interpreting the social text correctly and had made my contribution to the collective effort to understand what could be called "the enigma of Ciudad Juárez," I remembered yet again a phrase that had been with me since the day when Lourdes Portillo's documentary *Señorita extraviada* (2001) introduced the enigma into my life: "Decipher me or I'll devour you." Unconsciously, I came to associate the demand the Sphinx addressed to the King of Thebes with the conflict between the rational faculties and the disgrace of Ciudad Juárez.

Now, having arrived at a moment of stocktaking, I found that the Sphinx's riddle returned in all its menacing force: "Decipher me or I'll devour you." Full of doubt, I remembered Oedipus, the hero who, we think, defeated the Sphinx, resolving the riddle that she placed before all travelers, now regarded as an innocent riddle in childhood folklore. Indeed, Oedipus was clever, astute, and intelligent enough to find the right answer to the riddle of the Sphinx. I understood. He managed to make sense of what she said. But curiously this did not save either him or the city of Thebes from their tragic destiny.[14]

And it was precisely after his act of apparent understanding, grasping, deciphering, and unveiling that the tragic plot was set in motion. This, I believe, is our situation now in Ciudad Juárez. It is possible that we have taken a step forward in our understanding of events, so that we can catch a glimpse of an image, faded but recognizable, that shows us the game being played with dispersed pieces, a sinister charade. However, the discovery of a body, yet once more, in a "cotton field" on November 25, 2015 – the same day as the International Day to Eliminate Violence Against Women – seems again to reinforce our sense of uncertainty. The discovery of the body also happened to coincide with the anniversary of another, similar discovery in another fallow field in Ciudad Juárez in 2003. A recalcitrant and hostile interlocutor has not stopped responding to our efforts to intervene.

Let us say – let us suppose – that we have made sense of the enigma and that we know what we need to know. Nevertheless, like the tragic hero, we find ourselves still beholden to a destiny that we cannot bring to a halt.

I was engaged in these reflections when a book by Federico Campbell fell into my hands: *La memoria de Sciascia* (Sciascia's

Memory: Campbell 2004 [1989]). In a chapter titled "Nunca se sabrá" (We'll Never Know), Campbell offers a commentary on the book *Nero su nero* (in Italian, Black on Black), in which Leonardo Sciascia collected the pieces he wrote for Italian newspapers between 1969 and 1979. Here I came across the following fragment: "We will never know the truth about any criminal offenses that are even minimally related to the administration of power." Campbell then illustrates this maxim by pointing to numerous examples taken from the recent histories of Mexico and Italy.

We will never know who killed Pasolini, never know who poisoned Pisciotta, never know who shot Manuel Buendía,[15] never know who arranged for the massacre in Tlatelolco, never know whether the death of Enrico Mattei was an accident or a crime, never know who planted the bomb in the Banca dell'Agricoltura in Piazza Fontana [in Milan], never know who should be charged with the killings in San Cosme on June 10, 1971, never know how and in whose hands the publisher Feltrinelli died, never know why the lives of the residents of El Mareño, Michoacán, were cut short, never know who ordered the sentencing in Huitzilac in 1927, never know who shot Salvatore Giuliano or Francisco Villa, never know whether Benjamín Hill and Maximo Avila Camacho were poisoned intentionally or not, never know whether the plane crashes that killed Carlos Madrazo and Alfredo Bonfil were in fact accidents, never know who oversaw the holocaust at Topilejo, never know who murdered Rubén Jaramillo in 1962, never know who gave the orders or who was ordered to murder the tenant farmers of San Ignacio de Río Muerto, Sonora, in 1975, never know who ordered the killing of the journalist Héctor Félix Miranda, or "El Gato," in Tijuana in 1988, never know whose orders led to the shooting of Francisco Xavier Ovando (one of the leaders of Cuauhtémoc Cárdenas's candidacy for the presidency) and the young militant Román Gil Heráldez on July 2, 1988.

But, and here Campbell directly quotes Sciascia: "We knew very early, within a few hours, where the bomb that killed agent Marino came from: a clear sign that those responsible were not connected to the most powerful" (Campbell 2004 [1989]: 23–5). In my heart of hearts, I am afraid that the tragic character of human destiny may be the pattern that structures both personal life and history, and if tragedy has a salient characteristic, it is that it does not allow for the possibility of justice without distorting the nature of justice. What if no justice were possible, only peace? Would any peace be sufficient? Could we accept a future in which the killings of women in Ciudad

Juárez one day simply stopped and were gradually relegated to the past, without any justice ever being done?

I am asking these questions seriously. They are genuine questions, and I ask them in the first place when speaking to myself, alone, in private. What if they told us that the only exit was an armistice? Would I, would you, be capable of accepting it? And would we be capable of not accepting it? I am perplexed when I confront this question, because if Sciascia is right, then the decade of impunity suggests that the crimes in Ciudad Juárez are committed by those in power and that therefore we may only be able to negotiate their decline and eventual cessation.

2

Women's Bodies and the New Forms of War

Today's forms of war are characterized by their informality, and they unfold in an interstitial space that we can characterize as parastatal because it is controlled by armed corporations, with the participation of state and parastate troops. In this parastate realm, which is clearly expanding, violence against women has ceased to be a form of collateral damage and has become a strategic objective within this new theater of war. In this chapter, I examine the historical transformations that have led to war's informalization and the centrality of a "pedagogy of cruelty" aimed at those who do not act as armed antagonists in military confrontations – namely, women and children. Today's wars have undergone a substantial shift. They are not guided by ends, and their aim is not the achievement of peace in any of that word's senses. Today, for those who administer it, war is a long-term project without victories or conclusive defeats. We could almost say that, in many world regions, the plan is to make war into a way of life. One reason for this is that, with the progressive loss of control over the global economy and the displacement of capital's epicenter, imperial power sees the proliferation of wars as its last form of domination. The United States has been preparing itself for this apocalyptic phase for at least two decades, with disproportionate investments in scientific and technological research and in military industry. War is the last card that empire has left to play when it is faced with the loss of its dominion. More in keeping with Clausewitz than with Foucault,

war today is flagrant and conspicuous; it shows itself to be the ultimate and irreducible horizon of all politics, that is, politics by other means.

Without beginning and without end, war despoils and becomes lucrative. It stops being an emergency and becomes a permanent state. The temples of defeated peoples are no longer buried under new temples built by victorious peoples; instead, their exposed ruins become the places where predatory power displays itself, exhibits itself most forcefully. In this new global theater of war, the unconventional wars in the Americas make the region into the most violent place on earth when it comes to the waging of wars that are not formally limited conflicts between states, although state, parastate, and corporate troops take part in them. The most violent city in the world in terms of homicides per 100,000 residents, San Pedro Sula in Honduras, is located in the Americas, as is the most violent country in the world, Brazil, and eleven of the thirty most violent cities on the planet (UNODC 2014), including Mexico City.

Here, I consider the impact of new forms of war on women's lives. Today, war has been transformed, and some specialists in military history have begun to examine its workings and to identify its characteristics. From the time of tribal wars to the era of conventional wars in humanity's history through the first half of the twentieth century, women's bodies, *as* territories, were tied to the fates, the conquests and annexations, of enemy districts, subjected to rape by occupying armies. Today this process has undergone a mutation for reasons that remain to be examined. These have to do with the body's destruction through excess cruelty, its exploitation to the point where only a last trace of life is left, its torture unto death.

The pillage thus unleashed on the feminine shows itself both in unprecedented forms of bodily destruction and in forms of traffic and commercialization, which exploit women's bodies to their final limits. Despite all the victories that we have won in the realm of the state and despite the proliferation of laws and public policies that seek to ensure women's protection, their vulnerability to violence has increased, especially when it takes the form of the predatory occupation of feminine or feminized bodies in the context of new forms of war.

Even in the context of an account that emphasizes the continuities in women's fates in the history of warfare – the now-classic

text by the Costa Rican magistrate Elizabeth Odio Benito, who took part in the international tribunal's deliberations on war crimes in the former Yugoslavia and was the first woman judge for the International Criminal Court – the author recognizes that, despite the emergence of humanitarianism and the signing of humanitarian conventions including clauses on the protection of women during wars, in the military conflicts of the twentieth century, the situation for civilians, and especially for women and children, not only worsened; rape and other forms of sexual abuse "seem[ed] to have increased in sadism" (Odio Benito 2001: 101).

In my analysis, I try to demonstrate the existence of a break or discontinuity in the military paradigms of the present, characterized by the predominance of informality and by a form of action that can be described as clearly parastatal even in cases where the state may be the agency promoting and sustaining military action. I argue that, in the role and function assigned to the feminine or feminized body in today's wars, we can see a shift in the understanding of war itself. The wars in the former Yugoslavia and in Rwanda are paradigmatic of this transformation, and they inaugurate a new type of military action in which sexual aggression comes to occupy a central position as a weapon of war that produces cruelty, lethality, and a form of injury that is at once material and moral.

The impression that results from this new form of military action suggests that aggression, domination, and sexual despoliation are no longer, as in the past, the complements of war or forms of collateral damage; instead they have become central to military strategy. For this precise reason, after a period of initial invisibility and as a consequence of pressure from human rights agencies, "rape and sexual violence" (or "rape and other inhumane acts"), practiced as part of the occupation, extermination, or subjection of one people by another, were gradually incorporated into legislation on war crimes, genocide, and crimes against humanity. "[R]ape as torture and enslavement" and "other forms of sexual violence such as forced nudity and sexual entertainment, as inhumane treatment" in the International Criminal Tribunal for the Former Yugoslavia, and later "constitutive acts of genocide" in the International Criminal Tribunal for Rwanda, also began to be considered war crimes as well as forms of humiliation and degrading treatment ("outrages upon personal dignity, in particular rape, degrading and humiliating treatment, and indecent assault") (Copelon 2000: 230, 227, 226). This was also how various sexual crimes were finally

identified in the Rome Statute, which governs the proceedings of the International Criminal Court.

In order to understand the new forms of war, we must first review the contextual changes that make them possible, altering the structure of armed conflicts. These changes are in keeping with the economy of the world market in late modernity, operating in the midst of capitalism's cyclical crises, which have become ever more frequent, giving rise to political instability, the decline of "real democracy," and an increasing porousness in states and the national territories that they administer. The context for these changes in war, which is no longer a matter of conventional conflicts between nation-states as in the conflagrations of the twentieth century, has also changed many other dimensions of life: territory, politics, the state, the economy, and patriarchy itself. In the next section, I turn to the contextual shifts that have led to changes in war, restructuring the scene of armed conflict and assigning the feminine or feminized body a new role as it is moved from the margins to a central position.

The Informalization of Contemporary Military Norms

The new kinds of informal conflict and unconventional war create a context that is expanding throughout the world in many ways, especially in Latin America. Organized crime; the repressive, parastate wars waged by dictatorial regimes with paramilitary forces or official security forces acting paramilitarily; police repression that is at once undertaken in the name of the state and parastatal in its character; the repressive and brutal acts of the private security forces; the military contractors hired through the outsourcing of war; so-called "internal wars" within countries or "armed conflicts": all of these are part of a universe of war characterized by low levels of formalization. Here there are no uniforms, insignias, or standards, no territories delimited by states, no rituals or ceremonies meant to mark the "declaration of war," and no armistices or surrenders to mark defeat. Even when ceasefires take place and truces are implied, these are confusing, provisional, and unstable, and they are never observed by all of the subgroups or members of the armed corporations that confront one another. In practice, these conflicts have neither beginning nor end; they do not occur within clear temporal or spatial boundaries.

The armed groups or corporations that confront one another in this new form of war are factions, bands, gangs, mobs, tribal groups, mafias, groups of corporate mercenaries, and state and parastate forces that include agents of so-called "public safety," exercising their discretion within states whose increasing "duplicity" is no longer disguised. (I will return to the problem of the state's dual nature below.) This is an expanded and diffuse theater of war, in which violent actions are criminal or take place at the threshold of criminality, even while they are "corporate" in the sense that those responsible for them are the armed members of parastate corporations whose "heads" or leaders give commands to the perpetrators.

In his book *El negocio de la guerra* (The Business of War, 2005) and in a comprehensive interview in which he synthesizes his findings (Azzellini 2007), Dario Azzellini emphasizes the difference, or what I have called the "discontinuity," in the history of warfare. He notes that earlier mercenaries were individuals or small groups of persons who played marginal roles in the waging of war, whereas today they make up a significant amount of the military human capital managed under the rubric of "human resources" by large military contractors, and their action has been freed from the codes that constrained the behavior of state forces. This lawless corporate violence expresses itself in a privileged form on the bodies of women, and this expressivity indexes precisely the *esprit de corps* of its perpetrators. This *esprit de corps* is "written" on the bodies of women victimized by informal conflict, which makes these bodies into the medium through which the structure of war is displayed (Segato 2003a; 2006b, republished as chapter 1 above; 2011a; 2012; see also 2013, republished as chapter 7 below). In other words, in wars characterized by low levels of formalization, a convention or code seems to spread; it calls for the affirmation of the warring factions' lethal capacities through what I have called "the writing on women's bodies" (Segato 2006b, chapter 1 above; and 2013, chapter 7 below), both in general and as these bodies are associated with enemy jurisdictions, where they document ephemeral victories in struggles over antagonists' morale.

Why do these acts of expression, affirmation, and documentation target women, and why do they take the form of sexualized aggression? Because it is in violence by sexual means that the moral destruction of the enemy is staged when this staging cannot take place through the public signing of a formal declaration of surrender.

In this context, women's bodies are the medium or support for the writing of the enemy's moral destruction.

It is also very important to note that this is not a form of aggression against the antagonist's body, against the hitman for the enemy faction, for instance. It is something else. The abused bodies are fragile, not warriors' bodies. This is why they are so expressive: they show through their suffering the belligerent threat directed against a whole collectivity. They allow the aggressors to send a message about their unlimited capacity for violence and their minimal sensitivity to human suffering. In the parastate action of these groups, it is even more crucial to demonstrate that there are no limits to cruelty, since there are no other documents or insignias there to designate the bearers of jurisdictional authority. On the one hand, this truculence is the only guarantee of control over territories and bodies, and of bodies as territories. On the other hand, the pedagogy of cruelty is a strategy for the reproduction of this system. Through cruelty applied to the bodies of non-combatants, above all, the expressive function of these crimes is made visible and mobilized. As I have shown in all of my previous analyses, this expressive function is inherent in all kinds of gender violence. We are dealing, then, with the war crimes proper to a new form of war.

The rape and sexual torture of women and, in some cases, of children and young people are war crimes that take place in the context of the new forms of conflict proper to a continent where parastatehood is expanding. This is because they are also forms of violence inherent in and inseparable from the state repression of dissidents and excluded poor and non-white populations, the parastate military actions of private military corporations, and the killings led by gangs acting in the peripheral slums of Latin America's large cities. They may also be inseparable from the underground connections between all of these. Here, underground, the ends of violence are different from those of ordinary crimes involving gender violence or intimacy, although the elements central to the configuration of patriarchal structures persist and play a determining role, as, for example in the case of the directive to rape that I have considered elsewhere, the fraternal directive arising in the mind of the average rapist (Segato 2003a). This is analogous to the gang directive or corporate command that orders its armed addressee to suppress, subordinate, and morally massacre through the sexual violation of women associated with the enemy faction or of the child who does not agree to be recruited or who disobeys.

We must remember and reaffirm that these are not sexually motivated crimes, although the media and the authorities always insist they are in order to privatize them and thus to render them banal in common sense and public opinion. Rather they are war crimes, committed in the context of a kind of war that must be urgently redefined, analyzed in a new light and with reference to other models. It must also be addressed by new legal categories, especially in international law, that is, in the fields of human rights and humanitarian law. A new generation of researchers has begun to delineate the characteristics of this new modality of war. Elements that they have identified include its informalization, that is, the fact that war ceases to be a matter of conflicts between nation-states. For Herfried Münkler (2003), after a long period of capture by the state, we have witnessed a return to the privatization and commercialization of wars. Münkler, like Azzellini, also underscores war's lucrative nature and the use of mercenaries and children as human resources, as well as its transnationalization and "demilitarization" or informalization. In *The New Wars*, Münkler (2005: 3) refers to a transfer of control over war from the armies of nation-states to commercial groups owned by warlords, with the participation of states and parastate and private actors.

With these transformations, the old limit, once clearly delineated, between permissible violence in war and criminal violence is dissolved (Münkler 2005: 40). In the paradigmatic new war that was the war in the former Yugoslavia, on both the Serbian side and the Bosnian side, the residents of "the big-city underworld" made up of hoodlums and the members of criminal mafias "occupied key positions in the so-called paramilitary groups" (2005: 80).

But what is most relevant for my analysis here is the treatment of women and children in new forms of war, attesting to a discontinuity. If women have always been treated as "booty, a prize of victory, a sex object for soldiers," "this generalization, ... which presents violence against women as an ever identical phenomenon, an anthropological constant, overlooks the extent to which it has varied historically in both scale and intensity" (2005: 81). "Evidently there was always violence against women in the classical inter-state wars, but since the eighteenth century at the latest it has been considered a war crime for which the penalty has usually been death" (2005: 81). By contrast, the wars of the last few decades have shown no respect for any code or rule for the protection of women and children. Here Münkler emphasizes the efficacy

of rape as a low-cost tool of ethnic cleansing: a technique for elimination that spares perpetrators the costs of bombing and the inconvenience of neighboring states' reprisals. The three steps in the dissolution of a people without genocide involve, for Münkler, the execution of prominent figures; the destruction of temples, sacred constructions, and cultural monuments; and the systematic rape and forced impregnation of women. In this way, in an efficacious and "economical" fashion, the battles of conventional wars are replaced by the massacres of contemporary wars. Münkler also mentions the emasculation and humiliation of defeated men, the withdrawal of their ability to protect "their" women, that becomes evident whenever an attack on an enemy "takes place through the violence inflicted on" women's bodies rather than by "striking at the organs of state power," as in earlier wars (2005: 85). And because today this practice has extended to societies in which, before, rape rarely occurred, Münkler suggests that it is possible to argue that we are dealing with a calculated and premeditated form of violence that is part of a military strategy, one that is independent of traditional patterns of behavior. That is, we are not dealing with a "custom" that arises in the theater of war, but rather with a planned military behavior. As a result, an "extensive sexualization of violence ... is observable in nearly all the new wars" (2005: 86).

Another scholar specializing in new forms of war, Mary Kaldor, proceeds from an analysis of events in Serbia to arrive at the same conclusion, arguing that war has been privatized by paramilitary forces who rely on the demoralization of elites, the profanation of mosques and other sacred places, and the widespread rape of women as maximally efficient military methods. Considering other cases of widespread rape, Kaldor (2012) argues that although these have occurred in earlier wars, the systematic character that they have acquired today in detention centers and other enclosed spaces gives them a new character, making them into part of a "deliberate strategy" for waging war.

Kaldor's analysis lays stress on the globalization of the economy, the politics of identity, and cosmopolitanism as developments related to recent transformations in war, and it is very interesting that she traces parallels among three patterns of violence aimed at the achievement of territorial control not through the subjection of populations but rather by their displacement through the techniques of counterinsurgency, which create a permanent atmosphere of fear and insecurity, one that makes it difficult for these populations to

remain in their former territories. These three patterns involve (1) carrying out atrocities in a way that makes them public knowledge; (2) the profanation and destruction of all that is socially significant, from historical and cultural landmarks, whose physical traces are targeted for removal, to religious buildings and historical monuments, cleared away to allow for the reclamation of particular areas; and (3) defilement by means of systematic rape and abuse. Kaldor concludes by noting a key difference between wars in the present and the conventional wars of the past:

> Essentially, what were considered to be undesirable and illegitimate side effects of old war have become central to the mode of fighting in new wars. ... These wars are rational in the sense that they apply rational thinking to the aims of war and refuse normative constraints. (Kaldor 2012: 106–7)

In various Latin American countries, research teams have recently been formed to study the sexual crimes that have taken place in the context of internal conflicts and to create forensic and juridical categories (Fernández 2009; Otero Bahamón et al. 2009) for understanding, investigating, and prosecuting these kinds of violence as war crimes (see, among others, Sondereguer 2012; Theidon 2004; Uprimny Yepes et al. 2008). The case of Guatemala has been the subject of an extensive critical literature, including studies focused on the use of systematic violence against indigenous women, which was a central part of the country's "internal conflict." Here, military forces, acting in a parastate capacity, attacked women who were members of the various Mayan communities that make up the indigenous majority of Guatemala. These women were subjected to acts of extreme cruelty, including systematic rape; the acts became public knowledge and resulted in the stigmatization and ostracization of the women, a kind of dissolution of the social fabric, the sowing of distrust, and the destruction of communal solidarities.

In her interesting study of the case of Guatemala, Lily Muñoz (2013) refers to a revealing set of guidelines found in the *Manual del Centro de Estudios Militares* (Manual for the Center of Military Studies) which offers proof of what the scholars I cited above have argued: that in the context of new wars, the use of sexual violence is deliberate and calculated. The guidelines contradict the humanitarian rule according to which sexual violence in wars is forbidden and punishable; instead, they claim:

The troops deployed against subversive forces are subject to moral and psychological pressures that differ from those normally found in conventional military operations. This is especially true in the case of the soldier's ingrained reluctance to engage in repressive measures against women, children, and the elderly.

The manual concludes by emphasizing the need to train soldiers to direct violence against non-combatants, those who are not armed enemies but rather vulnerable civilians: "The soldier normally has a strong aversion to police-type operations and repressive measures aimed at women, children, the sick, and civilians, unless he has been well trained in the necessity of these kinds of operations" (*Manual Manual del Centro de Estudios Militares*, undated, p. 196, quoted in Muñoz 2013: 15–16).

Changes in the Territorial Paradigm

A second contextual shift that contributes to changes in the waging of war today and makes women's bodies more vulnerable involves a transformation of the paradigm of territory or territoriality. In his history of the forms of government, Michel Foucault seeks to periodize the relations between government and territory that interest me here. According to Foucault, in the feudal period and early modernity, the government of territory took the form of "dominion": a feudal lord or king ruled over a "territory" that included the things and persons contained within this delimited space.

Only later, beginning in the eighteenth century, did government become a matter of governing a population, that is, administering a human group residing within a territory. This change entailed a profound alteration in the understanding of property and possession; given the cognitive contiguity of women's bodies and territories, this resulted in a profound transformation in understandings of gender and sexuality. The same thing occurred during the next historical phase.

Disciplinary techniques and the exemplary displays of punishment that Foucault locates in the eighteenth and nineteenth centuries gave way to the twentieth-century society of control.[1] The exercise of pastoral power was a crucial part of this transformation. For Foucault, this type of power, with its origins in the Judeo-Christian

world of biblical times, is the most efficient, "both an individu-alizing and a totalizing form of power" (Foucault 1983: 332). The development of modalities of government continues, moving toward the goal of controlling society; hence biopower, exercised through biopolitics, with its corresponding type of government, that is, the government of persons as biological beings through the management of their bodies. All politics, in this context, refers to bodies (Foucault 2003; 2007; 2008).

Previously, I have argued that, at the level of government and when it comes to the objects of its administration, we are witnessing the gradual emergence of a third moment, in which states compete with non-state agencies, and both states and non-state agencies exercise control over populations through pastoral techniques, that is, by treating the population as their flock. In this new phase, the distinctive trait of the governed population is its flexible and fluid character, its status as a network that is not fixed under the admin-istrative jurisdiction of a state (Segato 2007c; 2007d; 2008).

The anchoring of governed populations within a fixed and nationally delimited territory has changed because control's focus has been gradually displaced, so that power now governs a mobile human flock that cuts across national borders. Through the workings of biopower, a network of bodies becomes a territory, and a territory becomes an expanding flock. A territory, in other words, is made up of bodies. Now as never before, because of the loosening of these networks' relations to the territorial jurisdictions of nation-states, with their rituals, codes, and insignias, the jurisdiction is the body itself; power operates on the body and in the body, which must now become the medium of or support for the markers of belonging.

This last claim implies a change in territoriality itself, where "territoriality" is understood as a particular and historically defined relation to territory. Subjects and their "territories" are co-produced by every historical period and by the discourse of every form of government. The elements that constitute a territory are thus not fixed, but rather historically defined. We can also say that the contemporary, networked form of territoriality is an apparatus for attracting subjects with the promise of belonging, a way of conscripting and marking them.

Late modernity, with its form of life colonized by the market economy, tends to liberate subjects from territories linked to states, and to produce populations and understandings of territoriality that are networked. These cut across and interact with state jurisdictions

but do not completely coincide with them. As I have said, state and non-state agencies for the management of populations coexist. Some non-state agencies operate entirely outside the law, while others are in tension with state institutions, redrawing and resolving their different projects and interests. For their part, networks give rise to their own landscapes.

To control the flock, the agencies that would administer these networks must intensify, as much as possible, their capacities for exercising pastoral power and their biopolitics as well as their strategies for marking bodies with the signs of their belonging. Government has thus been separated from the state, and state governments – in the sense of administrations – share space with, exist alongside, and compete with non-state governments, or agencies of management, whether these are businesses, corporations, identitarian political formations, religions, militaries, or mafias. This, together with biopower, which focuses its techniques of management on bodies, and pastoral power, which seeks at once to lead and to produce flocks as it works toward the production and control of subjectivities, results in a new paradigm of territoriality. In other words, it brings about a change in the understanding and definition of the territory. And this change forcefully impacts the position and role of women's bodies, which have long been thought of as analogous to territories.

In an earlier version of the society of control, the state would deploy pastoral and biopolitical techniques for the production of docile subjects. In the present version, organizations that manage population networks take care of the politics of subjectivation. The state apparatus and the territory of the state are shot through with these new jurisdictional realities, which, as I have indicated, can be associated with businesses, corporations, identitarian political formations, religions, militaries, or mafias. These lay claim to an important role in the making of decisions, and they seize resources for themselves.

These networks are internally heterogeneous and stratified; they divide preexisting territories; and they are governed by their own vocabularies. Because flocks become detached from national territories and the fixed landscapes that previously served as points of reference and tied them together, the subordination and cohesion of their members must now be expressed exclusively in and through the projection of a unified image. That is, their unity must be made into a spectacle even while it depends on performative code words.

There must be signs that can serve as clear indicators of belonging and exclusion or non-belonging. Loyalties to the network lead to the redrawing of territorial divides; these become proto-political entities, and those who rule over them lay claim to forms of parastate leadership, coexisting and vying with nation-states for control over populations. The type of loyalty that Jürgen Habermas called "constitutional patriotism" (1988: 135) is replaced by a form of patriotism governed by the network's rules, and new territories constantly expand in what could be described as a process of "soft annexation." The network, unlike the state, has no military tradition in the conventional sense, but it is constituted in and through conflict. Its formation and the drawing of its borders are not military processes, as in the histories of nation-states, but the network exists in a diffuse state of conflict, without beginning or end. This state is its way of being. Networks thus belong to an environment shaped by the all-encompassing paradigm of identity politics (Segato 2007e), and they offer everyday people substitutes for territorial fatherlands. While, on the one hand, territories become expanding spaces for laying claim to common identities and shared interests within corporate networks, on the other hand, the role of established landscapes that have long served as points of reference for identity is weakened. In networks, the ritual enactment of expressive loyalty becomes crucial. In this new environment, people are both the repositories and the bearers of territory, and the people who belong to a network constitute a population. In other words, the group of people who belong to a particular network is itself a population, and the population is this network. For this reason, we can say that bodies themselves are the landscapes and the points of reference, the bearers of the signs that make up the heraldry that symbolizes the very existence of the network, of the mobile territory or flock, always expanding and consolidating itself. The body, and especially the woman's body, with its archaic affinity to the territorial, is here the medium and support on which the signs of belonging, of adherence, are inscribed. Codified attributes of belonging are chiseled or affixed to it. And on it – again, especially if it is a feminine or feminized body – the network's antagonists cruelly engrave the signs of their enmity.

If the stress falls on the outward signs of affiliation, the only signs that express the unity of the group, then inner disagreement and deliberation must necessarily be restricted and repressed. This places pressure on the territorial paradigm, leading to a reliance

on the diacritical signs of cohesive loyalty; the conspicuous tattoos worn by Central American gang members are the perfect example of this kind of spectacularized belonging. These collectivities, thus marked, do not clash because they are civilizationally different, as in Samuel Huntington's thesis; on the contrary, the differences between them are exacerbated because they compete for resources. They belong to the same territorial and political paradigm, and they are united in many more ways than they are divided. Their spectacular signs of solidity and their antagonism are only window dressing, public markers of their existence as well as their corporate cohesion. Their role is to express, beyond a shadow of a doubt, the group's internal unity and loyalty and the capacity of their ruling class, their elites, to exercise control. When a domain or jurisdiction is not a determined fiefdom or nation, but rather a fluid congregation, the signs of adhesion and antagonism gain importance. The performative efficacy of a ritualized identity, an identity become politics, is crucially relevant. The obedient body now becomes a function of a territory whose unity cannot be announced in any other way. The central problem, within the logic of identity politics, is less a question of persuasion than a question of representation.

The body marked as territory, claimed by biopower, is the ultimate site of control, and it allows us to understand the new form of territoriality, with its demands for loyalty and ostentatious antagonism. We could say that this new form of territoriality is para-ethnic. It is nothing other than a *hidden script*[2] and precondition for the unconventional wars of the present, the new forms of war. Here power acts directly on the body, and this is why, from this perspective, we can say that bodies and their immediate spatial environments constitute both the battlefields where conflicting powers meet and the medium or support for displaying the signs of their capacity for annexation. As I have said, the feminine or feminized body is the most efficiently adaptable body for this purpose because it is and has long been imbued with territorial significance. The fate of women's bodies, which have been raped and inseminated in wars throughout history, attests to this (Segato 2003a; 2006b, chapter 1 above). But the new territoriality introduces another turn of the screw, because the body becomes independent of the territory to which it is contiguous, independent of the territory of a conquered country. It becomes, in and of itself, a terrain or territory for military action.

Changes in Political Culture, or The Factionalization of Politics

In keeping with this change in the territorial paradigm, we can observe a change in the realm of the properly political, that is, in the realm of conflicting interests, the field for the expression of antagonisms. In this new context, the spectacularization of the visible markers of difference among antagonists – ethnic, religious, racial, generational, and so on – is more important than the content of these differences, because what matters most is the production and reproduction of the conflicts that, in our day, have become ends in themselves because they are profitable for the war industry and private military companies (Azzellini 2005; 2007; Münkler 2005). Under this new territorial dispensation, value derives from belonging, affiliation, political identity, participation in the herd, and new corporate mechanisms in the economy and politics benefit those who can position themselves and mark themselves out in their behavior as members of the network.

Here it is necessary to note the stark difference between my own views and Huntington's celebrated and widely touted thesis, even while the latter is, like mine, a thesis about war. Huntington argues that peoples have been separated into antagonistic blocs because they are different from one another. He thus formulates a perspective that can be described as "ethnic determinism," one that leads him to predict a future marked by military conflagrations caused by the different cosmic visions, systems of belief, values, and social projects of peoples who live closer together than they did in the past. Civilizational difference is, for Huntington, the determining cause of these antagonisms. My thesis is exactly the opposite (Segato 2007c; 2007d; 2008): I argue that what is taking place in the present is the consolidation of an identitarian political language in which the positions that represent conflicting interests – interests that I describe as highly territorial in the sense explained above – are expressed through cultural markers that are exacerbated and instrumentalized to this end. Antagonisms reach for ethnic or religious languages to make sense of and politicize themselves, and the framework of identity politics predominates. But it is flattened and emptied of the dense and deep contents of substantial, civilizational, ethnic, ideological, doctrinal, and theological difference (Segato 2007e). There is an ethnic or religious impulse, an identitarian

tendency, in these various networks of political affiliation, but the conflict over territorial domination, like the globalization of capital and the market, unifies all disputes. For this reason, people are obligated and under pressure to identify themselves through signs that mark out jurisdiction; the risk of not doing so is an inability to express interest or find the means to work toward their realization.

The patterning or formatting of identities, their being recast as the structures of support for politics, also has to do with territory, or what I have described as the territorial character of contemporary politics. The political culture of identities is also territorial, and even party politics today has to do with identity and therefore with territory. The expansion of identities in networks, the means of recruiting members into identitarian networks, or, in other words, the status of networks as territories: this is the problem and the project of contemporary politics. Just as religion today is powered by the fundamentalist effort to control bodies (and here I place the veil in Islam and the obsessive opposition to abortion among Christians on the same plane) for reasons related to jurisdictional sovereignty, control over the flock, and the demonstration of this control, in the same way political discourses have abandoned their focus on the ideological dimension and have become matters of belonging and alliance. In this sense, even party politics today is "identity politics," and its projects can also be understood as territorial, if we define the network of their members as their territory.

Power is the only value that they seek, and the strategy that prioritizes belonging and alliance and their symbolization above all other kinds of difference has a hidden key: the competition for power, and a pact among the conflicting factions or parties. This pact determines the goals that orient their action and guide their struggles to obtain power, defined as jurisdictional control over resources and persons. These groups vie for the power to control bodies, where bodies are the supports that allow for power's symbolization and so the practice of its pedagogy.

When I refer to a "hidden key" and to a "pact" or strategic agreement among the factions that compete for power, I mean to indicate that these groups all recognize and respond to a reconfiguration of the political field, where territories are marked by the presence of networks that distribute human, material, and symbolic resources among themselves. These territories are neither democratic nor entirely socially homogeneous, but, rather, highly

stratified, with a class of political or hierarchical, doctrinal or religious or corporate leaders in a position to hoard its financial resources, wield a monopoly on deliberative power, and exercise control over its mechanisms for the surveillance and exclusion of all other members. This is because the lingua franca of political administration is only accessible if a process of internal stratification takes place such that conflicts between networks become conflicts between their elites, and the networks themselves become workforces for these elites, allowing for the expansion of their territorial domains. I am not claiming that this kind of strategy never existed before. What I am arguing instead is that this paradigm, which involves minimal belief in the power of doctrine and the preponderance of power over political and ideological projects, has become a general grammar that coordinates the actions of various political factions. For reasons that I will examine below, the new forms of war also speak this lingua franca, and they are wholly compatible with this new political paradigm.

The *Mafialización* of Politics and the State Capture of Crime

Note that I am not referring here to the *mafialización* – the organized criminalization – of the state, but rather to the state's capture of the criminal field, the institutionalization of criminality. This is my current reading of the phenomenon that results from the association between – the communicating vessels that connect – the state and the criminal underworld. My wager is that the age of Robin Hoods like Pablo Escobar or Escadinha (José Carlos dos Reis Encina) has entered a final phase; there is no aura of romance around the realm of crime; and today's institutionalized crime is to yesterday's crime what soy, eucalyptus, and pine plantations are to wheat and cotton, the staples of classical forms of monoculture.

In this chapter, I have referred to the contextual changes that have led to the formation of a new political and military sphere in the contemporary world, a sphere with its own alliances, antagonisms, and factions that confront one another against an increasingly homogeneous backdrop resulting from the expansion of the global market and the predominance of financial capital. Now I will shift my focus to the criminal universe within this widespread theater of war, which is transnational, especially in Latin America.

Urban violence, especially in Latin American cities, leads to the emergence of diffuse and expanding scenes of war, closely related to the informalization of the economy and vertiginous increases in the circulation of undeclared capital. The counterpart of this violence is an exacerbation of the state's duality, a process that we could also describe as the parastatification of the state, the increasing liminality of the state's functioning, or the cynicism of its exceptionalism.

To trace the relation between the economy and informal war waged in this mafia-like mode, and in order to address a universe that is not fully observable but rather accessible through dispersed clues – fragmentary and barely intelligible scenes of violence – we need to rely on a model. In other words, we need to posit the existence of a structure of relations capable of explaining the events that the media categorizes as pertaining to the "police" and that public administration defines as matters of "security." Faced with the evidence that today organized crime constitutes an expanding realm and that there would seem to be no public measure capable of containing it, we are compelled to move beyond these kinds of categorizations, which seek to contain episodes of violence, to relegate them to the margins of the social universe. We need to think in another way and to make another wager, to arrive at another understanding of the relations, the connections, between these dimensions of social life, which extend beyond the margins of society, beyond the realm proper to the "police," and beyond the issue of "public security."

The model that I propose here proceeds from the recognition that an interminable series of illicit deals leads to the circulation of massive amounts of undeclared capital. These are deals of various kinds: they govern the traffic in forms of contraband ranging from drugs to weapons; the traffic in humans, some of whom are consenting while others, including adults and children, are coerced and smuggled; the traffic in organs; and the traffic in an immense quantity of consumer goods smuggled from abroad, including alcoholic drinks, illicit drugs, and electrical appliances, among other products that are subsequently sold through legal trade. The deals also govern the export of strategic minerals, precious stones, wood, and exotic animals. They increase the profitability of sexual exploitation, with sex workers, especially but not exclusively women, kept in concentrationary enclosures or sold into sexual slavery. Other sources of this great stream of underground, undeclared capital

include casinos, whether public or clandestine, where it is very difficult to keep track of the money that circulates. There are also payments for various kinds of mafia protection, including private security services – whose accounts are always suspect because they are commonly hired on the "black market" – and the work of policemen who are off the clock.

The surplus value extracted from the unremunerated labor of the growing number of people who work as slaves or servants, not paid salaries that are declared; the various kinds of bribes and the money that circulate thanks to the traffic in influence and political payoffs; the corruption that abounds in large companies and the inter-mediary firms contracted by mega-corporations with transnational connections; tax evasion by big businesses and more generally among the rich (as opposed to the over-policed middle classes who live off their salaries): the list could continue. Suffice it to say that I am convinced that we are dealing with a whole second economy, an extravagantly large set of undeclared incomes and wealth.

In the subtitle of his book *End of Millennium* (2010), the last volume of his trilogy on *The Information Age*, Manuel Castells refers to "The Perverse Connection: The Global Criminal Economy," offering an assessment of this increase in capital derived from criminal activity. He notes, for example, that the United Nations Conference on Transnational Crime held in 1994 estimated that drug trafficking alone accounted for yearly profits that already exceeded the total of all global oil sales. This gives us an idea of the scale of the second economy, which, we can infer, either parallels or spectacularly exceeds the primary economy, the open economy. Today's informal economy makes up an immense continent, a home to bankers, businessmen, and others who come from "good families." Indeed, it could not be otherwise, given the enormous flows that must be managed. Unfortunately, those we see in the news are only foot soldiers from poor and non-white places; they are levied through persuasion, moved by necessity, or dispossessed by force, turned into flesh and canon fodder, first in the line of fire to which they are sent like so many peons. They are nameless soldiers, conscripted by a giant organization that cuts across all social and economic levels. If we remember that the role of the state, with its laws and various norms, is in the first place to protect property, including life above all – that is, if we remember the legal value *par excellence* in a world in which the central pact is between the state and capital, where the state fulfills its function through its

monopoly on what is thought to be "legitimate violence," in other words, violence wielded by state agents who act in the name of public safety – then we can conclude that the state dedicates a share of its considerable force and devotes some of the legitimate violence to which it lays claim to the protection of property.

A question then inevitably arises: What forces and what kinds of legitimate violence protect the copious and enormously varied property that resides in the underground that is the secondary economy? By asking this question, we arrive at the hypothesis that there are two realities. There is a first reality made up of everything that falls within the sphere of the state, everything declared to the state, visible in the nation's account books and on the websites dedicated to "Transparency in Public Management." This includes residential, commercial, and industrial real estate, whether it is purchased or inherited; taxes collected; public and private sector salaries; "aboveboard" payments; all goods officially produced and marketed; licensed businesses, nonprofits, and registered NGOs; and so forth. This economy relies on police and military forces for its protection, and on the institutions and policies dedicated to public security; the court and prison systems protect this legal, legitimate wealth.

On the other hand, in the underworld, beneath this supposedly transparent universe, we find what in the previous chapter, on Ciudad Juárez (first published as an essay in 2006), I called the second state, and what I now prefer to call a second reality, made up of what are probably identical amounts of capital and wealth, protected by their own security forces, that is, by armed corporations that seek to protect the property of their owners and masters [dueños], who lay claim to the incalculable riches that are produced and administered in this other universe.

We cannot understand violence as it is presented to us by the media, that is, as a dispersed, sporadic, and anomalous phenomenon. Instead, we have to perceive the systematic nature of the giant structure that binds apparently distant elements of our society together, capturing representative democracy itself. And if we think about it bit more, we realize that this structure is necessarily global in its reach and political in its import. That is, it interferes in politics and influences governments even while it is interfered with, both in national outposts and in imperial centers. In national contexts, its impact is evident because it determines electoral processes, keeping winners captive to the deals that they agreed to in order to win

power. And in the global context, the second economy's impact is evident because prestigious banks in the Global North launder the money that it produces and accumulates, such that it is not possible to investigate and prosecute cases of corruption with the full force of the law in the North because, as Eric Holder himself, then the United States Attorney General, argued in 2013, acts of corruption and fraud committed by North American bank executives cannot be adjudicated given the size of these institutions and their implications for the national and global economies.[3] We are dealing with a doubling of the state and an open acceptance of the workings of an untouchable second reality. This is another example of the interconnection between the sources of wealth that flow underground and those that flow on the surface.

In this way, crime and the accumulation of capital by illegal means cease to be exceptional and instead become structural. They come to structure politics and the economy.

On the other hand, the ever-attentive strategists of the North also see, in this partitioning of state control, a new opportunity to control national destinies. And they show up here, serving imperial interests by intervening in both realities, that is, both in the shady dealings of the underworld and in repressive politics aboveground.

These dealings are open to meddling by imperial agents, with their *expertise*, in two senses: underground, in the agreements reached in the underworld, with its traffic in capital and illicit merchandise, goods, and influence (as we see in the open declaration of the US Attorney General, faced with the fact that the country's banks launder the money of Latin American dirty businesses); and aboveground, in the support that these agents lend to states by becoming accessories of repression. If we bring these two kinds of evidence together – the evidence of Northern banks' complicity in laundering the money sent their way by the mafia-run businesses of the South, on the one hand, and, on the other hand, the evidence of the instruction that North American military experts offer to state efforts to repress gangs – we can see that the new forms of conflict are portals that open onto the control of the national realm. This is true in both "realities," the first and the second, or the primary and the secondary, as I am calling them here. It is therefore essential that we think them together and connect the sphere of the "police," "crime," and "public security" with that of the state and politics. We do not need to rest content with the observation of epiphenomena offered up by the media.

One of the consequences of the existence of a secondary reality, with its own capital, its owners and masters, and its businesses is the expansion of a military sphere with new characteristics, a diffuse space, difficult to apprehend, that is increasingly pervading and shaping social life. The methods and practices deployed within this sphere are very similar in various countries; they are transnational, betraying the possible existence of a common agenda as well as a set of connections among and shared journeys undertaken by bosses who travel together with their methods, and messengers who carry information and deliver instruction in new tactics. In Latin America, from Central America to Argentina, a *mafialización*, an organized criminalization, of politics has taken place, resulting in the spread of parastate, mafia-led wars and of state wars waged with parastate support. What is occurring thus involves the vertiginous expansion of what we could call the "parastate sphere," which has always existed and has always operated alongside the state and been inherent in its nature, but which now poses a new threat: it threatens to impose itself on, even to the point of overtaking, the state sphere, not through a military coup, but rather from below, by inflating the parastate, which resides within the state, in a new way. On the other hand, those who today are submerged within the parastate sphere of organized crime are in many cases themselves the former agents of repression, those who served the state during dictatorships. At times they now serve as human resources for private security companies or work as mercenaries hired by the private military contractors that participate in today's transnational wars, as Azzellini (2005; 2007) has indicated.

Ernst Fraenkel (1941) developed a theory of the state's duality centered on the case of Nazi Germany. Fraenkel quotes Ferdinand Tönnies's claim that the chief characteristic of the modern state is its dual nature. The coexistence of the rule and the exception, as Giorgio Agamben (2005) argues in his readings of Carl Schmitt, Walter Benjamin, and Franz Kafka, and Eugenio Raúl Zaffaroni (2006) in his interpretation of the work of Günther Jakobs, is a feature of all states in all periods, whether they are at peace or at war, whether they are democracies or (as in the more obvious cases) authoritarian. This dual structure derives from the fact that no government can act through the state alone, or only normatively; it must deploy other agencies and take discretionary actions that Frankel describes as "prerogatives" alongside the acts of "normative" agencies.

Although in authoritarian states this doubling is more visible, it is no less operative in democratic states. It is impossible to control or to discipline a national society – with its full range of interests and groups – using only constitutionally legal means. The so-called "trigger-happy" nature of the police, for example, results from the fact that in the street police are empowered to act as judges. The state agency that is the police has the discretionary power to judge and assess whether a given situation is dangerous and to use lethal force against citizens as a consequence of this determination, without legal responsibility. This "sovereignty," as Agamben would call it – that is, this discretionary power that characterizes the police in its relations with the population – represents a legal void or vacuum that is, however, itself legal. It constitutes a kind of hiatus within, inextricable and inseparable from, the law.

This duplicity inherent in the function of the police in the street is nothing other than an embodiment of the dual structure of the state, personified in the figure of the policeman, who acts as an executioner – performing summary executions called "extrajudicial" that are nevertheless "normal" in any and every country – without breaking the law, because this is one of the natural forms of the doubling of state action in and through the work of its agents. I mean "doubling" here in the sense of a permanent duality, with the state acting alongside the parastate. What I have described here is just one of the many ways in which the state is legally dual and acts through the parastate without betraying its own "norms." There are various kinds of doubling, just as there is a liminal territory between the legal and the criminal. This is a veritable limbo that discloses the fictional nature of the legal state.

If what I have called the first reality works by way of this type of doubling, then what I have called secondary reality is coordinated by the second state, and characterized by the action of its own armed corporations, groups of assassins organized and led by bosses acting at the local level, at the level of the neighborhood, as well as by others who direct from a distance, both socially (since they deal with enormous amounts of capital in circulation) and geographically (since although their location cannot be verified, it can be inferred given the recurrence of certain tactics, their systematic way of operating from remote locations and crossing national and continental borders).

As I have explained, the actions of these armed corporations seek to take over the illegal market and protect private property

and submerged capital flows, preserving the untouchability of the underground environment. To this end, they constitute a second state, with its economy, its laws, its security forces, and its own organization. The underground existence of these elements leads to the expansion, currently underway, of a theater of war, where warfare is not conventional but defined by informality, with factions fighting over the appropriation of territory and control over neighborhoods. Such wars are fought by people – in general young recruits who join the military forces – who do not wear uniforms or insignias and who express their jurisdictional power through cruelty, by making examples of others in the ways that I referred to earlier. There is, however, no legal language available for describing these new forms of war. They are not legislated anywhere. The United Nations Convention Against Torture, for example, speaks of torture by agents of the state, but here the torturers are the agents of another state, the members of other kinds of armed corporations. The second reality is an uncertain realm, an uncharted swamp.

Liberal democracy itself – "real democracy" or "actually existing democracy" – is necessarily affected by this complex situation. We should not ignore the public declaration made by an important representative of the Federal Police in Brazil, the head of the fight against organized crime, who noted that there is no political party in the country that can be elected without relying on some kind of illicit support.[4] Investigative journalists from various countries and police officials like this one offer descriptions pointing to the undeniable connection between politicians from all parties and mafias, which provide indispensable contributions to campaign funds and thus take part in the political processes held sacred by the state. This places a permanent question mark over the very structure of representative democracy, mass democracy, and the so-called "democratic" order, which cannot defend themselves against their own parastate shadows or the force of capital, with its double movement. Capital flows through the circuits of both the first and second realities, which are interconnected through a vast network of well-nourished blood vessels. This leads to enormously widespread instability and a state anomie that nevertheless emanates, as I have said, from the structure of the state itself. This anomie opens the doors to an aggressiveness that, I will work to show, is expressed in a particular way in the violence inflicted on women's bodies.

We tend to ask after the *ends* of violence, seeking these ends in an almost automatic way and guided by a form of instrumental

rationality. This is no less true of the acts of barely intelligible violence that we hear about, like gendered violence in the context of war. We investigate the instrumental function of this violence. We ask ourselves what this violence is "for," when, as I have argued before, we should instead track the *expressive* function of these crimes.

All violence has an instrumental and an expressive dimension. In sexual violence, the latter predominates. Rape – all rape – is not the anomalous act of a solitary subject but rather a message related to power and appropriation, a social statement. The end of this kind of cruelty is not instrumental. The vulnerable bodies in the new theater of war are not being coerced and made to surrender in order to perform a service, but rather because this coercion is part of a strategy aimed at something more central: a pedagogy of cruelty that forms the basis for a whole structure of power.

To instruct the gaze, teaching people how to look at nature and at bodies; to render these bodies external to life in order to allow for their domination, colonization, exploitation, and pillage: these are central elements in the military training that has intensified in the context of contemporary wars. The economico-military order, which operates within this informal and underground context, seems to depend on processes of extreme and limitless "desensitization," on the systematic dismantling of all human empathy, and on the spectacle of cruelty as the only guarantee of territorial control in a context as barely normalized as the second reality. Chilling forms of punishment are inflicted on young people living on the poor peripheries of large cities to entrap, conscript, and terrorize them violently. These forms of punishment also show that there is a breeding ground for violence that clearly threatens society as a whole; they are thus misleading signs, statements that loudly warn of a gathering danger to the social order and the predictability of its existence. A question mark hovers over the codes and conventions that give stability to interpersonal relations. Elsewhere (Segato 2013, also chapter 7 below), I have referred to this process as a *mafialización* or "organized criminalization of the republic," drawing on the image of "the serpent's egg," the title of a film about the origins of Nazism by the great Swedish director Ingmar Bergman. This kind of expressive cruelty, which points to the existence of a sovereign parastate that controls lives and businesses within a given territory, is particularly efficacious when it is brought to bear on women's bodies. This method is characteristic of the

new forms of unconventional war inaugurated during our military dictatorships and dirty wars against the people, in civil wars and so-called "ethnic" conflicts, in the salaried combat provided by private military contractors, in the work of paid assassins employed by gangs, and in the parastate actions of state security forces under conditions of "actually existing democracy."

Before, in the context of the wars that we now consider conventional – from tribal wars to the formal wars fought between states in the twentieth century – women were captured, like territories. They were appropriated, raped, and inseminated as extensions of conquered lands, and they were semantically associated with these territories; their bodies were themselves territories. These were collateral effects of war. "Seeds" were planted in women the way they were planted in the earth that had been seized. But the public rape and lethal torture of women that we see in contemporary wars are distinct; they are different acts with different meanings. They signify the destruction of the enemy in and through the woman's body, and the feminine or feminized body is, as I have argued on innumerable occasions, the very battlefield in which the flag of victory is planted. The body itself is made to signify, to bear the inscription of, the physical and moral devastation of the people, tribe, community, neighborhood, place, family, or gang that this feminine body represents, through a process of signification proper to an ancient, ancestral imaginary. It is no longer appropriating conquest but rather physical and moral destruction that is carried out in war today. This destruction spreads, extending to the figures charged with protecting the victim. In my view, it expresses a new relation between pillaging and nature, leaving only remains behind. This serpent's egg that is being incubated, whose existence can be seen in various epiphenomena, is the historical project of a new order in which evil is the norm.

I want to note that, in my analysis of this new order, I do not consider enjoyment or speak of hate as a motive. I do not use the phrase "hate crimes," for example, because it suggests a monocausal explanation and refers to an intimate, emotional realm as the location of this singular cause. I suggest instead that the attacking group seeks to signify its belonging to an armed corporation, a gang of assassins, a mafia. This is a calculation: in order to belong, to be part of the group, one must offer demonstrations of lethal power and a capacity for relentless cruelty. For this reason, the member of an armed, parastate corporation must be trained to lower his

threshold for the recognition of vulnerability and to increase his own capacity to inflict cruelty without suffering or being affected. He prepares to enter a world in which suffering is a way of life. I mean, then, that this kind of soldier subjects himself to the new order deliberately, calculatedly, on the basis of a determination of expediency. Cruelty is expressive and exceeds instrumentality, but the recourse to it is instrumental. It is a calculation that involves consideration of the benefits awarded to those who honor criminal pacts. These pacts, as I have argued elsewhere, obey and redouble the masculine mandate. For this reason, it is important to clarify that sexual crimes, especially those committed in the context of war, are crimes of jurisdictional and discretionary sovereignty; they involve the exercise of this sovereignty over a territory and therefore are not crimes of hate.

In this sense, although the idea of an aggressor's "hatred" for his victim is easy to access and understand, it is necessary to appreciate the idea's limits, which have to do precisely with its simplicity. To appeal to the feeling of hatred in an effort to understand the complex role of masculinity within the new forms of war is, as I have argued, to offer a reductive and simplifying, because monocausal, explanation. In the first place, this explanation pretends to account for scenes of enormous complexity in which psychological and social factors combine: the structure of patriarchy, extralegal deals and pacts signed by political elites. In addition, this explanation refers to private emotions, to affects like "hatred," which belong to the intimate realm, when in fact we are dealing with a theater of war shaped by the interests of orders that extend far beyond the intimate sphere.

The monocausal, common-sense explanation that attributes lethal forms of gender violence to "hate," defining femicide as a "hate crime," has done a great deal of damage to our capacity to understand what is happening in these gender crimes. The attribution of causality and, worse yet, monocausality is a superficial means of understanding any human action.

When it comes to rape as a method for waging war, I would insist that, in the context of the new forms of war, it is not a form of appropriation but a mode of destruction, that is, a method for the physical and moral destruction of an organism and a people. Here it is very important to note another key characteristic of the new theater of war: the body that represents the enemy country, the feminine or feminized body generally belonging to a woman or

young man, is not the body of a soldier, assassin, or mercenary. That is, it does not belong to a subject who acts on behalf of the armed, enemy corporation; it is not, strictly speaking, the body of a military enemy, against whom one fights. It is instead the body of a third, of a sacrificial victim, of a messenger, that is made to signify. On this body a message is inscribed, the message that a sovereign addresses to an antagonist.

This victimization of one who is not an opponent has greater efficacy as a spectacle of power, as a display of barbarousness and ferocity, a message about sovereign prerogative, despotic privilege. In other words, it expresses lawless supremacy. And this is also why, from a conventional analytic perspective, this kind of violence is all but unintelligible, and those to whom the message is addressed interpret it in an automatic and unmediated way. They know only that they are dealing with power expressing itself through cruelty, wielded with impunity.

If raping men is a way of feminizing their bodies, displacing them from a masculine into a feminine position, then the rape of women is also their destitution, their condemnation to the feminine position, a way of enclosing them within this position, defined as a kind of destiny: the destiny of the victimized body, depleted, subjected. The pedagogy of femininity as subjection is reproduced here. When a man or a woman is raped, the intent is to feminize the victim, to impose femininity as a definitive and indelible mark, and this act establishes the indisputable truth that the heterosexual matrix is inescapable. This truth is the foundation and first lesson of all forms of relation to power (Segato 2003a).

The lingua franca of gender that is spoken here, in and through this act of war, attests to humanity's capture within a hierarchical order, its confinement within a binary matrix of oppressors and oppressed, dominators and the dominated. In the theater of informal, barely codified war, the last law that seems to remain in the normative void is the law of power, expressed in the language of gender from start to finish. Hence the importance of rape, an act central to the new forms of war. In this way, unconventional wars, despite all the campaigns that women have undertaken and in many cases won in the legal realm, renew and consolidate the collective, colonial-modern imaginary that connects us all and confers meaning on rape or forced sexual access, which comes to signify indelible moral damage to the victim and to all those charged with guarding and protecting her body: the fathers, brothers, husbands, and

political officials in charge of the jurisdictional territory where they reside. This imaginary establishes the hierarchical relation that we call "gender," an unequal, binary structure. Within this structure, the masculine position claims for itself the capacity to speak truths and to give voice to universal interests in the so-called "public sphere"; it identifies itself as the paradigmatic, fully and comprehensively human subject, and in this way it banishes the feminine position to the margin, recasts it as a remainder, the site of particularity and venue of intimacy (Segato 2011b, republished as chapter 5 below; 2014a). Sexualized military aggression against women and children – that is, against those who are not, strictly speaking, opponents in war – is an aggression that is at once physical and moral, directed against bodies that should be protected, bodies that should be safeguarded by definition. The inability to protect these bodies from enemy cruelty is indicative of a breach; it is one of the most important forms of defeat in the archaic, ancestral imaginary. The production and reproduction of morale among soldiers is a central element in training for war, and the maintenance of morale is essential for the achievement of victory over the enemy. On the other hand, there is no defeat for the vanquished that does not also entail his moral destruction.

Femigenocide: The Difficulty of Perceiving the Public Dimension of War Femicides

As I have argued up until this point, in the type of informal war that characterizes late modernity and late capitalism, the feminine or feminized body plays a particular role. In the conventional wars of the past, such a body was annexed, inseminated, incorporated, treated as a part of the conquered territory whose new possessions – including the bodies of slaves, servants, and concubines – were distributed among men and their families. Today, a transformation in this ancient role of the feminine body in the theater of war has taken place. In the informal wars that are expanding in the present, women's bodies are tortured by sexual means, sometimes to death; they are destined for destruction through, among other techniques, the use and abuse of sexual invasion, which profanes what should be protected. As I have said on other occasions, "a woman's body is a battleground," because it is the site of attacks, demoralization, intimidation, demobilization, and, eventually, defeat. The hosts of

men charged with watching over and protecting this body are, in other words, defeated in and through its abuse. Cruelty against victims who are non-combatants and who are, moreover, not directly involved in the work of waging war takes unforeseen forms.

On the basis of these observations, we can see that although all forms of gender violence and all femicides obey an order whose structure is established in the early years of life, in the context of the family – an order that informs social life to the point of organizing it along patriarchal lines that structure the symbolic order and orient affects and values – there is nevertheless a particular type of gender violence here that necessarily involves the cruel and lethal treatment of its victims. It is separate from gender violence in general and has its own specificity. If all gender violence is structural and claims lives in numbers that come close to systematic genocide as it operates in many contexts, it is crucial for the struggle against the victimization of women – that is, for the ability to investigate and separate the perpetrators of these crimes – that we understand that there is a type of gender violence that is generated and mobilized in absolutely impersonal contexts.

In other words, although all femicides obey the dictates of a gender system and follow from the violence-generating character of the structure of patriarchy, the effort to bring impunity to an end calls for a rigorous form of classification, one that goes beyond the mere use of the term "femicide" and manages to distinguish between at least two broad categories within a general classificatory rubric. These categories bear on the immediate motive that unleashes or triggers the violence in question. There are motives that can be considered personal or interpersonal; these give rise to interpersonal or domestic crimes and those of serial abusers. Another set of motives is clearly impersonal; they do not relate to the intimate sphere and are not triggered within it. Instead they have the category of "woman," as genus, within their sights, or women of a certain particular racial, ethnic, or social type. These can be women associated with the enemy's armed corporation, women from another neighborhood, women belonging to an enemy tribe, or women in general, as in trafficking.

Here we are dealing with systematic aggression against and with the elimination of a human type. This aggression does not respond to any immediate motive or trigger traceable to the intimate sphere. It includes the kinds of gender aggression that we see in the new forms of war, human trafficking and the concentrationary

confinement of human beings, and the abandonment or deliberate undernourishment of babies of the female sex and of girls in Asian countries, among other places. I suggest that we call this type of femicide "femigenocide" (Segato 2011b; 2012). It approaches the scale of the category of "genocide" because it is a matter of acts of aggression against women that are meant to be lethal and of physical damage done to women in impersonal contexts, where the aggressors are an organized collective, or rather where they are part of a collective or corporation and act jointly, like people rallied to a cause. The victims also constitute a collective; they belong to a collective in the sense of being members of a social category, in this case a gender. I note in this connection that in countries that have recently undergone or are undergoing periods of high-intensity conflict, incidents of lethal violence against women increase. This would seem to indicate that what leads to these elevated numbers is an increase in crimes committed in an impersonal context, and that therefore there is a direct correlation between war and a significant increase in femicides.

A sampling of fifty-four countries and territories, containing information on the relationship between victimizers and victims of femicide, reveals that the rate of lethal interpersonal violence is lower in countries with higher rates of femicide. For example, in El Salvador and Colombia, which are among the countries with the highest rates of femicide, only 3% of all femicides are committed by victims' current or previous partners. By contrast, in Cyprus, France, and Portugal, countries with low or very low rates of femicide, 80% of killings of women are committed by victims' current or previous partners (Alvazzi del Frate 2011: 129–30).

Likewise, I note that in countries with high rates of lethal violence, women are more frequently murdered in public spaces, including by gangs and other organized groups (Segato and Libardone 2013). Unfortunately, we can only speak here of tendencies, since it is impossible to speak with more precision in the absence of greater awareness in the writing of survey questions that give rise to the data that allow for statistical studies; often those who prepare this data do not know that crimes associated with personal triggers (including domestic, interpersonal, and serial crimes, among others) should be separated from generic crimes committed by collectives or armed corporations targeting the category of women.

The crimes of "femigenocide," in general, are generic both in terms of their perpetrators and in terms of their victims. They

are entirely impersonal and collective, and their characteristics approach the definition of genocide. They are increasing both in their frequency and relative to interpersonal or personal crimes. We know this is the case, for example, in countries on which information is available to allow us to distinguish between these two categories of crimes. Guatemala, El Salvador, and Honduras in Latin America, and the Democratic Republic of the Congo, where the horrendous scenes associated with the war in Rwanda are being reprised, are emblematic of this reality. In the Congo, doctors already use the category of "vaginal destruction" to name a type of attack that, in many cases, leads to the death of its victims. In El Salvador, between 2000 and 2006, during a period of "pacification," while homicides targeting men increased by 40%, femicides increased by 111%. In Guatemala, where democratic rights were also reestablished, between 1995 and 2004, homicides targeting men increased by 68%, while killings of women increased by 144%. In the case of Honduras, the distance between these two figures is even greater: between 2003 and 2007, killings of men increased by 40% and killings of women by 166% (Carcedo 2010: 40–2).

All of these let us bear witness to an extreme form of the state's doubling, and to an "internal conflict" that, rather than being resolved, has been transformed and adapted during the course of several decades in recent history. The theater of informal war in these countries is intense. Another change in the traditional context of gender crimes in the region, blighted by informal conflicts during the period when these numbers were recorded: killings of women by their partners and ex-partners no longer account for the majority of these murders (Carcedo 2010: 49), and gender crimes in the intimate realm have been decreasing significantly. For example, in the case of Honduras, which saw the greatest increase in the frequency of femicide, only one out of every four of these crimes was committed in the home (Carcedo 2010: 53). This demonstrates that impersonality has come to characterize gender crimes, and that this change is associated with contexts of increasing conflict, that is, with the new forms of war characterized by their informality. The reluctance to acknowledge this distinction among some feminists ends up aligning them with the "will to indistinction" that effaces rather than clarifies the meaning of crimes against women, as in the case of Ciudad Juárez, for example, where this will is shared by security forces, judicial officials, and the media. This will to indistinction responds to and restores the conservative tendency – a forceful tendency in

public opinion and in the mind of many officials, and one that is perpetuated by the media traffic in stereotypes – to relegate all acts of aggression targeting women to the intimate, domestic, and inter-personal sphere, treating all motives for these crimes as emotional or affective. Categorical distinctions, statistics, and feminist reflections themselves all point to the existence of gender crimes committed in public and for impersonal reasons, crimes involving specific groups or populations, pertaining to general conflicts, and responding to pressures and interests that affect society in general. In these crimes, the roles of aggressor and victim are played by organized groups or contingents of men and armed corporations, on the one hand, and contingents or generic categories of women, on the other. To ignore and obscure these dynamics is to reproduce the stereotype that confines women to the domestic sphere and sees their demands as particular rather than universal. That is, it is to perpetuate the ideology of "the feminine mystique."

This privatization – that is, this relegation of all gender crimes to the intimate realm– is consummated by the refusal of the media, officials, and some very influential versions of feminism to imagine the existence of a particular type of crime, one that must be distin-guished from others, categorized acccordingly, and investigated in its specificity, through specific forensic and legal protocols. This refusal is derived and reinforces the prevailing stereotypes that draw an equivalence between the "feminine" and the "intimate." These stereotypes hinder police work and practices of legal investigation while also standing in the way of an administration of justice that might be capable of addressing the complaints of victims. They allow crimes against women to continue to be perpetuated without being perceived by public opinion as fully public occurrences, worthy of the public sphere; this perception is shared by the law itself inasmuch as all crimes against women are contaminated, in the collective imaginary, by the aura of intimacy, that is, by the sense of nuclear, privatized domesticity proper to modernity (Segato 2011a). Thus when the members of an armed corporation, made up of state agents acting in a parastate capacity, or the members of a paramilitary group or militia, sexually assault, rape, and abuse the body of a woman whom they have kidnapped and detained, they have "sexualized" this body. That is, they have dragged it into the intimate sphere, confined it there, and depoliticized their act of aggression, which they relegate to the realm of unequal relations that is the field of gender. They have removed their act from the public

sphere and eliminated the very possibility of fully public justice. They rely on the complicity of a collective imaginary in which sexuality and law belong to separate and irreconcilable spheres. Sexuality is assigned to the private, intimate, and domestic realm, law to the public sphere of universal and general interests. This means that despite the teachings of the feminist movement and the existence of relevant laws, there is always a difficulty to overcome when we are working to situate sexual crimes on a universal plane and to indicate their general interest in society.

Faced with a new theater of informal war – a widespread theater of war that continues to expand, working with the methods of the mafia and giving shape to a parastate sphere of control that increasingly captures social life and politics – we have to introduce a legal rhetoric and an awareness at the level of public opinion, an awareness of both the centrality and the meaning of the new forms of aggression targeting feminine bodies in order to maintain an order based on the arbitrary and sovereign domination over people's lives and territories. To locate *and* dismantle this system of domination: these are urgent tasks.

3

Patriarchy, from Margin to Center

On Discipline, Territoriality, and Cruelty in Capital's Apocalyptic Phase

The History of the Public Sphere Is the History of Patriarchy

Past and present colonial interventions in what I have called the "village-world" (Segato 2015c; 2015f/Eng.: Segato 2022) had the effect of *minoritizing* everything having to do with women. The term *minoritization* refers to their representation and to their position in social thought; minoritizing here means treating women as "minors" and also consigning their concerns to the intimate realm, the private sphere, regarding them as "minority issues" and consequently "minoritarian" problems. The factors that determine the minoritization of women are related to the transition from communal life to modern society and, in Latin America, to indigenous peoples' passage to colonial modernity within the national territories of the continent. This passage was driven first by the process of conquest and colonization, led by the overseas metropole and later by the administrations of the states constructed by Creole elites. This process can also be described as *creolization*.

The state-corporate-media-Christian front, which is expanding rapidly in the present, intervenes in the life of the village-world, whose residents are then integrated into the national "citizenry." This passage to colonial modernity has an enormous impact on interpersonal relations and on gender relations in societies governed by communal and collectivist patterns of coexistence, or societies

in which a communal fabric remains recognizable and vital, if not undamaged.

Here I argue that understanding the transformations in the "gender system" and the history of the structure of patriarchy allows us to shed indispensable light on the social turn introduced by modernity as a whole. If we properly attend to what this passage meant and how colonial interventions rearranged and aggravated preexisting hierarchies, we can understand many of the phenomena that continue to affect all of society in the present and are thus far from limited to "the woman question."

Here again, I insist, in keeping with this argument, that feminisms, like other social movements, make a grave mistake that is both political and epistemological. In other words, these movements make a theoretico-political mistake with devastating consequences when they ghettoize and compartmentalize "the woman question" or any other social question, whether in the field of analysis or in the field of action. As I argued in *Las estructuras elementales de la violencia* (The Elementary Structures of Violence: Segato 2003a), "gender" is the drag worn by a shadowy, subliminal social structure, a structure of relations between positions marked by differentials in prestige and power. This explosive, hierarchical system is transposed in an inaugural scene in our lives, where it takes the malleable form of familial patriarchy; later, it is transposed in other relations organized in this patriarchy's image and likeness. These include racial and colonial relations and the relationship between the metropole and its peripheries, among others. In this sense, the first lesson in power and subordination takes place in the familial theater of gender relations. But this theater is replicated *ad infinitum*; it structures and returns in the most varied scenes, whenever a differential in power and value is found.

A debate that has arisen within decolonial feminisms has to do with whether patriarchy – that is, gender as inequality – exists in the world before the colonial intervention. There is incontrovertible evidence of some form of patriarchy or masculine preeminence in the status order of societies that have not been reshaped by colonial processes. The origin myths of many, if not all, peoples, for instance, including the Judeo-Christian myth of Genesis, include an episode set in the time of the world's founding in which the defeat and disciplining of the first woman, or the first group of women, takes place. This episode, foundational for all of human history and omnipresent in the mythic histories of indigenous peoples, is

a proof of the priority of gender subjection, which provides the template for all other forms of domination, although it is fully historical, appearing in the compact narrative form of an account about the past in these myths. On the other hand, it is the conquest of a masculinity with already existing prerogatives by the white, pillaging masculinity of the conqueror that makes conquest itself possible, because the non-white man, defeated militarily, ends up acting as the hinge between the two worlds. That is, he becomes a colonizer within the home. Torn by a conflict of loyalties between the masculine mandate and his connection to the community and his kinship networks, the non-white man ends up emulating the virile and vanquishing aggressivity of the colonizer at home; he carries the appropriating violence of the colonial world into his own world's interior space of relations. We can see this dynamic today in the attitudes that characterize what I have called the fundamentalism of chiefs, or fundamentalist despotism. Women, the subjects of rootedness, communal subjects, are not vulnerable to this kind of capture. They are divided in their loyalties, in other words, but in a different way: they are asked to loyally defend the patterns of communal existence of their people without making their own complaints or demands as women, and this is, in general, no easy task.

The world that the colonial front, and later the colonial-state front, invades is a world in which the genders occupy two different *spaces* within social life. In this sense, as I have said many times, the structure of this world is *dual*, and it is shaped by a fiercely binding form of reciprocity. The dual is one of the versions of the multiple, and within its terms, passage and commutability between its two positions remains possible. In the dual world, both terms are ontologically full, complete, although they can be hierarchically related. One does not engulf the other. Public space, inhabited by men with their tasks, politics, and intermediation (negotiation, debate, and war), does not encompass or subsume domestic space, inhabited by women and families, with their many kinds of tasks and shared activities.

In this collective and communal atmosphere, there is no engulfing, and there is no universal subject, no Man with a capital M like the one catapulted by colonial-modern humanism into the position of Universal Subject. Nor are their general statements seen as capable of representing everyone. There is no *universal referent*, no one definition of the human. Nor is there a *universal equivalent* whose

value would allow for the commodification of the environment or render one territory, one landscape, interchangeable with another. No natural habitat is reducible to another.

This dual structure is captured and reshaped by the imposition of the colonial binary. The *binary* structure results from the modern capture of the reciprocal (if hierarchical) duality of the village-world. In the binarized world of modernity, the other of the One is destitute, deprived of its ontological plentitude and made to fulfill the function of alterity, reduced to being the other of the One that is the representative and referent of totality. As Edward Said (1978) and a whole generation of postcolonial theorists have shown, this Other (feminine, non-white, colonial, marginal, underdeveloped, indebted) becomes the condition of possibility for the existence of the one (the universal subject, the generalizable Human).

The tribute that the other pays, the gift it offers, flows toward *the center*, toward the *universal human subject*, which it constructs and nourishes. This process, which I have described in a condensed fashion, is what allows for the emergence of *the public sphere*; or, rather, it is how, through historical processes, *public space* and *masculine domination* in the communal world became *the public sphere* and *universal domination*. We can thus see that the history and the constitution of the public sphere participate in and are intertwined with the history of patriarchy itself, which undergoes a structural mutation with the colonial-modern capture of the village-world. Seen in this way, the history of the public sphere, or that of the state, is nothing other than the history of gender. The public sphere or the state *agora* becomes the site for the enunciation of all discourses that seek to acquire political value. In other words, it captures and contains what now counts as *the political*. Saying this also means saying that it seeks a monopoly on all discourse and action that seek to acquire the value and to produce the effect of politicality.

Because of its history, which I have just recounted in a very compressed way, the natural subject of this *public sphere*, heir to men's *political space* in the community, bears the marks of his origin and his genealogy. He is: (1) *masculine*; (2) a son of the conquest and thus (a) *white or whitened*; (b) *property-owning*; (c) *literate*; and (d) a *paterfamilias*. (It is not quite right to describe him as "heterosexual," given that we know very little of the sexuality of the patriarch.) Therefore, whatever his particular attributes, this paradigmatic subject of the public sphere will make statements

considered to be of general interest and to possess universal value. It is this process that makes it possible to argue that the history of men, the history of masculinity, is the state's DNA, and this genealogy is disclosed daily. This process rapidly devalues the other space, the domestic sphere, which had previously been crowded with many presences, the scene of women's activity, presided over by women. This moment bears witness to a fall, a decline of the domestic: having been subordinate in prestige but ontologically complete in itself, the domestic sphere is now removed from its place and relegated to a residual role, made into the *other* of the public sphere, *devoid of politicality*, incapable of making or containing statements with universal value and general interest. It becomes a margin, the site of the remainders of public life; it is understood as *private* and *intimate*. This means that when one wants to express oneself from this place, one has to wear drag and present the "I" in a distanced way in order to comply with the requirements of the public sphere, the rules of etiquette and the norms of masculine style that govern *speaking in public*. By contrast, in the village-world, in the community not reshaped by the colonial intervention, *the domestic is neither private nor intimate in any way.*

The colonial-modern construction of women as residual is what we must dismantle, oppose, and redirect, because it is this binary and *minoritizing* system that not only damages women's lives but also affects contemporary society as a whole. Because the forms of aggression that women suffer in instances of everyday violence and abuse in the home and in the new, informal wars are the symptoms that allow us to diagnose the movement of society as a whole. This is why we should demand the restoration of ontological plentitude to the spaces of feminine life as well as women's capacity and right to speak to general interests from a place of particularity. In the 1970s, we tried to do this by saying "the personal is political." This feminist slogan of the time led us to struggle for laws and public policies without traveling very far along this path. (Perhaps it was not the best idea, as Foucault noted early on, to fight to bring the eye of the panopticon into the home, or to aspire to have a lawyer in the bedroom, as in the North American model.) Perhaps, then, this path was not the most interesting or the one that yielded the best results, because the expropriating and violent structure of gender gave no ground. A more promising path involves suspicion of the public sphere, with its barely hidden bloodline, so that we can work to visualize a new movement capable of dismantling the universal

One that this public sphere establishes, pluralizing our worlds in the process. The capturing of the political by the structure of prestige based on the unitary public sphere, with its monopoly on general interest and universal value – its manufacturing of the abstractions of centrality, generality, and universality, rooted in and endlessly referring back to a naturalized masculine subject – can only lead to the democracies of the present in Latin America, with their drift toward the dictatorship of majorities. A democracy that does not rest on an irreducible defense of pluralism is not democracy, even if it allows for majoritarian representation. Why? Because it will always be structured by a public sphere designed according to binaries, where the many kinds of different and minoritized subjects (women, people with non-normative sexual practices, black people, indigenous people, children, and all of those who deviate from the norm embodied by the universal subject) become anomalous others of the One in the collective imagination. They will have to make an effort, wear drag, in order to speak the language of politics, now claimed by the state; they will remain uncomfortable anomalies embodying the "problem of the other" that is and can only be *the problem of colonial modernity.*

Discipline and the Pedagogy of Cruelty: The Role of High-Intensity, Colonial-Modern Patriarchy in the Historical Project of Capital in Its Apocalyptic Phase

The privatization and minoritization of lethal attacks on women, and their transformation into "issues of particular interest" or "minority problems," is a consequence of the passage from the low-intensity patriarchy, the masculine preeminence, of the communal world to the high-intensity, colonial-modern patriarchy characteristic of the reign of the universal. The effect of minoritization is felt, for instance, in how femicides and homophobic crimes are seen as residual, almost reduced to mere spectacles in the legal and media practices of Latin America. At the same time, feminists' demands are treated as *particular issues, compartmentalized and ghettoized.* In this way, people overlook the fact that these forms of violence against "minorities" are nothing other than forms of discipline that the forces of patriarchy impose on all those who dwell on the

margins of politics. We are dealing, then, with the crimes of high-intensity colonial-modern patriarchy, crimes against everything that destabilizes, against everything that seems to conspire against and challenge its control, against everything that evades its grasp by means of the various strategies and tactics that many of us use every day, whether on purpose or inadvertently, to escape, to evade patriarchal surveillance and disobey. In this way, patriarchy seeks to eliminate all who do not offer it the recognition it is owed, all who refuse its way of structuring and disciplining life, its way of enabling and naturalizing a system of inequality and increasing domination.

On the other hand – and this is the core of my argument here – if we study the crimes against women that characterize the present and seek to understand what they express, what they say, and what they occasion, we can see their close connection to the historical phase that we are moving through as a society. Just as understanding the history of patriarchy means understanding the history of the public sphere and the state, so too, at the point of convergence of all of these questions, understanding the forms of gender violence today also means understanding what society as a whole is undergoing.

If we had to produce a graphic or pictorial allegory of the world today, in our late modernity, it would show a series of human pyramids of the kind that circus acrobats create, where one by one performers balance on top of one another to the point of making up a whole human structure, with one performer's feet on another's shoulder's, layer after layer. But at the base of this pyramid, supporting the whole structure, we would find a woman's body. I often imagine this structure because it seems to be the only thing capable of explaining why it remains impossible to do something apparently simple like removing woman from the subordinate position in which she finds herself, punished, subjugated, and attacked, bringing her ongoing rape, trafficking, and enslavement to an end together with her objectification and dismemberment by the media. This would not be a difficult task, after all; a few acts, a few measures, a few local interventions would suffice, none of them very complicated. But for some reason *these aren't possible*. The task presents itself as impossible. There have never been more laws; there have never been more kinds of human rights granted by legislative bodies charged with providing security. There has never been more literature in circulation on women's rights, and there have never been more prizes granted or forms of recognition offered in this field. Nevertheless, as women we continue to die; our

vulnerability to lethal aggression and murderous torture exists like never before in today's informal wars; our bodies have never been so controlled or so invaded by media seeking to produce compulsory happiness or to enforce adaptation to coercive beauty standards. Nor have women ever been as closely surveilled as they are today, with abortion, symptomatically, the subject of debates more heated than they have ever been before.

If we approach the problem from this perspective, we begin to suspect that women's victimization serves as a kind of feast or celebration, marking the place where the power lays its table and the brotherhood displays its sovereignty, its discretion, and its will. In this way, we come to understand that something supremely important must depend, must hinge, on this constant and ever-renewed destruction of the feminine body, on the spectacle of its subjugation, on its subordination and its reduction to the status of an object for display. Something central, essential, foundational for the "system" must surely depend on women's confinement to and their inability to escape from this place, this role, this function.

Dismantling and opposing the minoritization of women's issues means accepting that, if we want to understand the forms of misogynist cruelty that mark the present, we cannot only work to understand what is happening to us as women and to all others who are placed in feminine positions, treated as dissidents and the *others* of patriarchy. Instead we must also work to understand what is happening to society as a whole. The signs indicate that we are dealing with a structure made up of a combination of corporations and the state, underwritten by all kinds of alliances, licit or illicit, or both at once, among corporate actors and government agents. We are dealing, in other words, with reasons called "reasons of state" that are in fact reasons dictated by businesses. I am certain of one thing: in order to understand this, we will have to remove "the woman question" from its ghetto and come to see it as interconnected with – as the cement and central pedagogy of – all other forms of power and subordination: racial, imperial, and colonial, Eurocentric, and those that govern relations between the center and the periphery and between classes. In 2015, 1% of the planet's inhabitants laid claim to more wealth than the remaining 99%, and sixty-two people owned as much wealth as the poorer half of the world's population, with this rate of wealth concentration increasing.[1] In the United States, 1% of the population owned all of the usable land in that enormous country, and just

nine families were the proprietors of the whole Chilean coast. In all of these facts, we can see that financialized capital is the most overwhelming of all forms of property, stockpiling, concentrating land in a few hands, extracting rents, and privatizing aspects of state management. A survey of these developments indicates that we can no longer speak of mere inequality, as we did in the 1960s; rather we are dealing with *ownership, dominion, or lordship*. I mean "dominion" here in a very precise sense: a small group of proprietors are the lords of life and death on the planet. They exercise discretion, impose their will by wielding power on a scale never before seen, one that renders all the ideals of democracy and republicanism fictional. The real meaning of this form of lordship is that the lords of wealth, with their purchasing power and the free offshore circulation of their profits, are immune to any attempt to institute oversight or institutional control over their corporate maneuvers, which today are shown to be totally deregulated. This immunity for those who wield economic power inaugurates an apocalyptic phase of capital, a moment of lawlessness that returns us to the final stage of the medieval period, an era of decomposition and transition. During this period, domains were discontinuous but consistently ruled by feudal lords who relied on the exemplary exercise of cruelty, on the spectacular punishment of bodies described by Foucault (1977).

Lordship in Latin America takes the form of mafia-run management, with gangsters wielding control over business, politics, and the law. But none of this should be seen as unrelated to the global geopolitical order that is imposed on our internal affairs. *Crime and the accumulation of capital by illegal means have ceased to be exceptional, becoming instead structural for and structuring of political economy.*

In this new world, the idea of a discursive order shaped by *the coloniality of power* becomes basically insufficient. This order gives way to the naked and crude practice of *sweeping* peoples from their ancestral or traditional lands. Coloniality is consummated, in other words, and we witness a return to *conquestiality*, to the practices and dynamics of conquest, unmoored and unchecked, no longer held back by the presence of the Church, which, at least to a degree and in some cases, once curbed colonial greed (Gott 2002). In Latin America, the extreme forms of cruelty that extend south from Mexico, Central America, and Colombia, the atmosphere of drama, chaos, and increasing violence, can be attributed to the idea that

the Conquest of our landscapes never came to an end, was never consummated. It continues to unfold to this day.

In this historical context, compassion, empathy, bonds of relation, and local, communal forms of rootedness, like all forms of devotion to the sacred capable of sustaining the collective social fabric, are *dysfunctional for the historical project of capital*, which uproots, globalizes markets, frays the communal social fabric where it still exists, tearing it to shreds, ravaging it, nullifying spatial markers and sacred points of reference, which stand in the way of the conquest of territories by the universal referents of money and merchandise. It brings about the transformation of *oikonomia*s of domestic production and local and regional networks of trade, capturing these within a global economy and introducing consumption as the goal *par excellence*. It disrupts relational forms of flourishing, shaped by patterns of reciprocity within communal life. In this apocalyptic phase – where extreme forms of pillage, displacement, uprooting, enslavement, and exploitation mark the path to accumulation and therefore the goals that guide the historical project of capital – it is crucial to reduce human empathy and to train persons to execute, tolerate, and live with acts of everyday cruelty.

This must be why a central strategy of contemporary wars, which are no longer wars between states and are characterized by their informality, in Latin America and the Middle East, involves profanation (Kaldor 2012; Segato 2014b, republished as chapter 2 above). This is also why experts refer to a "feminization of war." There are innumerable proofs, documents of all kinds found everywhere, of this development: it is the feminine position that guards, embodies, and represents territorial rootedness, the sacred, the relational, and community.

Chile and Qatar offer two models that disclose the tendencies of the current – apocalyptic – phase of the historical project of capital. In Chile, the orthodox application of Milton Friedman's formulas has led to a social regime ruled by the market. The sadness that saturates Chilean society is frequently associated by Chileans themselves with the effects of the *precarity* that this model produces and reproduces, where "precarity" is understood in a sense that decouples it from the idea of poverty or lack and points instead to the *precarity of relational life*, to the destruction of solidarity and stability, the targeting of the relations that anchor, localize, and concretize affects and everyday experiences. In this way, an experience of unpredictability and exposure takes over the life of

a nation. On the other hand, Qatar epitomizes the phenomenon of rule by owners, where the nation's territorial expansion becomes inseparable from the idea of property. The abstraction of the state no longer exists, and the state is plainly and literally patrimonial: a state of owners, of proprietors, of lords. In Latin America, the patrimonialism constitutive of the Creole republics runs the serious risk of *Qatarization*. The return to a focus on production, mega-mining, extractivist agriculture, and extractivist tourism is the corollary of an absolutist market regime and the fusion of political power with the power of ownership, which gives rise to extreme forms of aggression against human beings, leaving nothing but remains in its path. We see the increasing unpredictability of life, the commodification of everything with the owners and controllers of the mechanisms of the state claiming security for themselves alone. We also see the radicalization of despoliation, ethnocide, genocide, and *conquestuality*.

The emergence of this scene is tied to indifference to cruelty, an indifference that is tested and trained by means that are themselves cruel, means involving violence against the bodies of women and young people, as in Ayotzinapa, Mexico. These bodies do not represent the military opponent; they are not the bodies of soldiers for the enemy corporation. The state terror of the dictatorships in Latin America has become a diffuse terror that circulates through the capillaries of the social body. I argued above that *the new forms of war* in Latin America are repressive wars or mafia-led wars, or, perhaps more precisely, a combination of the two, leading to a kind of coup launched from another place, a second reality

(Segato 2014b, chapter 2 above). I believe that it is even possible to speak of a new form of terror associated with what here I have called the "unpredictability" of life; this would involve nothing other than a legal limbo, the uncontrollable expansion of parastate forms of control over life, laying claim to ever greater segments of the population, especially those who live under vulnerable conditions or in spaces of exclusion. This terror offers confirmation, for many people, that state control, the protection afforded by the state and the laws of the republic, is and has always been a fiction, "a system of beliefs," sustained by faith, the sources of a stable grammar for social interaction and of limits to human conduct. It is possible that the dictatorships ended when they had already prepared the terrain for these new forms of terror. This is no longer a matter of state terror, but rather training for an existence without sensitivity to

the suffering of others, without empathy, without compassion. This training takes place through the enjoyment of consumption, enabled by the competitive and productivist individualism of societies that have definitively left bonds behind. This recalls the difference between solitude and isolation identified by Hannah Arendt (1958), for whom the latter was a precondition for totalitarian control.

For a long time, I argued that we should see intimate femicides as separate from public, military femicides that take place against the backdrop of informal wars. Today, the lesson of informal, parastate war in its various forms has entered the home, and the threshold for empathetic suffering has vanished. In Guatemala, the war led to extreme violence in indigenous and peasant homes. It was not the other way around, as some Eurocentric feminists maintained. Sexual and femicidal violence did not move from the home to the field of war; their sequence was the inverse. In our time, as cases throughout the continent show, intimate crime has taken on the characteristics of war crimes: it spawns victims, left out in the open, in trenches, landfills, and sewers; it increasingly takes the form of spectacular murders that also happen in public places. Summary executions and extrajudicial killings committed by state agents – events that happen with increasing frequency every day in Latin America and especially in Brazil – also offer evidence of this diffuse terror, attacking the logic and the grammar that allowed for the expectation of a stable relation between oneself and others.

It is for all of these reasons that we can wager that, if every epoch has a modal personality or diagnostic category, functional for its economic relations (hysteria during the industrial revolution, schizophrenia, with its delirium for artistic expression, during the modern period), psychopathy is today's modal personality. Psychopathy would seem to be the structure of personality best equipped to function during capital's apocalyptic phase. The psychopath's profile – his inability to transform hormonal release into emotion and affect, his need for ever greater stimulation, the non-relational structure of his personality, his lack of sensitivity to his own pain and, consequently, that of others: his being caged, encapsulated, uprooted, bereft of context and collective ties, his instrumental and objectifying relation to others – all of these attributes would seem to be indispensable for functioning properly in an economy shaped by extreme forms of dehumanization and characterized by the absence of limits to the pillaging of bodies and territories, an economy that leaves only remains in its wake. So a *pedagogy of cruelty* becomes

the breeding for psychopathic personalities, valued by the spirit of the epoch and functional for the current, apocalyptic phase of capital.

The strange fate of the English film *A Clockwork Orange* (1971), based on the novel of that title by Anthony Burgess, written after the author's wife was raped by US soldiers in London during the Second World War, seems to confirm my thesis on the sudden decline of empathy in our times. The film version of *A Clockwork Orange*, directed by Stanley Kubrick and starring an unforgettable Malcolm McDowell in the lead role, was censored in various countries, including the United Kingdom; indeed it was one of the most censored films in the history of cinema. The film features scenes of attack, rape, murder, and a femicide. Alex, the protagonist, moves from utterly lacking empathy, as the victimizer, to a state of empathy and vulnerability to the suffering of others. This transformation is achieved through an experimental psychiatric treatment, which turns him inevitably into a victim. There is no intermediary position between victimizer and victim, before and after, in the "therapeutic" experiment; that is, if the role of victimizer is abandoned, there is no alternative available other than becoming a victim. But the most extraordinary thing about the film is that today, over forty years after its debut and as McDowell himself has acknowledged (Alverú 2021), the fear with which audiences reacted to the film has completely disappeared, giving way to laughter among audiences during what were previously seen as some of the film's most horrendous scenes. This is a clear indication of the naturalization of the psychopathic personality and of violence, especially violence against women of the kind that takes place in the film's central scene. This is undoubtedly a sign of historical processes and of the way of life that has been imposed under late capitalism. During this period, suffering and aggression against women's bodies – like the spectacularization, banalization, and naturalization of this violence – let us take the measure of the decline of empathy, its collapse in and through adaptive and instrumental process, a response to epochal new methods for the exploitation of life.

History in Our Hands

In conclusion, as I have argued, the reduction of the feminine marks a foundational moment in the history of the species, a moment

recounted in many dispersed myths found all over the planet. This myth points to a cornerstone in the pyramid of dominations, a moment in phylogenetic time that is also repeated as the first lesson in ontogenetic inequality, a lesson taught in the subject's family life (Segato 2003a). Today, misogynist cruelty, which transforms the suffering of feminine bodies into a banal, everyday spectacle, is the pedagogy that habituates the masses to living with sovereignty, with the senseless margin of human life, with the ultimately fictional character of all institutions.

But this whole question is "minoritized," shoved into a residual corner, relegated to a place outside politics, and regarded as separate from the major questions of social justice and security; that is, it is thought of as marginal with respect to everything that is categorized as a matter of state by virtue of its general relevance and universal value. This categorization, this structure that makes us believe that there are central questions, on the one hand (questions related to the economy and finance, politics and government, health, education, public security), and marginal questions, on the other (questions euphemistically called "transversal" so that their relegation to this marginal place is disguised), is what I am calling "minoritization" and is associated with the modern belief that everything related to the question of gender can be confined to the realm of the private and the intimate. This categorization does not hold water today; it is completely mistaken and historically shallow. It is nothing other than the result of the processes of modernization through which indigenous peoples have passed, and of the destruction of the communal environment in which many people in Latin America lived until relatively recently, and in which some continue to live. It has to do with the constitution of republican states on patrimonial foundations, and with the fact that these states were constructed in order to allow elites to continue to manage and determine the fate of national resources. The history and structure of this state made it appropriable by those who hold the keys to its institutions. And the destruction of indigenous communities and their logics also destroyed the forms of politicality associated with domestic spaces, enshrining men as the agents of all political life, even if occasionally we can find exceptional women in political roles. What resulted was a masculinization of institutional life and a depoliticization of the bonds that emerge in domestic space, a *de-domestication* of life and of all politics.

An inaccessible set of norms, a rarefied atmosphere, came to prevail within institutional spaces. This compounded the

particularization, residualization, and "minoritization" of all who were not active in the field of "public life," which was not designed to be within reach for everyone. This is the case because, owing to their colonial history, our states do not have the same relationships to their societies and their territories that European states have with theirs. Our states and those who come to manage them when they take up their positions can only reproduce the distanced and exterior relation to *what they administer – the peoples and territories* – that characterized colonial rule. It is very difficult to change this relationship of administrative exteriority, a relationship overseen and embodied by men, because it is the mark of the colonial relation and the sign that it inheres, remaining ever-present, in the architecture of the state.

At the same time that we have come to understand that the question of gender points to the foundation and support for all other forms of oppression, we have also come to see that women are the symptoms allowing us to diagnose what happens in a whole historical period. Far from being "minor," "the woman question" is the basis of the structure of all oppressions, and the cornerstone on which all powers rest, even those who have supposedly celebrated their "bicentennials" by reciting progressive ideas – whether from the halls of government administration or the enlightened *loggias* of the academy. It shows us power's weakness, its incoherence. So, for countless reasons, we must either *overhaul the patriarchal order or remain historically static, stuck in place.* (This is the same as saying: no one will leave their place, neither men nor women, neither them nor us.)

It is enough to listen attentively to the "progressive" discourse of the representatives of *state socialism* to perceive the entrenched and terribly damaging hierarchy that persists within it, the hierarchy that determines what matters more and what matters less, what is thought to be of general interest and universal value and those whose demands can be deferred, minoritized, and devalued, treated as particular and secondary, as coming from people who do not matter, people like us, women. This discourse's repeated and cyclical failure to lead the state to the longed-for reorientation of history, its failure to bring more benign societies into being, shows us clearly that there is a fatal error in its understanding of revolution, an error that follows from its having always relegated us to the position of the unthinking, its having rendered our voices inaudible. *Within the terms of this discourse, we cannot come to understand that history is in our hands, that we will have to show the way.*

There are innumerable examples of *women, women's activism, showing the way and making history*, examples of *the history that is in our hands, that we show and have shown the way.* These examples *reveal that our "minoritization," our relegation to a secondary place, a place of particularity, is mistaken.* The role that the Madres de Plaza de Mayo (Mothers of Plaza de Mayo) had and continue to have, their strategic way of conferring politicality on the maternal role, was liberating for Argentine society as a whole, and this move has been repeated by women in many countries throughout the world in their struggles for a range of causes. This is not for us, not partial, not particular, not intimate, not private, not minor; it is a fully political strategy, part of a historical project of general interest and universal value. It involves breaking the structure of minoritization and introducing, precisely from its margin, another purpose and another politics. It is becoming ever clearer that the strategies created and put in practice by women are the strategies that indicate the way for us and for everyone.

Women – and by "women" here I mean to refer to the feminine position – are the subjects of their own history, which has produced their own specialized knowledges. We are the sources of everyday stability, of trustworthiness, the guardians of rootedness and emblems of community. We are responsible for the genetic diversity that still exists on the planet, experts in relational life and in the management of the ties of intimacy. We are skilled in practices of everyday life that have not been bureaucratized, capable of dwelling within the hideout of domestic space and of politicizing this space. We are gifted with a marginal imagination, undisciplined by positive norms. We are skilled in survival.

This is why civic faith, which tells us to place our faith in the state and pursue the state's path and project, has led us to a dead end – because, as I have argued, the state is always patriarchal and cannot cease to be patriarchal; because its history is nothing other than the history of patriarchy. We should not abandon it altogether as the site of demands, but we cannot confine our struggles within it; we cannot let it monopolize politics. There is *intelligent life* outside the realm of the state, and there are non-state institutions in existence. It is people [*gentes*] who make history, in capillary ways, with their imaginations and their daily insurgencies, their technologies of sociability. They have the capacity to build worlds and to do so without egotistical vanguards, which ultimately always expropriate the voice of the people [*pueblos*]. It is possible now, as it has always

been possible on our continent, to emphasize immediate bonds, through a rigorous practice of reciprocity.

But the state, with its patriarchal structure, captures much more of us than we can capture of it. It was conceived and designed to allow for the appropriation by elites or to enshrine new segments of the population and make them elite by virtue of their participation in government. And above all, it was designed to sustain the binary matrix that was established to separate the issues that concern the universal human subject, the Human and Man, from those who belong to the realm of domesticity, particularized, limited, and minoritized. This is why I say that the way forward is a way out, that it will lead bodies onto the street, and that it will call for recourse to the feminine strategies that have always made history despite their intense and ongoing devalorization in and through the work that I have called *minoritization*. This is work that we have often been caught up in, despite ourselves. The body in the street, as in the case of the Madres, does not cease to be a body, and from its maternal position it makes claims on, brings pressure to bear on, the state, on those who work in the offices that manage the nation's resources.

We have to remake ways of life, reconstruct communities and strong bonds, ties to neighbors. We have to do so using the "technologies of sociability" that women wield in their domains, locally rooted and characterized by the symbolic density that is the sign of an alternative cosmos, dysfunctional for capital. This cosmos belongs to indigenous peoples, to the political path, strategy, and intelligence that has allowed them to survive five hundred years of continuous conquest. We have to make a politics of the everyday, reweave the fabric of community, break apart the walls that enclose domestic spaces, and return to the domestic politics of communal life. This politics, this form of politicality, and these social technologies will allow another form of political action to emerge, one capable of reorienting history, leading it in the direction of greater happiness, toward the end of the patriarchal prehistory of humanity. It is time for the politics of women.

To choose the path of relation is to favor the historical project of being a community. It is to perceive that the three watchwords of the French Revolution – liberty, equality, fraternity – left something out, a fourth watchword closely related to the experiments that have taken place in Latin America, with their communal goals. This is *reciprocity*, because reciprocity is what gives rootedness,

location, and relation concrete forms. Rootedness and the centrality of relational life offer us alternatives; they are dysfunctional for the world that is guided by things and for the historical project of capital, which seeks the accumulation, and thus inescapably the concentration, of wealth.

The project of bonds and *the project of things* are guided by different and incompatible goals, and our task as professionals of the word is to devise a rhetoric of value, a vocabulary for defending the relational project and countering the powerful rhetoric of the project of things, a rhetoric that is meritocratic, productivist, developmentalist, and centralizing. From now on our strategy will be feminine.

4

Coloniality and Modern Patriarchy

The following pages address the historical process prompted by the transition from what I have called (for lack of a better name for the social relations that obtained before the colonial intrusion) the "village-world" to the world reshaped by colonial administrations, first overseas and then within Latin American republics. My account is the result of ten years spent observing the expansion of the "democratic" state into the indigenous world in Brazil. The "democratic" state front to which I refer is made up of the post-dictatorship states in Latin America, which arrive at the indigenous frontier, the "village-world," with their laws, public policies, businesses, and NGOs. This front, which remains colonial and irremediably intrusive, intervenes in what is left of the village-world and gives with one hand what it has already taken away with the other. It offers antidotes, in the guise of rights, for containing the effects of the poison that it has introduced. Owing to the constitutive form of the state and the lack of awareness among its agents of the difference between the "citizenry," defined as a mass of individuals endowed with formal rights, and a communitarian and collectivist organization of life, the results of the state front's actions almost inevitably tear at the fabric of relations and the system of authority proper to the village-world, while also cutting the threads of this world's collective memory. I have seen this process unfold, expand, and affect women's lives, and these are the effects that I speak of in this chapter.

The event that inaugurated my decade of participation and observation in this world took place in 2002, when two women, Rosane Kaingang and Miriam Terena, proposed a seminar and workshop with the aim of making use of the vocabularies of gender and human rights in ways that would allow them to make demands for resources and rights for indigenous women, demands addressed to the state. The Fundação Nacional do Índio (National Indian Foundation, or FUNAI) entrusted me with leading this week-long seminar and workshop, which included a residency. The event was thoroughly interactive and allowed me to listen to forty-one indigenous women from all the regions in Brazil as they described their problems. These women spoke Portuguese as their second language, and I responded to them with categories, concepts, and narratives that I hoped might shed some light on the experiences they shared with me. This exchange sought to make a lexicon available, one that would allow for the construction of a discourse capable of formulating and communicating indigenous women's demands on the eve of the coming to power of the Partido de los Trabalhadores (Workers' Party, or PT) and of Luis Inácio Lula da Silva as president of Brazil.[1] During the decade that followed, two series of thematic meetings took place, and a working group on gender and generation was created, led by my indigenous colleague Léia Bezerra Wapichana. The following ideas are informed by these situations, meetings, and dialogues, which occurred in many places up and down this enormous country and made clear that many different peoples constitute it.

Duality and Binarism: The "Egalitarian" Gender Relations of Colonial Modernity and Hierarchy in the Pre-Intrusion Social Order

In this section, I discuss a specific form of infiltration: the infiltration of the gender relations in the village-world by the gender relations of the colonial-modern order. Julieta Paredes (2010) has identified something similar in and through her idea of an intersection or "conjuncture of patriarchies." Here it is crucial to understand that by comparing the colonial and, later, the republican state's intrusion into other worlds to the order of colonial modernity and its norms of citizenship, we not only shed light on the world of the village, but also and especially understand dimensions of republics and

the regime of rights that often remain opaque, dimensions that are hidden by the system of civic and republican beliefs by which we are surrounded, that is, by the civic religion of our world. I would also like to note that the analysis of what differentiates one world's understanding of gender from another's clearly reveals the contrast between their forms of life in general, that is, in all spheres and not only in the realm of gender. This is because relations of gender, although they are treated as "particular questions" in sociological and anthropological discourse, are ubiquitous and even omnipresent in all social life.

I thus try to read the interface between two worlds, the pre-intrusion world and the world of colonial modernity, from the point of view of transformations in the gender system. That is, this is not merely a matter of introducing gender as one more theme in decolonial critique, or as one aspect of domination in the order of coloniality. It is instead a matter of granting gender a real theoretical and epistemological status, of treating it as a central category that can illuminate other aspects of the transformation that was imposed on communities when they were captured by the new colonial-modern order.

In my view, this discussion contributes to a very recent debate, and in order to situate my intervention within this debate, I should first identify three strands within feminist thought. First, Eurocentric feminism argues that the problem of gender domination, or patriarchal domination, is universal. This feminism does not make further distinctions and, in the name of unity, points to the possibility of passing the advances of modernity on to non-white, indigenous, and black women and to colonized continents. This feminism thus assigns European or Euro-centered women a position of moral superiority, authorizing their interventions and their civilizing, colonial, modernizing missions. This position is also inevitably ahistorical and even anti-historical because it encloses history within the extremely slow, almost stagnant time of patriarchy, and it occludes the radical distortion introduced by the entry of colonial-modern time into the history of gender relations. As I noted above, although race and gender were installed by epistemic breaks that led to the foundation of new times – coloniality in the case of race and the time of the species in the case of gender – both make history within the stability of the epistemes that gave rise to them.

A second feminist position, at the other extreme, is taken by critics including María Lugones and also Oyèrónkẹ́ Oyěwùmí, who

argue that gender did not exist in the precolonial world (see Lugones 2007). In 2001, I published a critical analysis of Oyĕwùmí's 1997 book, which I read in light of one of my own texts from 1986 that showed the same perplexity in its response to gender in the context of Yoruba civilization but that reached different conclusions (Segato 2001).

A third position, which I espouse here, is supported by a great deal of historical and ethnographic evidence that indisputably points to the existence of gendered terms in tribal and Afro-American societies. This third position identifies a form of patriarchal organization in indigenous and Afro-American societies, though one, different from the Western gender system, that could be described as a low-intensity patriarchy. At the same time, those who argue for this position maintain that the prevailing, Eurocentric feminist position is neither efficacious nor accurate. This position's adherents include the feminist thinkers associated with the struggle in Chiapas, a paradigmatic context for the resolution of tensions resulting from the double participation of women in indigenous struggles and women's struggles for better conditions of existence (see, e.g., Gutiérrez and Palomo 1999; Hernández Castillo 2003; Hernández Castillo and Sierra 2005).

Women, both indigenous and Afro-American (see, e.g., Williams and Pierce 1996), who have acted and reflected, find themselves divided between, on the one hand, loyalty to their communities and their peoples in their confrontations with external forces and, on the other, a commitment to the internal struggle against the forms of oppression from which they suffer within these same communities and as members of these same peoples. These women have frequently denounced the blackmail exercised by indigenous authorities, who pressure them by claiming that the demands that they make as women risk fragmenting their communities, threatening their cohesion, rendering them more vulnerable in their struggles for resources and rights. The feminist authors whom I have just cited have answered these charges.

Documentary, historical, and ethnographic evidence from the tribal world points to the existence of structures of difference that are recognizable, similar to what we call relations of gender in modernity, with clear hierarchies of prestige that separate masculinity and femininity, embodied respectively by figures who can be understood as men and women. Although it assigns recognizable positions, this world is also marked by more frequent openings

that allow for the passage out of and movement between positions, whereas such passages and movements are prohibited in the modern Western world. As is known, indigenous peoples, including the Warao in Venezuela, the Cuna in Panama, the Trio in Surinam, the Javaés in Brazil, and the Incans in the pre-Columbian world, among other peoples, including a number of Native American peoples in the United States and First Nations in Canada, as well as all Afro-American religious groups, speak languages and allow for practices that transgress stabilized categories of gender: marriage between persons who in the West would be understood to be of the same sex; forms of gender transitivity that would be blocked by the Western gender system and absolutely ruled out by colonial modernity.[2]

In the pre-intrusion world, we can also recognize the features of an understanding of masculinity that has been with humanity throughout the history of the species; what I call "the patriarchal prehistory of humanity" is characterized by a very slow temporality, which is a *longue durée* that is so long as to be confused with evolutionary time (Segato 2003a). This form of masculinity is built by a subject who is compelled to acquire it as a status, undergoing trials and confronting death in the process – as in the Hegelian allegory of lordship and bondage. Throughout his life, this subject bears the weight of an imperative to comport himself – time and again, and in the eyes of his peers – in a way that proves and repeatedly confirms his capacities for resistance, aggressivity, domination, and the accumulation of what I have called forms of "feminine tribute" (Segato 2003a). In this way, he displays the set of powers – military, political, sexual, intellectual, economic, and moral – that allow him to be recognized and addressed as a masculine subject.

This indicates, on the one hand, that gender exists in such worlds, albeit in a different form from the one found in modernity. On the other hand, it indicates that when this colonial modernity comes into contact with the understanding of gender found in indigenous villages, it dangerously modifies that understanding. It intervenes in the villages' structure of relations, capturing and reorganizing these relations from within, maintaining the appearance of continuity while in fact transforming their meanings as it introduces an order governed by different norms. It is for this reason that I refer to forms of "resemblance": the terms referring to gender remain the same, but they are reinterpreted in light of the new modern order. This convergence is truly fatal, because a language that was hierarchical, when

it comes into contact with the egalitarian discourse of modernity, becomes super-hierarchical for the reasons that I will examine in what follows. These include a hyperinflation of masculinity in the communal context, where men act as intermediaries who bring the world of the village into contact with the outside world, that is, with the world of white administration; the emasculation of men in the extra-communal context, where they confront white administrators; the hyperinflation and universalization of the public sphere, already ancestrally inhabited by men; the collapse and privatization of the domestic sphere; and the becoming-binary of dualities, resulting in the universalization of the binary terms that oppose the realm understood as private to the realm understood as public.

To be sure, the village was always organized by status, divided into spaces that were clearly distinguished and governed by rules of their own, with different forms of prestige and a different hierarchical order; it was always inhabited by people assigned roles that could be understood very generally to correspond to those of men and women in modernity. These were also people marked by gender as by a sort of destiny related to the distribution of spaces, labor, and rituals. But despite being egalitarian, the discourse of colonial modernity – as many feminists have noted – hides an abyssal gap resulting from what we can here tentatively call the progressive totalization of the public sphere or the totalitarianism of the public sphere. It could even be argued that it is the public sphere that continues and entrenches the colonizing process today. We can shed light on this idea by considering Carole Pateman's (1988) notion of the "sexual contract," and showing that the sexual contract is openly exposed in the world of the village, whereas in colonial modernity it is disguised by the language of contractual citizenship.

Let me illustrate this claim with an example of what happened when we traveled with the women's committee of the FUNAI to villages to speak to indigenous women about the problem of increasing violence against them. News of this problem had reached Brasília. What happened – in general, but especially in areas where the forms of life considered "traditional" were supposedly better preserved and where there was more awareness of the value of autonomy in relation to the state, as is the case for the residents of Parque Xingú in the state of Mato Grosso – was that chiefs and men would be present and intervene in the meetings, arguing that the state should have nothing to do with or to say to their women. They supported this argument by making the plausible claim that their

world "was always this way": "the control that we exercise over our women is the control that we have always had over them." And they supported this claim in turn with a culturalist and thus fundamentalist argument of the kind that I referred to above. According to such an argument, culture has no history. Arlette Gautier calls this historical myopia "the invention of customary law" (2005: 697).

The correct, if somewhat complex, response to such claims is: "in part yes, and in part no." Because if there had always been a hierarchy in the world of the village, a difference in prestige between men and women, there was also another kind of difference, one that was now threatened by the interference of a colonizing republican public sphere. While disseminating a discourse of equality, such a public sphere also relegates difference to a marginal and problematic position; it creates the problem of the "other," expelling the other thus defined as a "problem." This shift introduced by the village's annexation, first under the aegis of the overseas colonial administration and later in the management of the state, which is still colonial, leads to the formation of a first symptom: the cooptation of men, the members of the class ancestrally assigned tasks and roles in public space before the colonial intrusion.

To engage in deliberation on communal village lands, to leave on hunting expeditions and come into contact with the residents of other villages, whether neighboring or distant, whether members of the same people or of other peoples, to converse with or wage war against these people: all of these were ancestrally male tasks. And for this reason, from the perspective of the village, the agents of successive colonial administrations were added to this list: the list of those with whom one conversed or engaged in debate or negotiated or signed agreements, or those against whom one waged war, or, recently, those from whom one obtained resources and rights (understood as resources) that could be claimed in an age of identity politics. The ancestral position of masculinity was thus gradually transformed by the relational role that men came to play, by their contact with the powerful agents who produced and reproduced coloniality. The colonizers fought wars against men and negotiated with men, and the colonial modern state did the same. For Gautier, this choice of men as privileged interlocutors was deliberate and functional for the project of colonization and its efficiency as an instrument of control: "Colonization entailed a radical loss of political power for women, where they had it, whereas the colonizers

negotiated with or invented certain masculine structures in order to secure allies" (2005: 718). They also promoted the "domestication" of women, their relegation and subjection, in an effort to facilitate the colonial enterprise (2005: 690ff; see also Assis Climaco 2009).

The masculine position thus underwent a change and was promoted, made into a new position distanced from the feminine. These processes were hidden from view by the old terms, even while the masculine position was strengthened by men's privileged access to resources and knowledge of the world of power. This position was thus displaced, repositioned, while a rupture in and reconstitution of the old order took place; the old names, signs, and rituals were kept, but filled with new contents. Men return to villages secure in their sense of being what they have always been, while hiding what now operates differently. Here we could refer to the famous and evergreen metaphor of *body-snatching*,[3] as in the classic Hollywood film *The Invasion of the Body Snatchers* (1978), where bodysnatching is also "the perfect crime," according to Baudrillard (1996), because it is successfully hidden behind a false analogy or appearance of resemblance. Here we confront a cast of characters in another drama, or one captured by another grammar.

Women and the village itself become objects under the masculine gaze, a gaze now infected with the diseases of distance and exteriority, diseases proper to the exercise of power in the world of coloniality, transmitted through contact and mimesis. Men's position now becomes at once interior and exterior; it is endowed with the exteriority and objectifying capacity of the colonial gaze, at once administering and pornographic. Very schematically, because I cannot elaborate at length here, I want to note that sexuality is also transformed by the introduction of a previously unknown form of morality, which reduces women's bodies to the status of objects and at the same time introduces the notions of sin, heinous crimes, and all their corollaries. We should attribute to colonial-modern exteriority – the exteriority of scientific rationality, the exteriority of administration, and the exteriority that seeks to eliminate the other and difference, all identified by Walter Mignolo (2000) and Aníbal Quijano (1992) in their work – the pornographic character that I attribute to the colonizing gaze.

I should note, however, that together with this hyperinflation of the masculine position within the village, an emasculation of these same men occurs in their confrontations with the white world, which subjects them to stress and reminds them of the relativity

of their masculinity by also subjecting them to the sovereign dominion of the colonizer. This process generates violence, because it oppresses here even while it empowers men in the village, compelling them to reproduce and repeatedly exhibit the capacity for control that inheres in the masculine subject position in the only place that they can do so, in an effort to restore the virility damaged in their confrontations with the external world. This is true of the whole universe of racialized masculinity, expelled from whiteness and relegated to the condition of non-whiteness by the order of coloniality.

There is another feature of this process by which precolonial gender is captured by modern gender: the sequestering of all politics, that is, all forms of deliberation on the common good, within the republican public sphere. This also leads to the privatization of the domestic sphere, to the othering, marginalization, and expropriation of all political tasks that previously took place there. Bonds between women, which led to reciprocity and solidary collaboration both in the performance of rituals and in the completion of productive and reproductive tasks, are now undone as domesticity is enclosed in and redefined as "private life." For domestic spaces and those who inhabit them, this means nothing more and nothing less than the disintegration of their value and political power, that is, their capacity to take part in the decisions that affect the whole collectivity. The consequences of this breaking of the bonds between women – and of the political alliances that such bonds permit and promote – are literally fatal, because this process leaves women ever more vulnerable to masculine violence, which is in turn worsened by the stress caused by the pressures placed on men by the external world.

The compulsory confinement of domestic space and its inhabitants, women as safeguards of the private, has terrible consequences, sustaining the violence that targets women. It is crucial to understand that these consequences are fully modern and the products of modernity, and to recall that the process of modernization that is still persistently expanding is also a process of permanent colonization. Thus just as the crime of genocide is, in its rationality and systematicity, a product of modern times, femicide, as the almost machine-like practice of exterminating women, is a modern invention. This is the barbarism of colonial modernity that I mentioned earlier. Impunity, as I have tried to show elsewhere, is related to the privatization of domestic space, as a residual

space that is not included within the sphere of broader questions thought to be of general public interest (Segato 2011b, republished as chapter 5 below). With the emergence of the modern grid of categories used by the state, politics, the discourse of rights, and science, both the domestic sphere and women, who inhabit it, become mere remnants, marginal to the affairs considered universally relevant and the perspectives considered neutral.

For many peoples in the Amazon and Gran Chaco regions, there are precise rules governing feminine participation and speech in the public spaces of the village, where the prerogative of deliberation is reserved for men. But, as is well known, these men suspend tribal assemblies and deliberations at sunset, often in a highly ritual fashion, without arriving at any conclusions, in order to engage in nighttime consultations within their domestic spaces. The deliberations only resume the next day with support from the world of women, who only speak at home. If this kind of consultation does not take place, the penalties for men are severe. All of this is customary and takes place within a world that is clearly compartmentalized. Here, although there is a public space and a domestic space, politics, defined as a set of deliberations that lead to decisions that affect collective life, cuts across both spaces. In the Andean world, the authority of the *mallkus* is always dual: although their internal organization may be hierarchical, they include a masculine leader and a feminine leader, and all communal deliberations are attended by women, who sit beside their husbands or in groups outside the enclosures in which deliberations take place; from here they send signals of their approval or disapproval during the course of the unfolding debate. If this is the case, then in such worlds, there is no monopoly on public space and its activities of the kind that we find in the colonial modern world. On the contrary, domestic space is endowed with politicality, in that the consultations that take place there are obligatory and because it marks the place where women come together as a group to form a political front.

Gender, governed in this way, constitutes a hierarchical duality, in the sense that both of the terms that make it up, masculine and feminine, are ontologically and politically complete, despite the fact that they are unequal. In the world of modernity, there is no duality but instead binarism. Whereas dualities involve relations of complementarity, binary relations are supplementary: one term supplements, rather than complements, the other. When one of these terms becomes the "universal," that is, the representative of

the general, what was hierarchical becomes abyssal, and the second term becomes a remainder. This is a binary structure, different from the dual.

In the colonial-modern order, which is a binary one, any element must be made equivalent – that is, made measurable by the grid of reference or universal equivalent – in order to attain ontological fullness or completeness, the fullness or completeness of being. This has the effect of making any manifestation of otherness into a problem that can only cease to be a problem when it is filtered through the equalizing grid that neutralizes particularities and idiosyncrasies. The Indian other, the non-white other, or the woman cannot fully adapt to the neutral, aseptic environment of the universal equivalent – that is, what can be generalized and endowed with universal value and interest – unless they are cleansed of their difference or exhibit a form of difference that has been made commensurable with the terms of an identity that is recognizable within the global order. In the modern world, only subjects (individual or collective) and questions that can somehow be processed, translated, and reformulated in the universal terms and transported into the "neutral" space of the republican subject – the place where the universal citizen-subject speaks – are endowed with political capacities. Everything that is left over in or left out of this process, everything that cannot be converted into or made commensurate with the grid, is a remainder.

Nevertheless, as others have already shown, there is a subject native to this space, this modern *agora*, only one subject capable of dwelling within it neutrally. This subject created the rules of citizenship in his own image and likeness, giving rise to it from a place of exteriority and shaping it in a process that was first military and then ideological. He has the following characteristics: he is male, white, and a paterfamilias – and therefore at least functionally heterosexual – as well as propertied and literate. Anyone who would exercise his capacity for citizenship must find a way to conform to this profile, through politicization defined as the rendering public of identity, since the public is the only realm that is politically potent in modernity.[4]

Dualism – as in the case of gender dualism in the indigenous world – is one variant of the multiple; or, rather, in this context the dual condenses and epitomizes a multiplicity. Binarism, which is proper to colonial modernity, results from an episteme that eliminates, that produces exteriority; it belongs to the world of the One. The one

and the two within indigenous dualities are some of the many possibilities of the multiple; here the one and the two, although they can function complementarily, are ontologically complete and endowed with politicality despite being unequal in their value and prestige. The second term in this hierarchical duality is not a problem in need of conversion or correction or processing through the grid of equivalence; nor is it the remainder of the transposition of the One. Instead it is fully other, a complete and irreducible other.

In order to understand this, we must also understand that the domestic space is, in this context, whole and complete, with its own politics, its own associations. These are hierarchically inferior to associations in public space, to be sure, but they can defend themselves and have the capacity to transform themselves. We could say that gender relations in this world take the form of a *low-intensity patriarchy*, unlike the patriarchal relations imposed by colonialism and consolidated in modern coloniality.

Without entering into the details here, I will underscore the well-known failures of the gender equality initiatives of prestigious programs for international cooperation; these failures result precisely from the fact that the programs bring a universalist gaze to bear, and they proceed from a Eurocentric definition of "gender" and gender relations. In other words, the fragility of such initiatives that seek to promote cooperation results from their lack of awareness of the categories proper to the contexts for which they are formulated. In rural communities and indigenous villages, society is dual, and this duality organizes spaces, tasks, and the distribution of rights and responsibilities. This duality defines gendered communities or collectivities. This means that the general social fabric is divided into parts, the community into groups with their own norms and ways of living together and forms of association, both for productive and reproductive tasks and for ceremonial purposes. In general, the projects and initiatives that involve the technical cooperation of European countries point to the difficulty of perceiving the specificity of gender in the communal contexts in which they are realized. As a result, projects and initiatives that relate to gender and that seek to promote gender equality are addressed and applied to persons, that is, to individual women, or to the relations between individual women and individual men. The result sought is the direct and immediate promotion of gender equality, defined as equality between persons rather than between spheres. Designed so that they focus on individuals, such initiatives that seek to promote

gender equity do not proceed from an understanding of context-responsive action, which in the communal context would require the promotion of the domestic sphere and the collective of women as a whole as they confront the hierarchy of prestige and the power of public space and the collective of men. In fact, these projects should aim to promote equality between the collectives of men and the collectives of women within communities. Only this form of equality could lead later to the emergence of prominent women who would not distance themselves from their communities of origin, that is, who would persistently return to and act within the group.

The other serious mistake made by programs that seek to foster international cooperation as well as by public policies and NGOs follows from their understanding of transversality and the strategy that derives from the effort to practice a transversal politics in order to redress the hierarchical nature of gender relations. The other mistake that I have just identified resulted from the Eurocentric tendency to see gender relations in the world of the village as relations between individual women and men, and the inability to understand that these relations are a matter of hierarchies between gendered groups, that is, a matter of inequality between the spheres into which the community is divided. The mistaken understanding of transversality is based on the assumption that there are dimensions of communal life that are of universal interest (the economy, social organization, political life, and so on) and others that are of particular or partial interest (domestic life, or what happens between women, or women's affairs). The effort to create a transversal gender politics is thus based on the erroneous notion, examined above, that in the village the public is a space for universal values, that is, that the public in this context is equivalent to the public sphere as it is defined in the colonial-modern order, and that the domestic is a particular, private, and intimate realm. This notion establishes a hierarchy between the two realms. As a result, what is "transversalized" is what is thought to be of only partial or particular interest, and what is seen as appended onto the affairs thought to be central and of universal interest. This is, like the other mistake that I have just discussed, a Eurocentric projection of the structure of modern institutions onto the institutions of the world of the village. To seek to "transversalize" particular or partial interests, including gendered interests, by introducing them into supposedly universal problems: this effort becomes a problem as soon as it comes into contact with the reality of worlds that do not conform

to the social organization of the modern West, worlds that are not organized by Eurocentric and colonial binarisms. In the world of the village, although it is endowed with more prestige, the political sphere is not universal but rather, like the domestic sphere, a space of partiality. Both spaces are, again, understood to be ontologically complete.

In addition to identifying the individualism inherent in the state perspective and in both state-led and international programs, I would note that the modern world is the world of the One, where all forms of otherness that deviate from the universal order represented by this One are seen as problems. The discipline of anthropology itself offers proof of this, since it is born under the cover of the modern conviction that others must be explained, their languages translated, made commensurate, processed by the rational operations that assign them places on the universal grid. Anything that cannot be placed on this grid is left over and left out; is not endowed with the weight of reality or with ontological fullness. It is discounted as incomplete and irrelevant. Derridean deconstruction, which destabilizes binary pairs, cannot accommodate or give an account of duality.

In and through the transformation of dualism, defined as a variant of the multiple, into the binarism formed by the universal, canonical, "neutral" One and its other – the remainder, residue, surplus, anomaly, or margin – exits and passages are closed off. Possibilities for circulation among positions are foreclosed as all positions are colonized by the logic of the binary. Gender is cast, as in the West, within the heterosexual matrix, and rights become necessary as protections against homophobia. So, too, do policies for the promotion of equality and sexual freedom, like same-sex marriage, prohibited in colonial modernity but accepted by a wide range of indigenous peoples in Latin America.[5]

Giuseppe Campuzano (2006; 2009b, among others) has studied the pressures that the colonizer brought to bear on the diverse forms of sexuality encountered in the Inca empire, as attested to in chronicles and other documents from the sixteenth and seventeenth centuries. These sources also attest to the constant pressure exerted by the norms and punitive threats that sought to capture indigenous practices within the conquistador's heterosexual binary, which led to the imposition of notions of sin that were foreign to the world that he encountered. It also caused the pornographic gaze to spread. This lets us conclude that many of the forms of moral harm today

thought to be matters of "custom" or "tradition" – those that the tools of human rights seek to combat – are in fact *modern* harms, customs, and traditions. That is, they are native to the order that was established by colonial modernity. For example, the supposed "custom" of homophobia is, like other supposed customs, modern. Here again, then, we are dealing with a legal antidote produced by modernity to counter the harms that modernity itself has introduced and continues to propagate.

The hardening of identity positions is also one of the features of the racialization established by the modern colonial process, which places subjects in fixed positions within binary orders – in this case, the white/non-white binary.[6]

Another unfortunate part of this process is the rearrangement of the cosmos and the earth so that all beings, both animate and inanimate, can be made to fit within the binary relation between subject and object proper to Western science. In this new situation – new and ongoing for many peoples who are still exposed to a persistent and daily process of conquest and colonization – the struggle for rights and inclusive public policies that promote equity is proper to the modern world. This does not mean that we should oppose them; instead it means that we should understand the paradigm to which they belong and especially that living in a decolonial way means seeking to open breaches within a territory that has been totally colonized by a binary system, which is possibly the most efficient tool that power wields.

For this reason, I said to my indigenous interlocutors in the workshops led by FUNAI's working group on gender and gener-ation, during our discussions of the Maria da Penha Law against Domestic Violence: the state gives you with one hand what it has already taken away with the other. Or, as I argued above, it purports to offer antidotes for the poisons that it has itself introduced.

When the world of binary structures, the world of the One and the rest, its remainder, comes into contact with the world of the multiple, it captures the latter world and modifies it from within, in ways that are in keeping with the coloniality of power. This then allows the world of the One to exercise a more powerful influence over the world of the multiple, or rather, more precisely, to *colonize* it. In this new, dominant order, public space in turn captures and monopolizes all deliberations and decisions that pertain to the general common good, and domestic space as such is totally depolit-icized. This happens both because of the loss of ancestral forms

of participation in public space and because the nuclear family is now cloistered within the space of privacy. New, imperative forms of conjugality come to regulate the family, ruling out the more extensive bonds that used to saturate domestic space (Abu-Lughod 1998; Maia 2010). This weakens the communal gaze that used to monitor and judge behaviors. The depoliticization of domestic space then makes it vulnerable and fragile, and innumerable accounts attest to the new degrees and cruel forms of victimization that emerge when the protection of the communal gaze is withdrawn from the world of the family. In this way, the authority, value, and prestige of women and their sphere all collapse.

This critique of the decline and fall of the domestic sphere and the world of women – of their fall, that is, from a position of ontological plenitude to the status of the surplus or remainder of the real – has important gnoseological consequences. These include a recognition of the difficulty that we face when we understand the omnipresence of gender in social life but still cannot think of all reality on the basis of gender, or grant gender theoretical and epistemological centrality, or treat it as a category capable of shedding light on all areas of life. By contrast, in the pre-intrusion world, constant references to duality in all symbolic fields suggest that this problem – the gnoseological devaluation of the gender system – does not exist there.

The most important thing to note here is that in this context of change, the old names for things are preserved, and a mirage arises, producing the false sense of continuity, making it seem like the old order, with its system of names, formalities, and rituals, has persisted. But it is now governed by another structure (Segato 2007a). This transition is subtle, and the lack of clarity about the changes that have occurred causes women to acquiesce without knowing how to respond to the repeated claim made by men, "we were always like this," or to their claim to be preserving a custom that they suppose or argue is traditional, a hierarchy of value and prestige that is proper to the community. Hence the blackmail that women permanently face, or with which they are persistently threatened: to touch or alter this order, this identity and this culture – where identity is political capital and culture is symbolic capital and a point of reference for peoples in their struggles to persist – would be to do damage to and thus to debilitate indigenous demands for lands, resources, and rights understood as resources.

But what has happened, as I have been saying, is that that hierarchical status and the power of those who previously held power – elders, chiefs, and men in general – are enhanced within the village as a result of modern colonization. As I noted above, although it is possible to argue that there was always hierarchy and there were always gender relations that functioned as unequal relations of power and prestige, the colonial intervention of the state and the entry into the order of colonial modernity exacerbate these hierarchies and magnify these oppressive distances. *A transformation takes place under the cover of apparent continuity.* And one must bring considerable skill to bear in the analysis of rhetoric to understand that the effect of historical depth is an optical illusion that serves to shore up new forms of male authority and other hierarchies in the village. Here we confront the perverse culturalism that is also the cultural and political fundamentalism of our age, beginning with the fall of the Berlin Wall and the obsolescence of old Marxist debates, when identities, now politicized, were turned into the language of debate (Segato 2007a).

To sum up, then, and to recapitulate: gestures that purport to allow for the universalization of citizenship are read as replacing a hierarchical order governing the relations between men and women with an egalitarian set of gender relations. But this reading overlooks the fact that what such gestures really do is remedy the harms that modernity has itself introduced, with solutions that are also modern. Again, the state gives with one hand what it has already taken away with the other. *Unlike the modern activist slogan that promotes the "different but equal," the indigenous world is guided by another formula, one that it is difficult for us to understand: "unequal but different."* In other words, this world really is multiple, because the other, who is different or distinct, and who may be inferior, does not represent a problem to be resolved. The rule of compulsory commensurability disappears. It is here that the world-between-worlds of critical modernity enters the picture, complicating and enriching ethnic hierarchies with its discourse of equality, and generating what some have begun to call ethnic or communal citizenship. This form of citizenship will only be adequate if it begins with internal autonomy and jurisdiction, that is, with debate and deliberation among the members of a community, weaving the threads of their own history. I conclude by referring to the extraordinary film *Mooladé* (2004), by the late

Senegalese director Ousmane Sembène: a film about the struggle fought by a group of women in a village in Burkina Faso to eradicate the practice of infibulation. This struggle begins from within, and is internal to, a community shot through, as it has always been, with elements of the world that surrounds it.

5

Femigenocide as a Crime Under International Human Rights Law

The Struggle for Laws as a Discursive Conflict

This chapter proceeds from an idea that I have already presented in two of the chapters in my book *Las estructuras elementales de la violencia* (The Elementary Structures of Violence; Segato 2003a). There I argue that, much more than in the performance of sentencing by judges, the law is instrumental in the hands of the people themselves in that it offers a set of words enshrined in and through the powerful narrative framework that is the legal code.

This means that the legal realm is above all a discursive field. It also means that the struggle for laws [*el derecho*], both in the sense of laws to be formulated and in the sense of the enforcement of those that have already been formulated (as in the seminal essay by Rudolf von Ihering; 1915 [1872]), is, on the one hand, a fight for the right to name the forms of human suffering through the use of legal consecration, or to enshrine the names that are already in use; and, on the other hand, a struggle to make public, to promote the use of, the law's words, putting these words in people's mouths, making them circulate.

In other words, we are dealing with a dual struggle: a fight for access to law, defined as the repository of the nation's master narratives, an effort to exercise our capacity to write ourselves into the law, to lay claim to it; and at the same time a struggle over the *use* of the words that the law authorizes, a struggle that takes place not

only in courtrooms but also in the realm of everyday relations, face to face.

On the other hand, laws are the means by which nations enshrine, through their states, their response to and recognition of the existence of communities of interest, acting on these communities' and particular accusations. If a community consolidated on the basis of an identity of interests is not enshrined in legal discourse, it will naturally conclude that the state is not granting its existence. The law thus acts as an institution that recognizes and traces the contours of each of the communities that it seeks to govern. The struggle for laws is therefore a struggle to obtain this inscription, this recognition, and anyone who gains access to the law also demonstrates this capacity, this ontological plenitude, its status as being-among-others, placed above those who do not achieve such recognition.

But if the law can amplify or offer the discursive power that confirms the influence of collective subjects, there is a very clear limit to its efficacy. This limit has to do with its discursive dimension; when I highlight this dimension to the point of placing it on a level with, or even above, the law's normative productivity, its sentencing power, I do so precisely because it has its own efficacy, its own effect. What is this efficacy inherent in the discursive dimension of the law? Nothing other than its capacity to impact and shape people's ethical sensibilities, through categories enshrined legislatively and juridically. In this sense, law, and especially human rights law, are indissociably linked to the progressive development of collective ethical sensibilities, and without this development the law is badly compromised (Segato 2006a). For this reason, a law that is not efficacious in this realm – that is, a law that does not manage to represent, interpellate, and guide people's ethics and their current ideas about what is decent or indecent, good or evil – will not really be in force. It will be a law without normative efficacy. This limits the faith that common sense places in the normative power of the law and the supposition that there is a direct, causal relation between laws and practices.

The fight for abortion is a clear example of this aspect of the law, this fundamental feature of the juridical. The legal ban on abortion never led to the abolition of the practice. According to a 2007 study led by the Comisión Nacional de Programas de Investigación Sanitaria (National Commission of Programs for Health Research), an offshoot of the National Ministry of Health in Argentina,

although abortion was criminalized in the country for nearly ninety years, this had little impact since, according to the study's conclusion, every woman has on average two abortions, leading to a rate of one abortion for every birth (Mario and Pantelides 2008). This indicates that we should not see the real purpose of the law that bans abortion as an effort to control the practice, which has been shown to continue unabated. Instead, we should recognize another aim in these laws. And the possibility of this law's ever being fully in force is severely compromised by the fact that it would be impossible to convince most women or the population in general that an organically unviable entity, often a mere collection of cells, should be considered a human being, a person. This claim runs counter to the rationality and the intelligence of common sense, requiring recourse to a set of magical beliefs that are dysfunctional for contemporary historical projects.

We can therefore conclude that the law, especially in this case, should undoubtedly be perceived as the result of a relation between parties, a relation between sectors whose members are represented in what the ban on abortion does not announce explicitly. That is, the fight to criminalize or decriminalize abortion is not a struggle to make the practice of abortion impossible or to make it possible; the law has not shown the capacity to control this practice. We are dealing instead with a struggle between two collective subjects contending with one another in the context of the nation, a struggle over access to and inscription in the narrative of the law. The struggle to authorize or de-authorize abortion is thus nothing more than a confrontation between parties that seek to affirm their existence and their capacity for influence on the national scene. One of these parties is made up of the Vatican and its representatives in Argentina, who are anxious to show that they still retain a significant amount of decision-making power over the nation's destiny.

Here it is necessary to clarify that these parties are not symmetrical or equivalent, although they represent different interest groups within society. They are not equivalent because one of them – the party that is struggling to decriminalize abortion – is genuinely working to achieve this cause with the aim of saving women's lives. The other, however, is not struggling – as I have just demonstrated and despite its proclamations – to defend life. Instead it is advancing what could be understood as a *politics of identity*: to affirm an identity by making demands and marking territories within the nation that remain under the control of the Church. There is an

antagonism, then, but only one position is genuine or authentic, while the other is inauthentic in its relation to the cause that it invokes to justify its political action.

In the *femicides* that I have studied for the past several years, we can clearly see a circular economy at work. Faced with the refusals of legislative bodies, jurists, and judges who theoretically have the ability to create jurisprudence or to wield influence in the development of norms, women have taken to using the word *femicide* as if this category already existed in law. This is a way of rising up, of opposing the authorities' refusal to recognize the category that would consecrate these women's demands, a refusal that continues despite the fact that the category already fully exists from the perspective of the population and is accepted by the media.

We can see this aspect of the law at work not only in the making but also in the application of laws. A good example is the debate in Brazil on the extradition of Cesare Battisti, a former member of the Red Brigades in Italy. This debate should also be understood as a conflict between unequal parties in a world shaped by coloniality and Eurocentrism (Quijano 2000). In this case, the conflict was between Berlusconi's Italy, on the one hand, with its presumed geopolitical dominance as a European country and its authorities' desire to demonstrate what being European meant to the rest of the world – the acceptance of Eurocentrism and the ability to influence Brazil's eminent jurists – and, on the other hand, the resistance of Brazil's executive branch, embodied in this instance by the Minister of Justice, Tarso Genro, a historic leader of the PT. Genro was a nationalist and, in this case, antagonistic in his relationship to Berlusconi's Eurocentric militancy and the relentless pressure that Berlusconi, the Italian prime minister, brought to bear on the Brazilian authorities. This had very little to do with any danger to the prisoner and much more to do with the need to show influence, in Berlusconi's case, and sovereign autonomy, in the case of the political actors in Brazil. This case thus takes us very far from what we would think of as substantive legal questions.

Seen from this perspective, the leadership of legislators and the court system would be more complex than jurists imagine, because these authorities would have, above all, the role of conferring legitimacy on certain subject positions through the exercise of their authority to name, in the sense that they have the authority to introduce names into consecrated legal discourse and to adjudicate names through the exercise of the judicial function. These bodies

would thus serve as anchors or points of reference for social suffering, guarantees of this suffering's validity, of its being officially recognized.

This seems to me to be a much more democratic understanding of the juridical function: if theory does not only seek to describe but also to prescribe reality, then we are dealing with a way of understanding how the law matters for all people, because, although only some people can be "practitioners of the law," all people can be practitioners of the discourse of law.

A case that perfectly illustrates what I have been saying is the great national debate in Brazil on the policy of reserving places or using quotas for black students in universities. I was a co-author, with José Jorge de Carvalho, of the first, historic proposal for this policy in November 1999 (see Segato and Carvalho 2002). Positions within the ensuing debate were collected in a series of manifestos, both for and against the policy on the use of quotas. The first pair of manifestos – one for and one against – was submitted by representatives initially to Brazil's National Congress in 2006 and then to the Federal Supreme Court in 2008. The elite, conservative position showed very clearly and shamelessly that Brazil's white and whitened elites sought to impede the entry of excluded people into public universities, which are the corridors through which people gain access to positions of control over national life. This group sought to maintain its monopoly over the university, knowing full well that it is the avenue that leads to access to both prestigious professions and the spaces where decisions over the nation's destiny are made. Race, for this group, would be "created," instituted, if it was mentioned in such a law; if it was not mentioned in the law, then it would have no reality. To "create" race by legislating it was, they claimed, counterproductive because it would divide and weaken the nation.

This can be seen in the Arguição de Descumprimento de Preceito Fundamental presented by the lawyer Roberta Fragoso Kaufmann, who represented the Partido Démocratas before the Federal Supreme Court, arguing against the adoption of racial quotas in Brazilian universities. The central argument made by this lawyer was not that affirmative action was unconstitutional in a democratic state; nor was it that Brazil should not adopt a social state model (as opposed to a liberal state model), developing legislation to encourage the "integration of minorities," the "eradication of poverty," "reductions in social and regional inequality,"

and so on. She did not argue, in other words, that the country should prioritize "solidarity, harmony, and the preponderance of the totality over the individual." Nor did she cast doubt on "the existence of racism, prejudice, and discrimination in Brazilian society" or deny that these "represent forms of injury that should be forbidden, fought against, and punished to the full extent of the law, both in the individual realm and in the collective sphere." None of these was the central argument the lawyer made, but her argument did clearly point to the discursive power of the law, since what it opposed was precisely "the implementation of a racialized state," that is, the institutionalization of racism in and through the naming of race in law. This is the echo, in the legal realm, of the claim in Brazil made by an important group of intellectuals, working at a remove from society, who argue unhesitatingly that the idea of race only exists in the nation if it is legislated, that is, if it is named in law. This claim shows the reach and impact of an understanding of the law as a set of sanctioned names that are granted validity, consecrated as capable of creating reality, in other words, as numinous and charged with mystical power. In what I have written here, I have tried to call attention to what I have defined as the "nominative efficacy of the law" (Segato 2003a) or, quoting the Colombian jurist Mauricio García-Villegas (1993), "the symbolic efficacy of the law." This could also be described as "the performative efficacy of the law" (Enríquez 2009), and it shares affinities with an understanding of "the law as spell" (Lemaitre Ripoll 2009). If misunderstood, this perspective might be conflated with the position critiqued by the distinguished Brazilian jurist Marcelo Neves in his book *Symbolic Constitutionalization* (2022 [2007]), which argues against the discursive inflation of the law, an inflation that has no impact on social practices. I do not dispute this book's conclusions, but my project runs counter to his: I think that the law should not only impact reality through judges' rulings, but should also be rooted in reality, in the everyday use of its names spread through publicity campaigns and through the acceptance of the names that people already use to point to ever-renewed forms of suffering. The law should offer people names for recognizing these in experience.

Seen in this way, the struggle for law comes close to what some scholars have called a struggle for the "right to narrate," because a collective subject's demand for access to inscription is also a demand for the right to name that subject's shared interests in the dominant

language of the nation that is legal discourse (Bhabha 2014; Said 2000 [1984]).

Disputes Over Whether or Not to Name

As is publicly known, there are various disputes over whether to name or not to name things in law. These sometimes involve whether to call the extermination of political or religious groups committed by dictatorial regimes in Latin America "genocide," against the insistence of those who see these as crimes against humanity more generally. However, it is the voice of the people that predominates in this debate, by crying out, "Genocidaires!"

We also see this in the pressure to extend the category of genocide to the colonial exterminations, understood as the first genocides in the modern sense of the term and as anticipating the Nazi genocide, the Shoah. As the indigenous activist Chris Mato Nunpa has argued, the Dakota in what is now the state of Minnesota were subjected to the same planned treatment that was anticipated in the 1948 Convention on the Prevention and Punishment of the Crime of Genocide: people were hunted down, and murdered indigenous people were made into hunting trophies; concentration camps were created; forced marches were conducted to the point of exhaustion and death; and forced relocations took place, as did flagrant acts of ethnic cleansing and extermination. Here in Argentina we have our own inglorious precedent. Mato Nunpa (2008) insists that *we need to begin using these terms*. We might say the same of the struggle in Brazil for the recognition of the genocide against young black people that is underway; the primary cause of death among Brazilians between the ages of 18 and 25 is murder (Paixáo and Marcelo 2008), and the state participates in these murders with impunity (Matos Menezes 2009). The state is effectively responsible, then, for this genocide in two different ways: by allowing people to be killed in areas that are not patrolled, where victims and executioners are from the same social group; or by directly killing, as state agents and so bearers of the monopoly on legitimate violence, always immune because they act as *de facto* judges, exercising the discretionary power and sovereign will to which the police lay claim both on the streets and in police stations or institutions of detentions. In this way, as we learn from those who have begun to critically refuse the historiography that sees state authoritarianism

as an exception, as limited to periods of dictatorship, it would be inappropriate and politically naïve to speak of a "never again," since the history of coloniality remains ongoing, uninterrupted, if it is seen from the perspective of the poor and those who are not white. The genocide against the peoples defeated in the process of conquest has been continuous, and it persists to this day (Passos 2008; Rufer 2009; Segato 2007f).

It is also important to remember here that there are not only struggles to achieve representation within juridical narratives; there are also struggles to withhold such representation, that is, to avoid capture by juridical narratives. An example that remains interesting in this connection is the debate between those who favor and those who oppose the criminalization of so-called "indigenous infanticide," a debate that played out in Brazil's National Congress. In this case, the project of constructing indigenous autonomies and the platforms for juridical pluralism that these autonomies required were threatened by a proposed law, Draft Bill 1057/2007. The defense of the right to difference appealed to the Indigenous and Tribal Peoples Convention (or Convention Concerning Indigenous and Tribal Peoples in Independent Countries, Convention 169 of the International Labour Organization) and the United Nations Declaration on the Rights of Indigenous Peoples to argue against state intervention. In this context, I proposed that "every people should weave the threads of its own history," introducing the principle that I call "historical pluralism" as an alternative to "historical relativism." I suggested that a relativist and pluralist understanding of each indigenous people as a historical project allows us to see that, if juridical debates are allowed to take place within these communities, they themselves will be able to deliberate, travel the journeys, and make the transformations necessary for their wellbeing, which in this case meant the elimination of the practice of infanticide (Segato 2009/Eng.: Segato 2022).

The Struggle to Elevate Femicide to the Legal Status of Genocide Against Women

We have come, then, to the problem of *femicide* and to the feminist and legal debates on this term. It is precisely in the law's reluctance to incorporate this category and make it justiciable that we can

perceive, with noonday clarity, the patriarchal limits of justice as it is understood by today's dominant jurist. This understanding is in keeping with the primitive, foundational, and abiding role of patriarchy itself, which is still the air we breathe and remains key to the maintenance and reproduction of all other forms of power and subjection, racial, imperial, colonial, regional, and economic. It is on the basis of patriarchy that the hierarchical scaffolding that organizes society is constructed; this is why the substrate itself is hard to bring into view and to target in any struggle for social transformation, including struggle within the legal realm. It can be argued, on the basis of evidence, that the maintenance of patriarchy is an *affair of state* and that preserving men's capacity to kill and guaranteeing that their violence goes unpunished are likewise *affairs of state.*

Our perception of the unbreachable limit that patriarchy imposes becomes even clearer when we pay attention, for example, to the conclusions of the report written by Patsilí Toledo Vásquez for the Mexican Office of the United Nations High Commissioner for Human Rights. The report considers the status of the incorporation of the category of *femicide* into the laws of Latin American nation-states and international human rights law (Toledo Vásquez 2009). Toledo Vásquez offers a detailed examination of a wide range of national and international contexts representing practically all the legislative and juridical efforts that have been made in the region to include crimes against women as a specific category under law. Concluding this examination, she discloses, without meaning to, the mechanism that produces the blind spot in the law as well as its inherent inertia. Toledo Vásquez argues rightly that the efforts that have been made within national jurisdictions – which form the indispensable basis for the recognition of femicide in international criminal law – come up against a limit because of the imprecision of the definitions of *femicide* with which they work, an imprecision that gives rise to normative indeterminacy (2009: 143). She also explains, referring to international law, that none of its three great categories – crimes of genocide, crimes against humanity, and war crimes – are adequate for understanding the crime of *femicide.*

In the case of genocide, this is because women are not among the groups – national, ethnic, racial, or religious – enshrined in the 1948 Convention or in the Rome Statute that reconfirmed it (Toledo Vásquez 2009: 50). Some countries have expanded this definition to include "political groups or other groups with their own identities,"

and the case of Uruguay is noteworthy in this connection. That country's Law 18.026, a 2006 law mandating cooperation with the International Criminal Court on matters related to the struggle against genocide and crimes against humanity, defines genocide, in its Article 16, as an act motivated by "the intention to destroy, in whole or in part, a national, ethnic, racial, religious, political group or trade union, or a group with its own identity founded for reasons of gender, sexual orientation, culture, society, age, disability, or health" (Toledo Vásquez 2009: 51). Toledo Vásquez notes, however, that the subjective dimension will always be problematic; in other words, "managing to show the intent to destroy in whole or in part a specific group." She concludes that genocide cannot include the crime of femicide.

When Toledo Vásquez turns to crimes against humanity, her conclusion is no different. She argues that acts of aggression against women committed "in the private or intimate realm" impede efforts to prove that a more general or systematic intention to attack is at work. She does refer, in this connection, to the argument I developed in *La escritura en el cuerpo de las mujeres asesinadas en Ciudad Juárez* (The Writing on the Bodies of Murdered Women in Ciudad Juárez; Segato 2006b, and republished as chapter 1 above), and to Julia Estela Monárrez Fragoso's argument (2006), describing both arguments in detail in the conceptual chapter of her report. However, she does not productively set either analysis to work, because she remains sequestered within the positivism of the already-enshrined legal lexicon. She is thus prevented from developing a broader and more open worldview, an understanding of the pressures of the present. The same thing happens when Toledo Vásquez refers to war crimes and the possibility of recognizing the category of femicides in international human rights law, because she ignores the characterizations of the new theater of war, the accounts of a new kind of war, that those of us who work on Central America and Mexico have offered. She thus misses an opportunity to promote the elaboration of creative concepts of the kind that have become necessary today.

The conceptual weakness that results from Toledo Vásquez's commitment to positivism can be seen in the concluding synthesis that she offers to explain the impossibilities that she has identified:

> Many of the models I have analyzed are inadequate from the point of view of criminal law because their categories are marked by various kinds of indeterminacy or imprecision, and these can weaken the

guarantees of law and accountability. This happens, on the one hand, because of a tendency to transpose sociological or anthropological concepts to the field of criminal law when these concepts lack the precision that constitutional law demands. On the other hand, there is a tendency to use expressions that are not entirely clear or precise in their content. In this connection, we must bear in mind that – given the legal academy's widespread resistance to recognizing these crimes – the standards used in these laws are much more demanding than those used in other regulations, as in the case of Costa Rica. This means that extreme caution is advisable. Any indeterminacy or vagueness in the law carries not only the risk of constitutional challenges but also the risk that the new rules will be inapplicable in practice. (Toledo Vásquez 2009: 143)

Here we go. If the law cannot account for complexities and changes in human action and is not able to avail itself of the contributions of anthropology and sociology in formulating laws and guarantees of protection, it should give up its own normative pretenses and reinvent itself as a system. It is because of this positivist weakness that, today, researchers working on problems related to public safety have sent us in the direction of struggles for juridical pluralism and for the rights of indigenous communities, which demonstrate the flexibility necessary for studying human actions in the variable contexts of their social matrices. If the focus on technicalities and the categorical purism that govern legal media foreclose the possibility of capturing the dynamism of history and the resulting mutability of the causes of suffering, the law should declare itself incapable of speaking to people's interests, to *our* interests. One cannot argue for the impossibility of creating something on the grounds that it has not yet been created. To point to the non-existence of this or that thing as proof that it cannot be created is to engage in circular and false reasoning.

Meanwhile, the staggering increase in acts of lethal cruelty against women's bodies continues apace. We are horrified when we speak about the era of witch trials and the tortures of the Inquisition, and we forget that humanity today bears witness to a moment of bleak innovations in the forms of ruthless destruction of feminine and feminized bodies, a ruthlessness that is expanding and uncontained.

The predatory occupation of feminine or feminized bodies is practiced now like never before. These bodies constituted, in the history of the human species and in the collective imaginary, throughout this history, not only the first colony but also, in fact,

the last. And the colonization of these bodies that takes place today, in this apocalyptic phase of humanity, exploits them to the point of leaving only remainders behind. I have argued not only for the importance, even the necessity, but also the possibility of categorizing the killings of women *as* women (Segato 2007g), calling on feminists to continue to engage in an urgent debate so that we can arrive at definitions and strategies. On the one hand, as I have been arguing, the position that emphasizes the difficulty of legally recognizing femicide seems to me to be unacceptable. On the other hand, Toledo Vásquez's claim that there are imprecisions and ambiguities associated with the indiscriminate use of the category does strike me as warranted.

Let me recall here that, after a period of initial invisibility and as a result of pressure from human rights organizations, the sexual violence and rape committed as part of the occupation, extermination, or subjection of one people by another were gradually incorporated as crimes against humanity ("rape and other inhuman acts") into international law, first in the statute for the International Criminal Tribunal for the Former Yugoslavia, then in the statute for the International Criminal Tribunal for Rwanda. They also went on to be considered war crimes, forms of humiliating or degrading treatment ("outrages against personal dignity, in particular humiliating and degrading treatment, enforced prostitution and any form of indecent assault"). Rhonda Copelon summarizes these advances as they appeared in the judgment against Jean Paul Akayesu, who led a Hutu offensive against the Tutsi in the Taba Commune during the war in Rwanda:

> Akayesu was a landmark: the first international conviction for genocide, the first judgment to recognize rape and sexual violence as constitutive acts of genocide, and the first to advance a broad definition of rape as a physical invasion of a sexual nature, freeing it from mechanical descriptions and required penetration of the vagina by the penis. The judgment also held that forced nudity is a form of inhumane treatment, and it recognized that rape is a form of torture and noted the failure to charge it as such under the rubric of war crimes.
>
> With respect to the issue of rape and sexual violence as genocide, the Akayesu judgment is important because it explains why rape and sexual violence "constitute genocide in the same way as any other act as long as they were committed with the specific intent to destroy, in whole or in part, a particular group, targeted as

such." The judgment emphasizes the ethnic targeting produced by the sexualized representation of ethnic identity, such as Akayesu's statement "let us now see what the vagina of a Tutsi woman tastes like," and parenthetically notes here the notion of women as booty as itself an instrument of genocide. The judgment characterizes these crimes as infliction upon women of serious bodily and mental harm, as they were charged, and also as an "integral part of the process of destruction." (Copelon 2000: 227)

As I noted in chapter 2, the International Criminal Tribunal for the Former Yugoslavia treated "rape as torture," and "enslavement and other forms of sexual violence, such as forced nudity and sexual entertainment" were considered "inhumane treatment" (Copelon 2000: 230). This was also how a range of sexual crimes were classified in the Rome Statute, which governs the proceedings of the International Criminal Court.[1]

But this important process of inscribing sexual violence into the legal and forensic framework of international law still refers to what I have been calling the occupation of women's bodies in situations of confrontation and domination, that is, where one people or faction confronts or dominates another. It does not yet address women's direct extermination as a gendered group. In other words, the crime of femicide is still not fully at the center of these concepts, which neither consider nor name femicide specifically. We must now attempt to develop a working definition of femicide at two levels: the national level of rights adjudicated in state jurisdictions; and the international level of human rights, which is also the level at which genocide and crimes against humanity are adjudicated. Indeed, the forensic guidelines laid out in both the Minnesota Protocol of 1991 and the Istanbul Protocol of 1999 regard sexual crimes committed under conditions of war as torture.[2] The protocols thus make a positive contribution to the effort to deprivatize this kind of sexual aggression. But they still consider women as part of the set of casualties in war. In the effort to write the category of femicide into law, what we are dealing with is an effort to approach gender as the focus and aim of femicidal aggression and of femigenocide.

We must therefore work not only to write the term *femicide* into the powerful discourse of law, lending it symbolic and performative efficacy, but also to derive other practical advantages from this efficacy. Some specific laws will require the establishment of rigorous and detailed protocols for forensic judgments made by police and

medico-legal experts. These should be both adequate and efficient for the investigation of a range of crimes against women, committed in all kinds of situations, even in those that aren't currently understood as situations of war or internal conflict. As we know from the experience of Ciudad Juárez, it is crucial that forms are prepared appropriately, so that they can guide police investigations and help to reduce impunity.

In the present, various kinds of violence against women are conflated and not recognized in their specificity by criminal investigators, who therefore miss a great deal of the information that is indispensable for categorizing cases and for working toward their resolution accordingly.[3]

Moreover, it is worth underscoring that common sense and the discourse of the authorities seek to ensure that all kinds of crimes remain relegated to the private realm, despite the serious indications I noted earlier that gender crimes should be deprivatized.

Regrettably, the condemnations like the one made by the Inter-American Court of Human Rights in November 2009, when it found the Mexican state to be in violation of human rights obligations in the case of three women who were raped and murdered,[4] "has not led the court to recognize the term *femicide.*" The presiding judge in this case, Cecilia Medina Quiroga, said in an interview with Mariana Carvajal (published in *Página 12* on December 21, 2009) that this was "the first verdict (by this court) in a case involving the killing of women for reasons of gender" and the first in which "the state had responsibility," despite the fact that it could not be proven that the crimes were committed by state agents. Nevertheless, she added, "it was difficult for the Court to accept this word [femicide] because in the academy and in activism it has many definitions, and so it would not be right to adhere to only one of these." Here we see the consequences of the imprecision in the naming of a concept and its normative indeterminacy. Again, we see here the relation between naming and law as well as the impact of naming on the law's efficacy.

The Conditions for Writing Femicide into State Law and Femigenocide into Human Rights Law

Two aspects of this effort to write femicide into the lexicon of the law are especially important, I think. The first is the necessity and

the possibility of identifying the generic, structural, and systematic nature of these crimes; the second, related aspect has to do with the task of redefining war given the new contexts of war that are proliferating in the contemporary world.

The first of these efforts is a response to the demand for systematicity, the demand that crimes be generic if they are to be recognized in international criminal law. Hence the need to grasp the concept of femicide as "a set of violent practices aimed specifically at the elimination of women as women." This will only be possible, as I have argued earlier (Segato 2006b, republished as chapter 1 above; 2007g), if (1) we are capable of understanding the fact that, although the means by which these acts are committed are sexual, *their purpose is not sexual* in nature but rather a matter of extermination, of the elimination of a category or genus of persons. We must also (2) demonstrate that their basis is "impersonal"; that is, we have to clearly characterize their subjective dimension as a matter of *generic, not personal, intention. This is true both of their relation to the aggressor's motives and when it comes to the relation between the aggressor and the victim.* Demonstrating the "impersonality" of these acts means developing a rhetorical strategy that will convince judges, prosecutors, and the public that femicides are crimes against a genus.

A problem presents itself here, giving rise to muted debates within the ranks of feminists: Should we include within the category all killings of women, whether they are domestic, committed by serial killers, or the kinds of killings that I have called "public"? Or should we reserve *femicide* for those acts of killing that are specifically public, so that the term can be efficient? Of course, it could be argued that any and every gender crime has an impersonal dimension and is a matter of generic antagonism, produced by the structure of hierarchical and patriarchal power. This structure, which we call the "the structure of relations of gender," is itself generative of violence and potentially genocidal by virtue of the fact that the masculine position within the hierarchy can only be reached – can only be acquired as a status – and reproduced as such through the exercise of one or more of several powers, that is, forms of domination: sexual, military, intellectual, political, economic, and moral. This makes masculinity as an attribute something that must be proven and reaffirmed repeatedly. The imperative to reaffirm this position of domination arises whenever it is threatened with behavior that might undermine it. Individual emotional response is

suspended, as is the particular feeling that can exist in a personal I–you relation between a woman and a man who share an "amorous" bond. Even in the domestic realm, recourse to aggression already implies the suspension of any personal bond or attachment. All such attachments give way to the irruption of the generic and impersonal structure of gender, with its mandate of domination. This is what makes me doubt, with Catharine MacKinnon (1993), whether there is such a thing as "peacetime" at all where gender is concerned.

Today, everyday people and the media in Latin America use the terms *femicide* and *feminicide* with some frequency, more or less interchangeably.[5] This use perhaps attests to a gradual understanding of the generic character of crimes against women, but the terms are also used to refer to the killings of women because of their gender in the intimate sphere of interpersonal relations. Common sense has not yet assimilated or understood the distinction between these two terms, a distinction introduced by the Costa Rican researcher Ana Carcedo, whose use of the terms is different from Mexican scholar Marcela Lagarde's. The problem is that if, on one hand, the terms help audiences to perceive the frequency of misogynist crimes, on the other, they reinforce the privatization of gender and make it difficult to perceive the manifestations of this same violence in other, public contexts. But it is precisely the perception of this gender violence in other scenes – in public and in scenes of war – that should prompt us to transform the social imagination, guiding people toward an understanding of gender not as a particular issue, deprived of human significance, but rather as public, political, and general in its import for the history of collectivities.

On the other hand, until the patriarchal prehistory of humanity gives way to a new era or a collective epiphany marks the beginning of one, and unless we develop a previously unknown rhetorical capacity, it will be difficult for people to accept that these crimes have the impact and enormity of a genocide. This will be difficult to accept, in other words, as long as we continue along the path of privatizing the concept of femicide. Our imaginary has been shaped by the perverse notion that the public and the private are hierarchically opposed, and only the former is of general interest, while the latter is a place of partiality, of particularity, a veritable remainder. If we take the opposite approach, we can show that there are gender crimes that take place fully within the public realm, in the context of war. This will allow us to redirect the collective gaze and place gender relations on a plane of general importance and

universalizable value. This is a strategic consideration, almost a didactic one, and it leads to the formulation of a counter-rhetoric that can make up for and reverse the privatizing project of patriarchal common sense.

The oppositions between the public and private, the universal and the particular, are perverse and nefarious. They hamper efforts to prove acts of gender aggression and impede the recognition of these acts by the public and the law. Two examples, very different from one another, can serve to demonstrate their negative impact. The first example is the recent setback suffered when the Superior Court of Justice in Brazil ruled on appeal that, in the María da Penha Law against domestic violence, such violence – crimes against women committed in the domestic sphere and involving bodily injury that is considered minor – should be understood as a crime of a public rather than private nature but that the adjudication of these crimes was *conditional*, that it required representation (where "representation" refers to the representation of the injured party or victim, who can withdraw her complaint in public hearings and is not infrequently induced to do so by the judge). In fact, domestic violence should be considered public action *unconditionally*; that is, it should be regarded as unavoidably within the state's purview.[6] This was what the 2006 law sought to establish and in fact was its most significant advance in legal efficacy. The other example comes from Natalia Cabanillas's interesting thesis on women's testimonies before the Truth and Reconciliation Commission in post-apartheid South Africa (Cabanillas 2009a). Here she shows that, despite the fact that women offered between 53% and 60% of the testimonies, they felt displaced from the center of the national narrative, relegated to the position of victims and made peripheral in this story precisely because their experiences were privatized and sexualized. They were, according to Cabanillas, displaced from a political to a private plane even while they demanded the position of fully political actors. (Cabanillas 2009a). It is worth considering a passage from a text sent to me by the author:

When the Truth and Reconciliation Commission held hearings for women in a separate, "special," "protected" space so that women could "speak in their defense" ("Final Report", vol. *5, Special Hearings*, 1998), this had a particular gendering effect: a sexualization of violence against women came to predominate. It was thought that women must necessarily have suffered more sexual

violence then men, and that because this type of violence was "the most traumatic," it was necessary above all to encourage women to make these kinds of declarations before the Commission. Other forms of violence against women were thus disregarded or treated as less important, ... and the focus was on rape and genital torture. (Cabanillas 2009b)

I do not have space here to pursue this analysis to its ultimate conclusions, but we should understand that rape privatizes the experience of violence, and the politicization of rape requires deprivatizing feminine experience in general. However, we must also understand that mere voluntarism does not suffice to win the argument, because the goal of universalizing gender aggression will be attainable if and only if a shift takes place in the tectonic plates that sustain the collective imagination. For this reason and to this end, it is crucially important to insist unceasingly that rape, especially in the context of war, is not sexual violence but *violence by sexual means*.

I could give a third example, particularly pertinent to the problem that I am considering: the domesticating and privatizing pressure brought to bear on acts of gender aggression. I am referring to Judge Cecilia Medina Quiroga's vote in the case before the Inter-American Court of Human Rights, about which she said: "I do not agree with the fact that the Court did not classify the acts perpetrated against the victims as torture. . . . The state's description of the corpses ... these events should be considered acts of torture." The judge wrote a separate, concurring opinion taking issue with the Court's omission of the term "torture," engaging in rigorous technical and legal argument anchored in international human rights law. Given the argument that I have been developing here, it is enough to underscore the silencing, that is, the gap in naming, that again leads these crimes to be relegated to the sexual realm and hence the private and domestic sphere, where the victims' bodies are treated. We still need a term to decisively move these victims into the public realm, the space of the universally relevant. "Torture" is such a term, even when the torture in question is sexual.

As I have noted in chapters 1 and 2, it can be argued without exaggeration that, in the paradigmatic case of Ciudad Juárez, what I have described as a *will to indistinction* is at work, that it prevails among the authorities and the media, who repeatedly point to "a crime with a sexual motive," and say, "It is difficult to curb sexual crimes." Again, they interpret the evidence in a confused manner

and disorient the public with a mistaken reasoning. Here I would add a second interpretive dimension to the notion of a *will to indistinction*. This is not the purely practical problem of mishandling the protocols of police and forensic investigation. This second aspect refers to the strategy of obstruction deployed by local powers who discursively promote, in the collective imagination, what I have described as the *privatization* of all crimes involving sexual abuse as a tool of aggression.

Returning, then, to my analysis of the conditions of possibility for the creation of a legal category that could name the killings of women as women, I note that, even if we persist in thinking that it is worth including in the set of crimes called femicides both those that are impersonal and those committed in domestic contexts – and even if we prove that the latter are also generalizable and fall within public jurisdiction – we will still have to request clear and *radically differentiated* protocols to encourage more investigative efficacy and allow for the collection of information on perpetrators, including those with personal motives and those we could call femigenocidaires, who act in impersonal contexts. These kinds of violence are structurally different, and their workings can only be studied through the use of specific investigative strategies. Only their clear separation in protocols for police investigation will guarantee *due diligence* of the kind required by international human rights law. For this reason, it seems to me to be more effective to highlight some traits of the crime of femicide, to make it recognizable as femigenocide even within the patriarchal common sense of judges, prosecutors, and the public, and to make it legible as a generic, systemic, impersonal type of crime, not an intimate one.

Without this classification and the adoption of protocols for forensic investigation of femicide, we will continue to go around in circles, because forensic techniques will not be able to determine whether a crime constitutes a femicide or not; there will be no established guidelines for making this determination, and no forms or questionnaires with pertinent questions will allow for the classification of the crime.

The second thing to bear in mind are the transformations in the theater of war in the contemporary world. A more precise definition of the category of femicide as a specific type of crime against women allows us to see changes in the waging of war, where the consequences of these changes are evident on women's bodies, in the types of violence perpetrated against them. It is therefore essential that

we understand and adequately represent the historical ruptures that have occurred within the field of war.

These new forms of war are in their third or fourth generation and are often described as unconventional or informal. They are promoted by organized crime, repressive wars, and so-called "internal wars" or "armed conflicts" within countries. Those responsible for them are corporations, and their perpetrators are the armed members of these corporations, obeying their orders. International law will have to address the kinds of war crimes that this new kind of military confrontation is producing, especially the systematic attacks on women's bodies that occur in jurisdictions in dispute. As I have indicated, what takes place in this kind of context is no longer the annexation and occupation of women's bodies in the territory that has been seized. It is their torture and destruction. We need to remember and to note repeatedly that these are not sexually motivated crimes, as the media and the authorities insist in order to render them banal. They are instead war crimes, where "war" urgently needs to be redefined.

A final consideration, related to another type of extermination, should be added to this discussion of the category of femigenocide because of its impersonality and the levels of lethality associated with it, aimed as it is against women as a genus, though not in the context of war. I am referring to what I would call *nutritional violence* as a modality of gender violence in a double sense, material and symbolic. This violence is material because it materially affects women when it privileges the sustenance of fathers and male children within a family, and it is symbolic because feeding the male members of a domestic group is a way of expressing the greater social value of these members. This message – that women are undervalued – is understood by women and girls from a very young age. Their systematic undernourishment results in malnutrition, and in situations of scarcity it can cause death. The Nobel Prize-winning economist Amartya Sen published a calculation in 1990 according to which 100 million women were missing from Asia on account of discrimination and the various forms of aggression that derive from it, including the abortion and abandonment of daughters and malnutrition (Sen 1990). This genocide of women is systematic and impersonal. Ayaan Hirsi Ali, commenting on the figures that appeared in a report published by the Geneva Centre for the Democratic Control of Armed Forces in March 2004, has compared global violence against women to the Holocaust: "Between 113

and 200 million women around the world are demographically 'missing'" (Hirsi Ali 2006).

We still have to determine with care whether we should include the forced trafficking of women within the category of femigenocide, because in many cases this trafficking entails depriving women of their freedom, mistreatment, forced displacement, and forms of poisoning through the use of chemical substances that result in severe physical impairment or the death of victims.

In conclusion, I would argue that the category of femicide – as long as it is duly defined and the subcategories that make it up are identified – can be used within the field of state law to encompass all crimes committed at the border of gender, including those that occur in interpersonal contexts as well as those perpetrated by agents whose motives are personal. On the other hand, it is necessary to show that femicide is also femigenocide, that it should be included in the international laws that deal with crimes against humanity and genocide. To this end, we must study crimes of an impersonal nature, those that cannot be personalized either in relational terms or in terms of the perpetrator's motives.

We should recognize in the increasing frequency with which women in Latin America use the term *femicide* in the media and in everyday language, the spontaneous pressure that they bring to bear, the pressure to write this category into law. This is also a struggle to enter the public record, to be recognized as a community of interests that is expressing itself in this demand. The ever more frequent use of the term suggests that it must be defined with precision and written into the law in a way that recognizes its peculiarity and novelty so that the discourse of law can begin to address the casualties collectively imposed on women and work toward the formulation of effective investigative protocols. The Ley Especial Integral para una Vida Libre de Violencia para las Mujeres (Special Integral Law for a Life for Women Free from Violence), approved in November 2010 by the Legislative Assembly of El Salvador, the most recent rule of its kind formulated in Latin America, shows, in its Article 45, these advances, defining femicide as "The death of a woman motivated by hate or disrespect for her condition as a woman." And a list of behaviors that constitute proof of motives of hate or disrespect is appended:

> If the death was preceded by any incident of violence committed by the perpetrator against the woman, independent of whether it was

denounced by the victim or not; if the perpetrator sought to exploit any condition of risk to the victim or her physical vulnerability; if the perpetrator sought to exploit his superiority as the product of unequal relations of power based on gender; if before the woman's death the perpetrator committed any act that would qualify as a crime against the victim's sexual freedom; death preceded or caused by mutilation.

The renewed effort of classification to which the new law in El Salvador attests is of great value, as are other aspects of the law, which is worth studying carefully.

The term *femigenocide*, then, would be reserved for crimes that, by virtue of their systematic and impersonal nature, have as their specific aim the destruction of women (or feminized men) only because they are women (or feminized men). Here, as I have indicated, there is no possibility of personalizing or individualizing, either at the level of the perpetrator's motive or at the level of his relation to the victim. Another characteristic can be added to this one, namely that *the multiplicity of victims is related to the number of those responsible*. Femicides of an impersonal nature, which I am calling femigenocides, are systematic and repetitive in a way that points to shared norms of the armed faction that perpetrates them; this distinguishes them from crimes that occur in interpersonal contexts and have subjective motives, as in the case of serial killing.

In this way, I would assign the category of femicide to all misogynist crimes that victimize women, both in the context of interpersonal gender relations and in impersonal contexts. And I add the particle -gen- (from the Latin "*genus*," meaning "sort" or "kind") to name those femicides that are lethally aimed women as a genus, and carried out under impersonal conditions.

As I have argued, all violence against women is domesticated and confined – relegated to the domestic, private realm – by the collective imagination. On the one hand, categorizing all killings of women for reasons related to gender as femicides or feminicides is interesting because it points to the numerical volume of these violent deaths as a set. On the other hand, emphasizing that there is a type of murder directed against women and committed with increasing frequency in contexts characterized by their impersonality allows us, by means of rhetoric, to introduce into patriarchal common sense the idea that feminine experience is public. It lets us prove that our victimization is a problem of general interest. This

can contribute to the effort to redirect the public gaze, so that the public will get used to seeing crimes against women as a general problem, a problem for everyone. By making visible how this kind of aggression is a form of extermination that operates impersonally, translating this view into the language of international human rights law, we would be putting pressure on the collective imagination, compelling it to deprivatize the role of women and the feminine, undoing their domestication by power.

6

Five Feminist Debates

Arguments for a Dissenting Reflection on Violence Against Women

In 2003, I published *Las estructuras elementales de la violencia* (The Elementary Structures of Violence; Segato 2003a), a book in which I presented gender violence in a universalist way, or, rather, in a way that sought out the most enduring aspects of the structure of gender. In that book, I argued that gender has a history that is as long as that of the species; this history moves very slowly, much more slowly than the history of attitudes or ideas. This is an almost crystallized history; it appears to be a natural history. This is why it is so difficult to change gender oppression. I have not stopped believing in the truth of this argument, but as time has passed I have managed to historicize gender and to introduce a radical inflection point into this history.

That the history of gender moves slowly is something that we can see in the present. Despite struggles, laws, public policies, and institutions, the lethality of gender has only increased. This implies not only an increase in the number of gender crimes, but also an increase in the cruelty that they involve. Something similar happens in the case of non-lethal violence against women: we cannot put the brakes on it. Many of those who oppose our struggles argue that the past cannot be compared with the present, because today women file many more complaints. But in the realm of lethal violence today, when there is a body, when there is a death, we can be fairly sure not only that that corpse in question is one of many, but that the numbers of these corpses

continue to increase as a percentage of the total population. In Brazil, in 2012, a woman was killed every two hours. This rate, considered in terms of Brazil's total population, was already very high, but the next year a woman was killed in Brazil every hour and a half. We have seen something similar in Central America in recent years. When it comes to non-lethal violence, we can indeed accept the optimistic argument that there are more complaints filed today, more charges of rape and domestic violence filed. But this is because in the past these forms of violence were understood in many places to be customary, and so women did not denounce them. Even so, it remains true that we have not managed to bring these acts of violence to a halt. The imaginary of gender that sustains them – and serves as their breeding ground – remains intact. There is no sign that these other kinds of non-lethal violence are being curbed by laws, or rather by our struggles fought at the level of the state.

Thus gender is a kind of crystal. It's very difficult to break and seems to be outside time. One of the challenges I face as someone who has thought about gender for a long time is locating the history within it. Because it is one thing to argue that gender isn't natural but rather cultural and fully historical, but it is another thing to locate history within gender. This is a very different task, and it has not been easy, at least for me.

What follows is a set of fragmentary notes on my efforts to this end, notes that I have been collecting for the last decade or more, since the publication of my book on violence. And because I believe that one thinks better in and through polemic, I present these notes in the form of a list of five points of divergence that I have encountered since 2003, five disagreements that I have had with feminists while presenting my ideas to diverse audiences and participating in various forums for debate. Disagreements summon us, stimulate thought, make us think more: hence their utility.

I will present these five disagreements in chronological order, as they arose in my thought. Recently, I have realized that they all belong to the same sphere, to the same universe of questions, and in fact I think they are all profoundly related, all part of a single, indivisible argument. I have not arrived at the end of these reflections, which I do not present here in a conclusive form. But I sense that behind these disagreements there is a single structure that gathers together two opposed positions.

Femicide and Femigenocide

The first disagreement, and possibly the most familiar to those who have read my analyses, is the one I came to when I confronted the reality of Ciudad Juárez. I arrived there after receiving an invitation from several organizations in the city, because the model of the masculine mandate that I had presented in *Las estructuras elementales de la violencia* fit them like a glove, contributing to their efforts to understand the crimes against women happening there. As I have already indicated, *Las estructuras* is a universalist book that speaks of a very long history and locates tribal societies, on the one hand, and modern and contemporary societies, on the other, on the same plane, considering them in a similar fashion. In the book, I argue, among other things, that women's bodies are the first colonies, that the first colony in the history of humanity was a woman's body. Above all, though, the book is about masculinity, and about the masculine mandate, the masculine fraternity, the brotherhood of men understood as an organization sealed by a pact that requires sacrificial victims. Women play a fundamental role here because of the place they are assigned. My conclusion is that this masculine pact already in and of itself has the structure of a mafia pact, an oath of loyalty to the club, to the brotherhood, to the fraternity.

In Ciudad Juárez, I found that what I called, in my essay *La escritura en el cuerpo de las mujeres asesinadas en Ciudad Juárez* (The Writing on the Bodies of Murdered Women in Ciudad Juárez; Segato 2006b and republished as chapter 1 above), a "will to indistinction" was at work in the media and among authorities, prosecutors, the police, and forensic investigators. The discourse in which the crimes and the corpses were discussed had this characteristic. In the news, updates on the finding of bodies abound. Women killed by jealous husbands, debts owed to drug dealers, mass graves, and the corpses of murdered women that were emblematic of Ciudad Juárez: these were all presented in the same way, all mixed together. At night all cats are gray.

At the event in which I participated in Ciudad Juárez, the group was divided between those who spoke of the victimization of women as a single phenomenon and another, small, minoritarian group in which I took part. We began to speak of the need to classify the crimes, though not in the sense in which "classifying" is normally understood. Most people understand "classification" as a matter

of writing into law the categories of femicide and crimes motivated by gender. In this case, in the minoritarian group, we were saying that it was necessary to distinguish between two kinds, two types of motives, two contexts that produce feminine victimization. All crimes against women are contained within the vast symbolic system that is gender, within the structure of patriarchy. All of these crimes are subtended by the underground schema of gender. But the case of Juárez makes it clear that we have to understand some killings of women in their particularity. Why? Because if we do not, then we cannot investigate these killings. The task becomes impossible.

This is what I understood and what I have argued in various texts, including, for example, "Femi-geno-cidio como crimen en el fuero internacional de los derechos humanos: el derecho a nombrar el sufrimiento en el derecho" (Femigenocide as a Crime Under Human Rights Law: The Right to Name Suffering in Law; Segato 2011b, republished as chapter 5 above) and another, shorter text, "Femigenocidio y feminicidio: una propuesta de tipificación" (Femigenocide and Femicide: A Proposal for Categorization; Segato 2012). My claim is that if we do not have specific protocols, we cannot investigate crimes like those that were made visible in Ciudad Juárez, whether they occur there or in other places. We cannot investigate all of these crimes using the same forensic methods; nor can judges rule on them using the same frameworks for understanding. This would mean, for instance, treating them the way one treats a husband who kills his wife, a femicide that occurs in domestic space or in the realm of interpersonal relations. This argument has not yet registered for many in the feminist movement. I have read various theses on femicide and have even been asked to serve as an examiner for some that do not grasp this conceptual difference.

We do not have protocols for dealing with crimes against women that are not committed in the space of relations, where there is no interpersonal relationship of any kind in play. The same is true of cases where it is impossible to refer to individual motives, including serial killings, for example. And we see this in police bulletins and forensic forms. We must understand that there are women who are not killed in the intimate sphere and whose cases therefore call for the use of different protocols. These cases come close to war crimes or paramilitary crimes, where so much depends on the victim's neighborhood or on her relationship to a given group, geographic space, or tribe (as in Africa, in the Congo). If we do not distinguish

between these kinds of crimes and others, they cannot be understood. No light can be shed on them, they cannot be investigated, and they cannot be adjudicated.

Consider, for example, the concurring opinion written by the Chilean judge Cecilia Medina Quiroga in the case of the crimes in Campo Algodonero in Ciudad Juárez.[1] Medina presided over the tribunal held by the Inter-American Court of Human Rights in Santiago de Chile in 2009, which did not agree to treat rape as a form of torture. Medina registered her dissent and defended her position that this was a matter of sexual torture. Why did the tribunal not adopt the same position? Because, they reasoned, torture is a crime of general interest, and rape is a particular crime, a crime against women. To frame the rapes committed in Campo Algodonero as sexual torture would be to place them on a universal plane. This is an enormous problem, one that has not been resolved, in my view. If we accept that rape is a form of torture, then what kind of torture is it? I agree with Medina's vote, and it is very interesting to me that she, as president of the court, was not able to impose her perspective or convince the court's other members that they were dealing with torture, a crime of general interest, a fully public crime.

This is the first disagreement. Despite the fact that all of the crimes emerge from the matrix of gender, from the underground structure of gender, today more and more women are dying in a realm that is fully public and that cannot be understood in terms of interpersonal relations and in crimes that do not have to do with personal motives. For reasons that we have yet to analyze, it has been very difficult for the feminist movement to understand this difference. But this understanding is indispensable in practice, because we need to be able to formulate protocols for investigation and specific forensic protocols. Legal and police protocols need to change so that they are tailored either to one kind of crime or to the other. In my work, I have argued that we should use the term *femicides* as a name for all crimes against women that are lethal in their aims, and that we should use *femigenocides* to refer to the subcategory of femicides that cannot be understood in terms of either personal motives or interpersonal relations. Here many problems arise. The most important of these is related to the political desirability of gathering all gender crimes into one category, because this results in numbers that are striking and that can catalyze response with their sheer enormity. Moreover, domestic crimes clearly make up a majority of cases. Another problem is that our mental frameworks tend to make

us privatize and domesticate everything that has to do with women, relegating their affairs to the sphere of intimacy. This has to do with modernity, which privatizes the feminine, the domestic.

But we should remember that, according to the United Nations, Latin America is the most violent continent in the world. When it comes to the lethality of criminal violence rather than war, it is even more violent than Africa. Latin America is home to the world's most violent city, San Pedro Sula, in Honduras. In this context, in Central America, crimes against women that are not domestic in nature are increasing far more quickly than domestic crimes. And in almost all of the countries in South America, which is somewhat calmer than Central America, with the exception of Brazil, which has crime rates that are equal to or greater than Mexico, we are also seeing increases in crimes that we do not have tools to understand, because we tend to privatize all of them.

To emphasize the need to categorize these kinds of crimes is not to deny the value of struggles in the field of the state or for the introduction of legal categories like femicide or feminicide into the frameworks of international organizations.

As discourses, these are very interesting, although I do not believe that they significantly affect judges' rulings. What they do manage to do is circulate words for people's suffering, building a rhetoric. Legal discourse thus gradually creates a way of speaking. This is the symbolic efficacy of the law, its performative efficacy. Legal terms are all the more powerful when they are used by people before they are used by judges.

The Victimization of Women in War

The second point of divergence, which I see with increasing clarity, is related to the first and has to do with the new forms of war. Although it concerns what is happening in Ciudad Juárez, it extends beyond the city as well. The heart of my observations in this connection is Guatemala. Already in Ciudad Juárez, I saw a context of war, but of a kind of war that had not yet been defined, one without the definitions that are so essential today for speaking about the new forms of war. I am referring to the vast parastate realm that is expanding in our countries and that takes various forms (Segato 2014b, republished as chapter 2 above). In the past, dictatorships acted with a great deal of parastate latitude. Today

mafias act in this way, too, and the state is redoubled; control and the exercise of organized violence also take various forms.

As part of this phenomenon, part of its doubling, the state shows us all the force that its second arm or wing commands. I am thinking of the work of scholars who have spoken of the state of exception, including Agamben (2005) and others. In the case of Germany, for example, the contemporary jurist Günther Jakobs has recently returned to a legal discourse associated with Carl Schmitt in order to argue that special laws for Arabs are necessary. Jakobs lives in Germany today, and still some of us believe that Europe is free of these kinds of ideas, with their echoes of Nazism. In the Nazi world, common laws remained the same, but special laws were created for Jews. "Normal" people – Germans who engaged in commercial transactions, married, or ran into conflicts of interest, and so forth – continued to rely on "common" legislation, but there was special legislation for Jews. In *El enemigo en el derecho penal* (The Enemy in Criminal Law), the Argentine jurist Eugenio Raúl Zaffaroni (2006) offers an excellent analysis and exegesis of Jakobs's thought.

The state always tends to duplicate itself, to double itself. When it needs to, it takes out its arm and produces a duplicate, and this happens almost everyday. Police officers act in a parastate fashion in any and every state, in any country in the world, because they are invested with judicial power, authorized to make judgments in the street. In England, for example, they killed a young Brazilian man, and the police were not deemed culpable, because the street is the police's jurisdiction.[2] Here they make judgments about whether there is danger, and they make these judgments alone. And if they determine that there is danger, they kill and cannot be judged themselves. This is the margin for parastate action that the state gives itself and that persists in all legitimate state violence, in any place in the world. This realm, which is always present in the structure of the "modern," "civic," "law-governed" state, which is always there, expands in some contexts, where this margin becomes wider than the legal order, the normal order, itself.

The always dual and duplicable nature of any and every state is a very important problem that I cannot treat exhaustively in this context. Despite it, we are moved by an intense and fervent faith in the state. We have faith in citizenship, although our reasons for holding onto this faith are never validated, never checked, never carefully examined. It is worth asking if this faith in the state that

so moves us – this faith that motivates our movements and all social movements – is warranted.

In Latin America, we see the expansion of a theater of war that has given rise to what some scholars call new forms of war, or new wars, or non-conventional forms of war. In the most violent countries, we also witness the broad expansion of the sphere that I have been calling the parastate. We are confronting, then, the spread of an informal war that first began to expand under the authoritarian governments and then persisted in the period of gangs, of *maras* and *pandillas* in Central America. There are sectors here that we could call armed corporations, and they organize, maintain, and control the circulation of wealth held by bosses. And this point, which is related to what I have suggested about the first disagreement, leads me to conclude that we need new definitions for understanding war.

In our world, there is a historical and personal nexus that connects those who were active in the armed groups that engaged in parastate, paramilitary repression during the era of state authoritarianisms and the members of today's mafias. Many of the people who were previously active in the state or acting on its behalf, as part of its second arm, went on to become members of private security forces or of criminal organizations. They went on to form the armed, criminal corporations that are active today. This relocation of human resources is evident in Argentina, but it is even more evident in El Salvador and Guatemala. In this way, the practices that were part of wars in the 1980s have become practices associated with gangs today. These are the practices of drug trafficking – or so they are called, although they involve more than drug trafficking.

The new forms of war are characterized by the extreme victimization of women. Two positions – two ways of understanding these forms of victimization – have emerged within feminism. Elizabeth Odio Benito (2001), a Costa Rican judge and first woman to serve on the International Criminal Court, wrote a beautiful essay on the history of war and women. Her perspective emphasizes continuity, although she does argue that forms of cruelty against women's bodies seem to have worsened since the wars in the former Yugoslavia, thus referring to a difference of degree. Other scholars, including Mary Kaldor (2012) and Herfried Münkler (from East Germany and the author of two studies that map out the new forms of war, focusing on the former Yugoslavia: Münkler 2003; 2005), concentrate on new aspects of these forms of cruelty against women's bodies. I see a striking coincidence between what

I have written about the Americas, especially Central America and Mexico, and these latter authors, who have written about Europe. In earlier wars, damage done to women's bodies was collateral to the war itself. Women were taken as booty in war, and when territory was annexed, women were annexed as forms of territory, both through insemination and when they were captured as concubines, sex slaves, and so on. These scholars say – as do I in my work on Central America – that war is fought today in and through the victimization of women. What had been collateral becomes central, becomes the very way of waging war. It is important to note that these authors are not feminists, although I am; they are specialists in the study of war. Kaldor argues that contemporary wars are waged through profanation – including, among other things, the profanation of mosques. This could also be a characterization of the destruction of archeological Buddhas and colossal stone sculptures in Afghanistan. Women's bodies are profaned in a comparable way. And along similar lines, Münkler argues that a form of destruction without genocide involves attacking communal ties by attacking the bodies of women, profaning the women. This is the very way war is fought today. In Guatemala, this can be seen clearly, because it is even included in the manuals, among the instructions for waging war.

Here I introduce a second disagreement that I want to address. Part of the feminist movement – following the especially influential work of Catharine MacKinnon (1993) – speaks of continuity between crimes of war and crimes of peace, arguing that there is no peace in relations of gender, that there is no peacetime for gender. This group of women argues that the practice of rape in contemporary wars, in the new forms of war, is a continuation and expansion of women's domestic experience, of what takes place in the home. In the case of Guatemala, for example, according to an underground discourse, the problem with Maya homes is that the men who live in them are uncivilized and beat their wives, that theirs is an explicitly hierarchical world without the civic norms that govern gender relations in our world. But I wonder whether these norms exist for us. When war came to Guatemala, then, according to these feminists, an already violent tendency spread and came to victimize women. This victimization was a continuation of what happened in the space of the home.

But the authors I have been citing, and especially Münkler, argue that even in societies where rape was not a regular practice but

rather one that happened rarely, its use entered military manuals and became part of training for war. In Guatemala, this is perfectly clear. We could say, then, that in Guatemalan homes, there was a gender hierarchy; women and men did not have the same value; a hierarchy of prestige was in place, one based on the sexual division of labor, social roles, and so forth. We can note the presence here of everything we criticize in tribal societies. But, as in the Arab world, there was no rape.

This is why it is so important to walk a fine line. The tendency to ignore differences in various forms of gender violence, the practice of conflating them all, can lead us in circles and prevent us from finding the exit from our problems that we seek. Both in the world of Eastern Europe, which these scholars analyze, and in our Central American, South American, Our American world,[3] war has come to involve the sexual torture of women, and their torture unto death, as a strategy. This happens both in wars of repression and in those of the kind that we see in Ciudad Juárez, gang wars that take place in the expanded paramilitary, parastate sphere. Rather than an expansion or movement outward from the home into the theater of war, what we find are men returning home from war and this return's leading to an exacerbation of domestic violence. This happens because of the existence of the war, which affects certain parts of the population more than others. In some countries, like Guatemala, Honduras, and El Salvador, it affects the entire population. Brazil could also be included in this set of countries, despite the peaceful façade. The numbers of victims of domestic violence and homicides per 100,000 residents are very high. They are numbers that suggest a country at war. So in some countries war is diffuse and affects life as a whole, becoming palpable for the whole population. In other countries, there are folds, pockets, or areas of enormous lethality. My position is not that in these areas the forms of war are continuous with domestic life. On the contrary: it is the form of war that brings about the focus on the destruction of women's bodies, which also destroys communal trust.

In this sense, I have been changing my position. Until fairly recently, I spoke of the destruction of women's bodies as a destruction of enemy morale. Today, after having worked in Guatemala for several months, I have changed this understanding somewhat. I now understand that this is a matter of destroying the ties of trust in the communal fabric. It is a way of waging war that returns to and enters domestic space. It is a way of sustaining

patriarchy in and through war. It is like a circle or a feedback loop, and I see a reversal at work in this sequence of events. War learns from patriarchal structures and makes use of them to dissolve communities and clear territories without genocide. This is what the work of authors who focus on Eastern Europe suggests: that these are techniques for clearing territories and bringing about the disintegration of a people without genocide. Women's bodies are the backbone, the center of gravity, the navel of the social body. In the manuals to which I referred earlier, there are even articles, guidelines that clearly discuss ways to reduce soldiers' reluctance to cause harm to women. Here a problem emerges, a question: Why attack women? This question had already arisen for me in Ciudad Juárez: Why women?

A woman is not a military enemy, not an enemy soldier, not an armed adversary or part of the enemy's troops. Men die much more often in homicides, but they also kill at the same rate; there is proportionality between the lethal violence that they exercise and the lethal violence they receive. Women, by contrast, are murdered many times more often than men and kill much less often. So, why do the new forms of war not simply involve the annexation and insemination of women, as did wars from the earliest wars in the tribal world of which we have evidence through the Second World War? Until this moment, there is clearly continuity, and women were not the targets of destruction. They were annexed, raped, kidnapped, taken as concubines or slaves, but these were byproducts of war. What happens after the wars in the former Yugoslavia and Rwanda, for example? What takes place in this phase of late modernity and late capitalism, such that women become the targets of war? In Rwanda and the former Yugoslavia, war was paramilitarized; there was a paramilitarization of war. Before, wars were fought between states, and they involved insignias, uniforms, and methods for raising troop morale. Everything was conventional; these were old-school wars. After the second half of the twentieth century, war was paramilitarized.

Today, war is technical. It involves professionals, social psychologists, neuro-engineers. Just as there is such a thing as neuro-linguistic programming, there is clearly neuro-military programming. These studies make up their own kind of engineering, a kind of social engineering that seeks to identify the center of gravity in a social fabric, a communal fabric, in order to destroy it in the most efficient, direct, and rapid way, without using too much ammunition. There

are studies that show that, by attacking women, the armed forces attack this center of gravity, laying waste to the social structure, which is destroyed. Feminists know that women play this role of propping up the world, of keeping it on its feet, reproducing it.

One piece of evidence that supports my argument is the content of Guatemala's military campaign plan).[4] These military manuals literally say that soldiers who do not habitually victimize women must be trained so that their threshold for engaging in this victimization is lowered, so that they too can victimize. This is very much like what happened in Argentina after a period when prostitution was prohibited in the 1940s. In the 1920s and 1930s, French and Jewish pimps brought prostitution – or what in the period was called "white slavery" – to Argentina and opened brothels that were later banned. At the end of this period, the brothels that opened legally were located close to military barracks. And this was required by law; it was the law and is written in documents from the period. More recently, there is evidence that something similar has happened in some places. For example, Comodoro Rivadavia is a city in Patagonia located on the Atlantic Coast, in a region in the south of Argentina that is the site of intensive oil extraction. These operations and other large infrastructure projects always bring with them brothels and human trafficking. Near Comodoro Rivadavia, in the mountains, there are indigenous or *mestizo* people who are still very close to indigenous Mapuche ways of life. There are also military barracks. Some researchers in this region argue that when soldiers are recruited from these communities, stationed in the barracks on the coast, where the oil fields and brothels are located, the first thing that they are made to do as part of their military training is visit the brothels. There are testimonies from these soldiers who recount that degrading women by sexual means was not something they did before, that these were learned behaviors. This does not mean that there were not gender hierarchies or forms of victimization in their communities. It means that not all forms of victimization are the same; they do not all have the same meaning or work in the same way.

The victimization of women, then, is part of military training, part of being trained for war. Here we can see the functional nature of sexual victimization, of cruelty against women's bodies in the context of war, where agreements among men have to be very firm and the dissolution of communal forms of life is vitally important. Because of the nexus of historical and personal relations

that I mentioned above, today organized crime still relies on the military strategies of the repressive parastate, including the strategies outlined in Guatemala's military manuals. This remains a military strategy in Latin American drug wars.

A classic case in Argentina is the murder of the young girl Candela Rodríguez,[5] which involved the actions of a corporation within a parastate sphere formed by police, carjackers, and drug traffickers. Another case that struck me when I was in Ciudad Juárez involved a very young boy whose case was much discussed shortly after Candela's. Both of these cases made me think that the same thing that happens to women can happen to children, because neither women nor children are soldiers. They are not the enemy, not the armed corporation's antagonists, not armed enemies. They die and are attacked in and through a form of expressive violence. I use this category throughout my book *Las estructuras elementales de la violencia* and even more so in chapter 1 above. This is a type of violence that is not used directly to defeat the enemy but rather to express the enemy's defeat, to symbolize his destitution, to indicate that the enemy force is no longer respectable, important, or powerful. The bodies of innocent people who are not enemy soldiers are attacked, killed, and destroyed. In this way, the message becomes independent, becomes a pure message. This is not just war; it is war in the symbolic field, specialized war.

To recapitulate, we can see how, in the case of the first disagreement described above, the majority of the feminist movement finds it necessary to gather all lethal crimes against women together. I think that we have to learn to think of femicides that are not particular, that are not committed by perpetrators with private motives but result from motives that are not private, not intimate. In the case of the second disagreement, there is a group within the feminist movement that thinks that in war, and especially in informal wars, domestic violence and violence in the theater of war are continuous with one another. Here I think there is discontinuity and that there are forms of violence in war, forms of cruelty against women, that are learned and that then reenter the domestic realm.

Unequal but Different

If we consider patriarchy to be the foundation of all expropriating violence, a structure whose history is nearly as ancient as the

history of the human species itself, then it seems almost natural. We should understand, however, that the structure has undergone modifications throughout history and that it is itself historical. Here I confront a third disagreement, the most difficult to explain because it is the least concrete and requires a bit more caution. What I would like to underscore is a third kind of discontinuity: the discontinuity within patriarchy itself, which changes after the process of conquest and colonization. I think I can prove that the structure of patriarchy undergoes a transformation, a shift such that it becomes modern patriarchy as we know it, and in my view this is patriarchy in its most lethal form (Segato 2015f/Eng.: Segato 2022).

My understanding of this problem is informed by ten years of collaboration with the Fundação Nacional do Índio (National Indian Foundation, or FUNAI), the state organ that handles indigenous affairs in Brazil. In 2002, two indigenous women appeared before the FUNAI to ask the foundation to develop policies on indigenous women, policies that until then had been non-existent. When Lula won the elections and assumed the presidency in January 2003, these women asked the president of the FUNAI to organize a major meeting and to bring a petition to Lula, who was then arriving at the Palacio do Planalto, in Brasília. I was invited to lead this workshop including forty-one indigenous women from all regions in Brazil. This workshop would then lead to a series of workshops, different from one another but ongoing for a ten-year period. These took place in all regions of the country, and they came to include "displaced" women, already living in cities, as well as women who still lived in their villages. (The use of "still" in that last sentence is part of the inheritance of an evolutionist way of thinking with which I have not managed to break.) They included women who spoke Portuguese fluently as well as those who spoke with strong accents or did not speak Portuguese but only their own languages. I joined this state action in the indigenous world, and in this way I was able to observe the advance of the front that I call the state-corporate-media-Christian front, still a patriarchal front and persistently colonial, into Brazil's interior. One thing I wondered at the time was what was happening to the men in these villages, or in what – using a Weberian typology – I call the "village-world." In the interior, among people whose communal and collectivist forms of life still exist – with their strategies for controlling the accumulation and concentration of wealth, their own technologies of sociability, and their own historical projects that diverge from the historical

project of capital – what was happening to gender? What happens when this well-intentioned state front – with its NGOs, its public policies, its schools, its clinics, its initiatives for indigenous women, and so forth – enters the world of the village? It turns out that what happens is that, together with all of this, violence increases. But why does this happen? It is a totally striking phenomenon to think about. Why do forms of aggression against indigenous women advance and increase with the arrival of the state front and its corporate, media, and Christian allies? This increase is demonstrable, a feature of reality. There is a woman whose husband cut off her arm with a machete, another who was disabled by the blows she received. These kinds of domestic violence, these forms of cruelty against women, of hatred of women, were not features of the previous communal structure. They have to do with how men were captured by the colonial world.

Here I am synthesizing a lot of material (e.g. from Segato 2015f/ Eng.: Segato 2022), compressing an analysis that should be much longer. A key question has to do with creolization. I am from Argentina, and for much of my life calling something "Creole" seemed to be saying something lovely. Today I believe that "Creole" is synonymous with "prejudiced," "homophobic," and "misogynist." Our Creole world is a world that is lethal for women. And this has to do with the colonial front. I am not the only one to argue this; French researchers in Africa have said the same thing. I observe it in our world. The man who fights a war against the colonizer is creolized, whether the colonizer is an overseas administrator or a republican colonizer, a state agent. It is all the same.

At the root of this observation is the recognition that they tricked us when they told us that our republics represented a decisive break, a real rupture, with the world of overseas administration. This is a myth. Or it's not even a myth; "myth" is too dignified a word to use here. It's a trick; we were tricked, because our republican states, our Creole governments, are mostly continuous with the colonial world, with overseas administration. They are much more continuous than they are discontinuous or the products of rupture. This can be seen in how states treat their interiors, the interiors of our nations.

The case of Uruguay is very interesting. In Argentina and Brazil, we are fascinated with Uruguay's great citizenry. But we are used to ignoring the fact that this country is built over an enormous mass grave. And the specters that are felt – these specters are always present. You cannot fully repress a population that has long

moved through a landscape, burying this whole population near the Salsipuedes Creek.[6] This cannot be done.

With the advance of the state front, a creolization of men takes place. They are the first to be captured, initially when they defend themselves militarily against conquest and then when they negotiate peace. Men are captured, kidnapped by white men, caught within their ways of seeing and their form of sexuality. The gaze and the meaning of accessing the flesh change completely. And the creolized man is profoundly transformed; he adapts, because he has to make a choice. He has to choose between his peer, his partner, his brother, the white man, on the one hand, and his wife, his children, and his home, on the other. The interpellation of white masculinity is very strong, especially because white masculinity vanquishes and emerges victorious. The creolized man thus surrenders, accepts the mandate of white sexuality and white power, and becomes a colonizer within his house.

This is my understanding of the history of colonization and conquest, but within feminism we can see three different positions, three different approaches to the problem. A first position, which we could characterize as Eurocentric for the sake of simplicity, says that gender is the same here and there, and if anything more oppressive in the world that is "peripheral" from the standpoint of Europe. At the other extreme, there is a group of scholars that includes the Argentine researcher María Lugones, who teaches in the United States. Although I disagree with her, I appreciate her essays and other texts. Drawing on ethnographic and historical evidence from a range of scholars, Lugones (2007) argues that in the precolonial world there is no such thing as gender. She is especially inspired by the work of the Nigerian author Oyèrónkẹ́ Oyěwùmí, who also teaches in the United States. Oyěwùmí (1997) notes that in the Yoruba world gender is a colonial invention of the British, that it did not exist before British colonialism. These two figures would thus represent the other extreme, at a far remove from Eurocentric feminism. My own position is between these two.

My argument is that in the precolonial world patriarchy did exist; there was indeed a gender hierarchy, and men and masculine tasks were more prestigious. There was also a certain violence in this world, because hierarchy is necessarily maintained and reproduced by violent means wherever it exists. But this patriarchy was – and is where it still exists, and it exists in many places, although often in decline – a *low-impact* or *low-intensity patriarchy*. Where

there is community, women are more protected. What occurs in the passage to modernity is the colonial capture of the non-white man and an abrupt decline in the value and politicality of domestic space. We can see this happen – it is almost literally visible – in some areas, some places.

In the communal world, there are two kinds of space. On the one hand, there is public space. Is it monopolized by men? Yes. Do they enjoy greater prestige? Yes. And can only men speak within this space? Yes, in many tribal societies this is the case. On the other hand, there is domestic space, which is less prestigious but political, endowed with its own politicality. This space is not intimate, not private. How, though, is this domestic space political? When the family is nuclearized – when domestic space comes to encapsulate a mother, a father, and children – it is also depoliticized. This can be seen in the indigenous world. Before, communities had domestic spaces that were full of dozens of people, seen by everyone. The notion of private life – the idea of a protected privacy, the value of the private, which is fully modern and fully individualist – did not exist. The intimate and the invisible did not exist. Such a vision of things did not exist. But this kind of collective eye was lost with the advent of the nuclear family. Modernization, individualism, and the nuclearization of the family – in all of these phenomena, we see an abrupt devalorization of the space of the particular, of domestic space, which becomes a space of intimacy and privacy. This is not what it had been.

Another very important difference is that public space in the communal world is not the platform for the delivery of statements that have universal value. There is no universality. The two are two, and this is a dual world, a world of duality. With the advent of modernity, this dual structure became a binary one. The dual and the binary are not the same thing; there are differences between them. Binary structure is the structure of the One. To speak politically, to produce a discourse with universal value and general interest, a discourse recognized as clearly political, it is necessary to speak in the public sphere. This sphere did not exist in the tribal world, because there was only public space, one of two kinds of space. Here, in the world of modernity, there is only one space of the One, one public sphere where speech can have political import for all people. Whoever wants to speak here has to adapt, to learn to behave, to hold his body in a certain way and to dress in a certain way. This claim might at first strike us as false, because women,

black people, gay people, and disabled people all speak. But they
have to make a great effort – to cross-dress – in order to do so, in
order to speak in the public sphere. No one speaks here wearing
an apron, because the public sphere monopolizes and totalizes all
politics. All the rest is a remainder, is residual.

That is the structure of modernity, and it is more lethal for
women than any others because it transforms their lives, nuclearizes
families, and alters everything that happens to us. This is why it is
also crucial to speak of what happens to us in war, not because this
is numerically the most significant set of events, but rather because
it changes our way of thinking about what happens to us women;
it shows us that what happens to us is fully public and not private.
This is key, because all of the mechanisms at work, all of the official
discourses on women, push their lives into the realm of the private,
the intimate, the particular. As it is defined in modernity, this
difference is a binary structure.

This is another disagreement, another debate within feminism
that I consider immensely important for the effort to think more
clearly. Elsewhere, I say something perverse, *épater le bourgeois*, but
it is necessary for challenging the right-thinking schemas that cause
us to go around in circles. I say the following. If the modern slogan
is "different but equal," and this is ultimately a fiction – because in
a binary structure it is impossible; there is no place for the other; the
other is a function of the one – in the tribal world the slogan would
be "unequal but different." Here the world is explicitly plural.

When we repeat our slogan, in a heartfelt way – when we say
"different but equal" – we are placing faith in the discourse of
modernity. This is an egalitarian discourse, but it is only a discourse.
As feminist legal scholars have always said, very rightly – this is
the key critique of feminist legal scholarship – modernity has a
discourse of equality that hides inequality. Never in the history of
humanity have the concentration of wealth or levels of inequality
been greater than they are in the present. Eighty-five people own
the same amount of wealth as the whole rest of humanity. Never
before has the concentration of wealth been greater. And this does
not mean that inequality is a question of money. It is a question of
power. Those eighty-five people have the power of life and death
over others.

In the tribal world, men and women are two different natures.
There is no belief in a universal equivalent, in a universal human
being with all the problems that such a figure entails. Here men and

women are not hierarchically equal, but in this inequality both are full, in their being, in their difference, in what they are. Each has his or her own world. Thus they are unequal, but in a plural world. To say "unequal but different" is to deliver a warning, a challenge. In these societies, men and women make up two sets, two groups of people who are ontologically full, ontologically complete. One group does not stand for the other's deficiency, is not a function of the One. This is not a world of the One like ours is. Each of the two has his or her fullness, his or her historical projects. Each has his or her agreements, his or her forms of politicality, his or her alliances even in disagreement, his or her space for politics. The woman is shielded; the community protects her; a collective eye looks out for her, because domestic space is full of the many people who pass through it.

I emphasize this difference because it is difficult for us to understand that there are diverse ways of being. Arab women have said this very emphatically. And we see the same phenomenon in the Americas. Anyone who goes to the countryside and who comes close to communal life sees that women here behave very differently than they do in cities. In Argentina, I live in a very rural region in the Andes. Here women are much more powerful than they are in the city. It is an observable phenomenon, one that is being gradually lost with the advance of urbanization, the world of mass culture, and the world of citizenship.

In the Western world, the European world, difference is a problem that must somehow be "resolved" through the use of a universal equivalent to produce equality. This requires many sacrifices. Today the communal world is shot through with discourses of equality, the discourse of Human Rights; there is also internal debate within communities which are creating their own paths – in Chiapas, for example – and developing good slogans that find their way into the world of modernity. These are open worlds.

This is not a question of customs. I am not referring to culture, because culturalism, in my view, is one of the forms of fundamentalism. In some tribal societies, in indigenous societies, we sometimes see forms of despotism that are not Creole but that present themselves as customary, as native to communities, as if gender hierarchy were prescribed by tradition. This recourse to custom is a culturalist recourse, which means it is fundamentalist. This happens not only in Islam but also in Catholicism, in some evangelical religions, and in the tribal world. This is why for the

most part I do not refer to the notion of culture unless it is indispensable. I am not talking about customs, then, but about historical projects, about historical pluralism, about a different history. In these different historical projects there was – there always was – internal deliberation, and there was always change. Humanity has never been self-identical anywhere. The idea that history is ours – that it belongs to the modern, white, European world – and that other peoples have customs is a binary invention, a Eurocentric invention, the product of a Eurocentric view of tribal peoples. But it is not true. All peoples have always had customs *and* history, both. And we do, too, if we are a people.

Sometimes, people have suggested that I idealize the tribal world. But aren't we dealing with prejudices against this tribal world? Don't we need to examine our beliefs? Isn't this a constant obligation for any investigator – that she investigate herself and examine her own certainties? Can we advance in thinking if we do not doubt our certainties, question our convictions? Now, our certainties indicate that the tribal world is underdeveloped. And what I say – and here I understand the resistance I encounter, because my statements challenge the certainty that the tribal world is underdeveloped – is that the world is moving toward violence, that the Holocaust is modern, as both Hannah Arendt and Zygmunt Bauman have argued. In other words, without modernity there is no genocide. I say this while fully aware that I am instilling doubt, that I am questioning a series of unexamined certainties, a series of convictions with which we think and work. I believe that this is necessary because we are arriving at a moment of defeat; the feminist movement has been defeated in its struggle to reduce violence.

This call, this alarm, is usually totally disconcerting, because we have a civic blindness, a civic faith, that prevents us from seeing the reality of the world we live in and the real consequences of our faith. The discourse of modernity is egalitarian, but legal, liberal, general equality hides a world that is increasingly unequal. And we have placed all our bets on the state. Social movements have jumped in with both feet, entering the field of the state and seeking to expand it. And I always ask: What are the results of this wager? What has resulted from our having wagered on the historical project of equality?

The challenge is enormous. If we need to make all the distinctions that I have been discussing and, at the same time, note that all violence is underpinned by a common structure, the symbolic

structure of patriarchy, how are we to do this? The solution is to think historically. We need to avoid the tendency to compartmentalize our theories, our thought, and our struggles. Why do I say that this is a mistake? Because we are not achieving great results. Today we are confronting a world where the use of the pedagogy of cruelty is evident. To see this, one need only listen to reggaetón or to many other kinds of massively popular music, or to watch television, or watch commercials. All the time we see that we are subjected to training, trained by a pedagogy of cruelty. The televisual gaze is a pillaging, despoiling gaze.

Finally, we must also ask ourselves: Why do feminist women demonstrate this historical, civilizing will to indistinction? I believe that this is a characteristic of current feminist thought. It encourages indistinction within the feminist movement, hiding forms of domination and unequal prestige within the movement itself. But there is also a struggle within the movement, as everyone knows: a struggle for control, for influence, for prestige, and even, especially, for resources. We women should be the first people to acknowledge the plural character of people's experiences, and we should be able to understand different historical projects.

On the Role We Assign to the State

Here I note a fourth disagreement among feminists, one that I will refer to only briefly because it has been discussed in the literature on debates in institutional feminism. It divides those groups, today in the majority, who have placed all their faith in the state and in efforts to advance within the field of the state through the creation of more laws, public policies, and institutions, from feminists who observe that this institutional strategy has yielded few results, especially when it comes to reductions in lethal violence and in the forms of cruelty aimed at women. These women note that when results have been achieved, they have prioritized white, middle-class women, who have managed to be "included" and to become actors in the public sphere. The first group believes that there is a causal relation between laws and practices – a view that I have critiqued on various occasions.

This position is related to the third debate that I examined above, which opposes European feminisms to non-white feminisms or feminisms for Our America. It follows from a Eurocentric

perspective and belongs to a reality in which, for historical reasons, the relationship between the state and society is different from the state–society relationship in Latin America, in spaces of colonization. In these spaces, our spaces, the republican state, heir to overseas colonial administrations, has remained external to the nation's territory and society. Women who place faith in such a state hold fast to an unexamined belief that institutional failures are caused by the inadequate observance of norms on the part of state agents in charge of delivering public services. They believe, then, that adequate instruction will remedy these circumstantial defects, and that the state can be reformed through the improved provision of social services. As I indicated above, this belief emerges from the influence of Northern feminisms, which pressure us in the South to impose objectives and develop policies in the image and likeness of the objectives and policies that serve their geopolitical context. They do this without recognizing the constitutive history and architecture of the state in postcolonial contexts. This constitutive architecture, inherent in Latin American states, has served since the founding of these states by elite republican Creoles, to guarantee that the nation's resources would remain appropriable and that the appropriators would remain protected. This is, as I have said, a constitutive failure; history has never proven that it could be overcome, that resources could be reapportioned. Instead, the work of appropriation has continued and has been territorially overseen by an administering elite that endogamously reproduces itself within its own spaces. (An "elite," in the definition of the term that I adopt, is any group or network of state administrators.) To this we can add the increasingly ungovernable and unrestrainable agreement between the state and corporations, which the discourse of human rights seeks to bring to an end, without success.

Responding to this set of arguments, I wonder: What is it that the state can do for us, and what can it not do for us? I think we should look for solutions both *within and outside the field of the state*. Almost without realizing it, we have been conforming to the feminisms of the North, accepting their strategies and objectives, which have led us to place all our bets on the state, without exception. This has not taken us very far in our efforts to achieve our goals and realize our demands.

Without giving up our struggles on the state front – because we must struggle on all fronts – we need to try to advance outside the state as well, to pursue extra-state projects through

the reconstruction of communities on the basis of the fragments of communal fabrics that can still be found, that remain recognizable and vital, or what I have called the shreds of community. We should never use abstract models to this end, because communities need history and symbolic density: their own cosmoses to support their cohesion and guide their historical projects.

How Not to Ghettoize the Question of Gender

I have mentioned this fifth point of divergence before, while examining the difference between the dual world of collectivist societies and the binary structure that organizes modern societies. But the debate warrants its own specific section. As I have explained in my analysis of gender and coloniality and the emergence of a colonial-modern *high-intensity patriarchy*, in modern societies, the binary structure of the relationship between the *public sphere* (the venue that authorizes statements about everything of universal relevance and *general interest*) and its *margins* (where all problems pertaining to the *particular interests* of so-called "minorities" come to reside) causes everything related to gender relations and everything that affects the lives of women to be deemed marginal, relegated, reduced to the realm of the intimate, the private, deprived of politicality. This binary structure captures women's experience and confines their "citizenship" to a space of particularity, specificity, and partiality. It also underlies approaches to gender that ghettoize it, that is, that define the question of gender relations and the problem of women's victimization and the victimization of those marked by their non-normative sexualities as issues that can and should only be examined in the context of attachments, affects, and representations of men and women. This is a position that does not represent my view either as a theorist or as an activist.

The position that I describe as ghettoizing the question of gender can also be traced to the entrenched priorities, categories, and practices of Eurocentric feminisms, which we could describe as "productivist" and institutional. These feminisms – "specialist" feminisms – tend to isolate the problem of relations between men and women from broader and more general considerations of historical context and relations of power.

Against this approach, we find a feminism that approaches historical context first of all and then considers women's destinies

within this historical scene. Here the study of historical context becomes fundamental to the effort to locate power and analyze how it is exercised. This approach understands gender as a kind of thermometer, a field that allows us to read and be read in light of a broader context, one produced by the workings of capital, politics, and social practices in general. The situation of gender allows us to diagnose a given historical scene, and only the analysis of the framework that is this scene allows us, in turn, to understand events at the level of gender.

It is only when the problem is seen in this way that we can understand why it is so difficult to remove women from the position of increasing vulnerability to which they remain relegated in today's world, despite the increasing numbers of laws and institutional measures meant to protect them and promote their wellbeing. The history that keeps women bound to this subordinate position extends far beyond what any ghettoizing, specialist analysis of patriarchal structures can account for.

7

Power's New Eloquence
A Conversation with Rita Laura Segato

In your essay Las nuevas formas de la guerra y el cuerpo de las mujeres *(The New Forms of War and Women's Bodies; Segato 2014b, republished as chapter 2 above), you link the mafia's control over ever-broader segments of society to the problems of accumulation and political representation. You also point to and denounce the existence of two realities, one legal and the other illegal, but where both are interwoven into a single structure. What are the social consequences of this structure that, as you say, connects social sectors that are apparently very distant from one another and that also encompasses politics?*

From my perspective, I try to formulate a model that transcends particular cases, however painful they may be. And this kind of theoretical formulation is nothing other than a discourse on the very structure of representative, mass democracy. In other words, what I seek to offer is not a constructive criticism of this democracy's malfunctioning, of its failures, but rather a destructive critique of its structural foundations, which render it defenseless against its own para-state shadow and against capital. Both in its movement through what I call the first reality and its movement through the circuits of the second reality – where these are interconnected through capillary networks, very well-nourished blood vessels. Democracy does not hold water. It is vulnerable to a new kind of coup that's underway, one that doesn't arrive from above and isn't led by

uniformed soldiers who seek to overtake the state's resources and apparatuses by force. Rather this coup, this attack on democracy, arrives from below; it comes from the place where gangs exercise control and acquire the ability to finance politics itself. Without their contribution, no candidate can be elected today; this influx of resources is necessary for the purchasing of political will and for the destruction of coalitions and alliances within the field of politics. So my argument about the state's defenselessness, its helplessness, as it relates to the second reality is an argument that unfolds within an expanded theoretical and political horizon. It's not a matter of finding remedies for resolving particular cases or holding this or that guilty party accountable; it's not a matter of reforming policies in order to bring them into alignment with the law or of disciplining politicians or making them more trustworthy. We have to be willing to evaluate the real possibilities in a stark and realistic fashion; we have to ask what concrete possibilities remain in light of our past experiences. How can a state structure recognize the enormity of the difficulties we are facing? How could it arm itself against the opportunistic expansion of the para-state, which acts within the state or alongside the state, in a second reality. I have been clear about this in all of my writing of the past decade, and I am certain of it: only a state that promotes the reconstitution of the communal social fabric, a state that restores and allows for the reconstruction of ethnic or communal arenas, will be able to protect people in Latin America. This is why we have to relearn how to think outside the terms of the republic, liberate ourselves from the enclosure of all politics within the state public sphere. Social movements have let themselves be captured by this public sphere, and they expend all their energy and intelligence in this realm. This is why I believe their faith in the state is pious, that they are totally naïve. It is, however, important to note that struggles and processes of political recomposition should occur both inside and outside the state realm.

When power cannot be expressed through law, or codified, it uses bodies as territories for inscription. In Ciudad Juárez, women occupy this place, play this role as supports for inscription. But here in Argentina it would seem to be young people who serve as the surface on which this new form of sovereignty writes.

I began to think of this as an alternative explanation, confronting something that seemed irrational, because we always look for the

instrumental dimension of violence. We ask what violence is "for." I tried, instead, to look for the expressive dimension of the crimes in Ciudad Juárez. All violence has an instrumental dimension and another dimension that is expressive. In sexual violence, the expressive dimension predominates. This isn't a matter of receiving a service without paying for it. The rationale for a common act of sexual assault, an attack by a rapist in the street, is elusive; it's difficult to describe for even the aggressor. When a prisoner, already found guilty of committing one of these crimes, is confronted some time after the event and asked to account for the rape that he committed, he finds something so opaque that it amazes him, frightens him. The rapist himself cannot access or account for the rationale for the act that he himself perpetrated. It is as if rape had taken over the rapist himself, surprising him. There is a shared structure, something that acts through the subject or from within him, something that makes use of the individual to effectuate his acting out. And the person is dissolved in this act. The subject who seeks to reconstitute his own virility appropriates a woman's body as tribute in an effort to manufacture his own manhood. I have analyzed this kind of irruption – the irruption of shared content in and through the subject – in my book *Las estructuras elementales de la violencia* (The Elementary Structures of Violence; Segato 2003a). Jacques Lacan uses two different categories to describe these kinds of irruptions: on the one hand, *acting out*, in which the person, instead of speaking, has recourse to an expressive action; and, on the other hand, the *passage à l'acte*, in which the subject is destroyed in and through his action. This is what occurs in rape. It is very striking to listen to the rapist say things like, "I died then," or, "I killed myself." In the patriarchal atmosphere of colonial modernity, rape is experienced as a kind of moral murder. But the woman who is raped has no reason to comply with this expectation, to see rape in this way. Many feminists, especially Mexican feminists, had a problem with my making this claim. Rape is a terrible act of aggression but not necessarily a moral murder, despite the intention that it be one. Patriarchy is the air we breathe, and it is this atmosphere that turns rape into moral murder. The rapist is an agent of this atmosphere.

This passage to the act that you're describing, what kind of force is it expressing?

Something that traverses the subject, a structure that works through him and through all of us. Rape is not the anomalous act of a solitary subject; it is a message, a statement made in society. All of society participates in what is said here. It is present not as discursive consciousness but as a kind of immediate, practical consciousness. The goal of this kind of cruelty is not instrumental. These bodies are not being forced to provide a service; rather, they are part of a strategy that seeks something more fundamental, a pedagogy of cruelty that is the cornerstone of the whole capitalist edifice. To instruct the gaze, teach it to remain external to nature and to bodies; to create a set of beings who are external to life and can colonize and dominate life from this position of exteriority, can extort the living and pillage in a new way. Still, we are speaking here of rape in a general context, and especially as an act related to the construction and reconstruction of masculinity. But the focus of this interview is on war crimes, that is, rape and the sexual torture of women and, in some cases, as in the case of the slums outside Rosario, of children and young people as war crimes committed in the context of new forms of conflict unfolding in the peripheral neighborhoods of Latin America's large cities. Rape in the context of gang violence. Here, there is another rationality at work, although some elements of the patriarchal structure remain in place, including, for example, what I have described as the directive to rape that comes from the masculine fraternity in the psychic life of common rapist. This is analogous to the gang's directive to destroy and to conduct moral massacres by raping women associated with the enemy faction or children who refuse to be conscripted and disobey.

Still, there are different forms of understanding or fields of intelligibility. There are those who understand this violence and its codes and those who keep their distance and see senseless deaths.

Returning to your first question, when I began to see what was happening to the women in Ciudad Juárez in and through the mutilation and sexual torture of their bodies, later discarded in wastelands or dumpsters, I realized that this could also happen to children. This is not a form of aggression against the body of the enemy, against the assassin employed by the enemy faction. It is something else. Those who are attacked have fragile bodies; theirs are not the bodies of soldiers. This realization was chilling. Candela Rodríguez was just a girl.[1] In Argentina, there was also the case of

a young boy, Marcos De Palma,[2] which is striking. A boy who had lost his mother: they kidnapped him together with his father, who had been a moderately successful businessman and whose business had begun to thrive. Things went so well for him that he bought a small plane. It's worth asking about the purpose of the plane. They killed the father, whereas they not only killed the boy but also cut off his hands. And the media said: "Ok, they killed him as a way of destroying evidence, because he would have testified about how they killed his father." But why cut off his hands? This is clearly a kind of mafia "signature." It is an index of the expressivity of gruesome threats addressed to the whole collectivity. A message about the capacity for unlimited violence and an absence of sensitivity to human suffering. In the para-state action of these groups, the need to demonstrate this absence of limits on cruelty is very important, since there are no other documents or signs of their jurisdictional authority.

In Rosario, Argentina, there are statistics on the young people killed by narcos but no data on the cruelty at play in these killings or the marks that are left on the bodies of those who are injured but not killed. In our conversations with health workers, we've been coming across shootings that target victims at waist level, or that are aimed at the sciatic nerve or the spinal cord or the knees and leave victims paralyzed.

This is what the Irish Republican Army would do in Ireland to traitors and deserters; it's what's known in English as *kneecapping*. They'd take out the knees because this would cause irreparable damage and leave the person who was shot permanently handicapped. In other words, it left an indelible mark on the body. In the case of shootings aimed at the spinal cord, victims would become paraplegic. These were punishments imposed in response to specific kinds of disrespect or betrayal, since most offenses were punishable by death. We should not forget that conditions in the second reality preclude the existence of prisons, which are the place of punishment in the first reality.

All of these forms of punishment and diffuse violence, the fear that has undoubtedly taken hold among people in the poor peripheries of Rosario, Córdoba, Buenos Aires, and all of Latin America's large cities – these show that there is a breeding ground from which a clear threat to society as a whole emerges. They are disguised

signs that nevertheless loudly warn of the danger that hovers over the social order and the predictability of everyday life. A question mark now hangs over the codes and conventions that lend stability to interpersonal relations. I am thinking of Ingmar Bergman's extraordinary film on the portents of Nazism, *The Serpent's Egg* (1977). This film shows how a new regime of power emerges, how a new form of power appears. This is the serpent's egg incubated in a hidden nest. Everything that is happening with the mafias, with gangs, is very new. This kind of cruelty directed against women's bodies, for example, belongs to the new forms of war launched during the military dictatorships and dirty wars waged against the people: in Guatemala, in various civil wars, in the former Yugoslavia, in Rwanda, and now in the universe of the gangs. Before, in wars that are today considered conventional – from the tribal world through the wars fought between states during the twentieth century – women were captured as territory. Land, in the sense of nature, is not territory. A territory is a delimited, circumscribed, and politically inhabited space, an administered realm. Women were always appropriated, raped, and inseminated during campaigns of conquest. Seeds were planted in them just as they were planted in the earth; this was a sign of appropriation. But this was not yet what is happening now. The torture of women is a very different kind of act of war. It is the destruction of the enemy in and through the woman's body. This is not appropriating context but rather destruction. And I think that it is also the expression of a new way of pillaging nature. This serpent's egg that is being incubated – this egg whose existence can be seen in various epiphenomena – belongs to a new order in which evil is the rule, not the exception.

In various neighborhoods in Greater Buenos Aires, social organizations have been accused of abusing minors in identical ways. These accusations have been fueled by members of criminal groups, who seek to organize protests culminating in the burning of houses. The aim is to drive people from their homes and to dispose of them in order to make their territories available. But those who attack, rape, and brutalize children in these neighborhoods are the criminal organizations themselves.

This is the inversion of a communal procedure, a method that has been adopted and perverted by gangs that seek to destroy forms of community, working against people's politicization. In the

punishment of boys that takes the form of rape, the punishment is the feminization of their bodies, their displacement to the feminine position. It is worth noting here that the rape of women is also a form of displacement and destitution, a condemnation to the feminine position, an enclosure within this position, which becomes a kind of destiny for the body that is thus victimized, subdued, and subjugated. Whether a woman or a man is raped, the intent is to feminize. This is because it is the collective imaginary that works through us that confers meaning on rape and establishes the hierarchical relation that we call "gender," that is, the relation of inequality that binds the feminine position to the masculine one. When we are dealing with a child, as in the case of the poor kid whose hands were cut off, he appears in the same position as a woman in the collective imaginary; he appears, that is, as one who must be protected, as a body that by definition should be guarded. The failure of the protective or tutelary power – the failure to protect this victim from the enemy's cruelty – is indicative of a moral break, one of the most important forms of defeat in the archaic, ancestral imaginary. The gendered imaginary cannot be changed easily; it cannot be altered by decree, and any alteration takes a very long time. Within this very ancient collective imagination, the bodies of women and children must be protected. This is what fathers, older brothers, uncles, fiancés, and soldiers are for: they are there to protect, to watch over, the bodies of the women who are under their care, who live within their territorial jurisdiction.

But in a case like what happens in Rosario, where those who are the victims of these kinds of attacks are children who are already potential soldiers – that is, who are 12 years old or older – the structure, the symbolic economy, that gives meaning to the message is not exactly the same, because a boy of this age is collectively seen as a relatively autonomous subject. He does not need to be cared for. When the body of a woman or a child is attacked, this body is a conduit for a destructive challenge to the morale of those who should be protecting it, caring for it. In the case of the "little soldiers," by contrast, these would be the bodies of recruits, a workforce for war. Punishing them would be destroying the workforce that refuses to be recruited, that does not surrender to forced conscription into trafficking or the other tasks required for the maintenance of the front in this new conflict.

The distinction that you made between child and young soldier, even when the two may be the same age, may be key. The question

of why these young men are not raped but are shot in the knees or the waist would then seem to have to do with disabling the labor force . . .

Sure: if you're not going to be part of my legion, then you're not going to increase the ranks of anyone else's either. What's also frightening is that there are techniques that are becoming transnational. But how can we convey an understanding of these techniques? There is a tradition of war at work in this second reality that has transnational implications. There are leaders, bosses, who travel; we know Colombians went to Mexico, that the Sendero Luminoso (Shining Path) spread throughout the Southern Cone, taking their methods, their techniques, with them. There are also messengers who convey and instruct others in new tactics.

One gets the impression that this second reality is made up of a code that presupposes a specific kind of legibility, one increasingly at odds with the first reality's order of meaning. The ability to read these forms and manifestations of violence belongs exclusively to those who live in these territories, and those of us who see them from the outside, through the media, do not understand what they're about.

On one occasion, I took part in a protest organized by mothers in Ciudad Juárez. They were demanding two things: an end to impunity, on the one hand, and, on the other, surprisingly, freedom for the accused who had been imprisoned. This was something never before seen, because victims and their families in general tend to want a guilty party, even a lynching. But these mothers didn't want that. The mothers knew, in a disquieting way, that those who were imprisoned were not the guilty parties, not the perpetrators. Why? This was the interesting thing. How did they know? Where did their conviction come from? The truth, a great and interesting one, was that in Ciudad Juárez there is a consensus, a shared knowledge, which is nothing other than the understanding that those strange crimes against women are crimes of power. And the prisoners are not the representatives of power. I want to make clear that, just as I am trying to give a name to what was at issue in that strange protest and the name I have found is "crimes of power," so too am I convinced that our role as intellectuals is to create rhetorics, to offer a lexicon to people that can allow them to give voice to what they

know. Because people were saying something at that march, saying: those prisoners are not the ones; they're not the powerful ones. And we work with words; we're the carriers and operators of words. We're the ones who can formulate the idea of "crimes of power."

On the other hand, let me say to sum up that the untouchability and impunity that we find in contemporary theaters of war are enormous problems. The governor of the Province of Buenos Aires, Daniel Scioli, gave his support to all who were implicated by the Provincial Congress in the case of Candela Rodríguez. This is why I do not believe that the state can protect people. We are dealing with a fiction that doesn't work, one that's no longer functional.

What advances have we seen in the realm of the state?

When it comes to violence against women, there have never been so many laws for women's protection; there have never been more ways to make accusations. There are laws, public policies, and institutions. But rather than decreasing, lethal violence against women has increased. In Brazil, a woman is murdered once every hour and a half. For all the urgency of this problem, there is no correlation between law and justice. The demands of justice have not been translated into the language of law. The law is far removed from important questions, life is being feudalized, and corporate networks trade favors and conquer more and more space in the everyday lives of common citizens. This situation should find its way onto the theoretical plane so that we can elaborate a contemporary critique of the structure of representative, mass democracy. As I have said, it is possible that a constructive critique of democracy's failures, its malfunctioning, is not enough, because its structural foundations are very vulnerable and appear to be compromised, complicit. Institutions can no longer defend themselves against the double movement of capital that I spoke about earlier.

This means we are also confronting a challenge ourselves, those of us who seek to understand what is happening. A theoretical model is an interpretive wager that lets us assign meaning and see shape in disparate events that would seem to be unconnected and inexplicable, events whose causes have not yet been discovered. Suddenly one begins to think that there is a deep structure that cannot be seen or observed directly but has to be posited, presupposed, if we want to disclose the coherence of the events that take place on the surface. My essay on Ciudad Juárez, in this sense, offers

a possible model, reference to which might make a series of events intelligible.

In an analogous way, in the case of Argentina, we can think about human trafficking and ask ourselves many questions that can only be answered by positing models of invisible relations. These cannot be easily observed or confirmed, but positing them lets us explain otherwise unintelligible aspects of the phenomenon, including, for example: How can trafficking and impunity both persist? It would seem that certain kinds of crimes are untouchable, although it would be extremely easy to bring them to an end. Trafficking happens in front of everyone, in places known to everyone; in city neighborhoods it is very easy to find out where the brothels are. So where does the sense that it is impossible to touch them, to dismantle human trafficking, come from if the problem is so evident?

Now, we have to stop to think: What is the source of the perpetrators' protection? What shields them, makes trafficking indestructible, and allows it to continue as a crime that everyone can see? To answer this question, as in the case of Ciudad Juárez, we have to make a series of reasonable, acceptable, and convincing conjectures. For example, that the following causes contribute to, produce, and guarantee untouchability: first, from the economic point of view, trafficking and the exploitation of coerced sex work are forms of dispossession of women's bodies; they "add value" while requiring only the most minimal investment, so much so that we could say they allow for the extraction of rent, derived from the exploitation of the body-territory that has been appropriated. We could even speak, in strictly economic terms, of accumulation by dispossession. According to figures provided by the United Nations, trafficking for purposes of sexual exploitation yields yearly profits of $27.2 billion.

Second, these profits derived from trafficking in the ways I am describing here find their way into politicians' campaign funds, and bribes are paid to the police to ensure that the brothels are not shut down. I have heard of a police commissioner working near La Plata who, because he did not agree to the ongoing exploitation of Paraguayan girls in a brothel located in his district, was given two options. He could either retire early or be relocated to a remote and insignificant municipality in Buenos Aires Province. The order came directly from a functionary working in the government, motivated by a decrease in campaign contributions. The motivation here is not mere enrichment, but rather, as I have been arguing, a concern

about the health of campaign funds. This is what we call "representative democracy."

A third reason for the persistence of trafficking is that the practice plays a role in a symbolic economy. It supports and sustains the material economy of the market in this apocalyptic phase of capital, because it stages perverse scenes – what I have called a *pedagogy of cruelty* – that promote, and accustom people to, the spectacle of pillage, the destruction of life that leaves only remains. It is the propagation of an idea of enjoyment as entailing consumption followed by destruction.

Fourth, we have to keep in mind that men do not visit brothels today seeking sexual satisfaction, if they ever did. Clients generally go to these establishments in groups. These groups often use the brothels as sites for fraternization, for meetings among men who gather to celebrate the agreements, alliances, deals, and pacts that bind businessmen from far-flung places to judges, policemen, and the members of other armed forces, with their leaders and campaign connections. On the other hand, as a byproduct of this use of the brothel as a meeting place for the sealing and celebration of business deals among men, it becomes a place that excludes women, including businesswomen, female judges, and so forth, who are denied access to the deals that are thus finalized.

Trafficking and sexual exploitation in brothels are thus big businesses, totally shielded from view. This is the only way to explain its proven indestructibility.

We are putting forward a hypothesis according to which, in a complex context, a new kind of social conflict has emerged, one that calls for the creation of an unforeseen form of political intervention . . .

For me, the kind of relational structure that I have described represents the ultimate ruse of democracy. It is a *coup* that arrives *from below*. It is not thus surprising that the assassins employed by criminal organizations attack the community organizations working to politicize the residents of urban neighborhoods and to build collectivities capable of practicing reciprocity and implementing alternative, popular economies. There is a clear opposition between two forms of organization: criminal organizations operate outside the law but do not fool us because, on the other hand, they are perfectly compatible with and work entirely within the

logic of capital, as we can see in the account of trafficking offered above. The construction of alternative, popular economies based on reciprocity and mutual aid: this is an enemy undertaking from the criminal organizations' point of view, an obstacle for the expansion of their markets. At the same time, community organizations offer an alternative vision of collective flourishing, one that does not accept death-dealing as the aim or the project of life. From the standpoint of capital and in the second reality, it is essential that this alternative – an alternative to war and death as ways of life – not be allowed to exist. Only when this option no longer exists do people let themselves be trapped within this scene. This is why criminal organizations devote so much ammunition to the effort to extinguish practices based on solidarity and community organization.

So what is the alternative? What can bring an end to these new forms of conflict? What is the role of the state in confronting the danger of gangs' expanding control over society and politics?

Central America is a laboratory for working through these questions, and it can shed light on our efforts to respond. It can guide us as we work to halt the destruction of popular projects by mafia projects. There is a phenomenon that has a lot to teach us about what is and what is not a breeding ground, a context favorable for the proliferation of gangs acting in the service of criminal organizations. It is well known that the gangs that have multiplied, from El Salvador to the other countries in the region, have not crossed the southern border of Honduras. And it is well known that the territory they did not manage to pass through, lying in the direction of Costa Rica and Panama, is Nicaragua. Analysts have wondered why Nicaragua has until now been an unbreakable barrier, why it has arrested the movement of the gangs that have been conscripted to serve as murderous troops for criminal organizations. The question as to the nature of the Nicaraguan antidote to the proliferation of gangs has two answers that ultimately point to a single theme: politics.

One analyst, Steven Dudley, explains the phenomenon by referring to the different treatment that Nicaraguan immigrants faced in the United States in the 1980s, when, naturally, those who left Nicaragua for the US were dissidents fleeing the new order introduced in the country after the Sandinistas' revolution. These immigrants were thus welcome in the North. By contrast, immigrants from El Salvador, Honduras, and Guatemala were seen

as undesirable and marginal, and they were deported in massive numbers, sent back to their countries of origin, where their return gave rise to gangs.

A second explanation, offered by Francisco Bautista Lara, one of the founders of Sandinista politics after the overthrow of Anastasio Somoza Debayle, seems to me a more interesting one. It involves the transformation of Nicaraguan society in and through the revolutionary process led by the Sandinistas and the reorganization of the country through the implementation of mechanisms for robust popular participation in politics. Bautista Lara also highlights the fact that Nicaragua is a country where people maintain strong communal ties. Here we find, then, a response to the question that we posed: What is it that can bring the *mafialización*, or the organized criminalization, of society to an end? The answer can only be political participation in society and the organization of communities.

In the end, to synthesize, what I have argued here is that we can no longer see the state's problems as the fault of its agents, its representatives, or its administrators. We have to face the state's vulnerability, its openness to the opportunism of capital's expansion within *two realities*. We need to ask again about the very structure of the state; about its real capacity to lead society toward the goals of peace, justice, and equality; and especially about the reasons for the recurring, enduring failures of states throughout the history of Latin American countries. Why have the good intentions of all of those who have worked to correct the state in part not produced results?

I believe that Latin American states must abandon the *ethnic terror* that guided them during the processes of national unification and the founding of the republics. They must instead promote the reconstitution of the communal fabrics that have been attacked and have disintegrated as a result of colonial interventions, first from overseas and then led by the Latin American republics. The only state capable of curbing the expansion of mafias is one that will reconstitute community jurisdictions and protect mechanisms for internal deliberation, a state that restores communal citizenship. Only communities with strong social fabrics, communities that are politically active and home to dense symbolic practices that bind their members together, have the ability to protect all of their members, sustain economies based on reciprocity and solidarity, and give meaning to life. When this option exists, it is possible to refuse the historical project of death.

8

From Anti-Punitivist Feminism to Feminist Anti-Punitivism

Responses to the violence unleashed today against women's bodies are far from intelligent or efficacious. There has been insufficient imagination in these responses to what we could call a veritable catastrophe of gender. This is why, if we want to understand the problem of gender violence, we must not decouple this effort from an honest self-critique; we must not seek to minimize the failures of those of us who have worked within the world of letters and within the realm of the state to contain this evil.

In this chapter, I bring together two public presentations, which I have revised and partly rewritten. The first, aphoristic in its form, contains the arguments that I presented at a consultation hearing held by Argentina's National Senate. The hearing's goal was to assess a legislative proposal sponsored by the Ministry of Security under the administration of Mauricio Macri, which sought to impose more severe conditions of imprisonment and to limit the practice of excarceration.

For an Anti-Punitivist Feminism: "Two Wrongs Don't Make a Right"[1]

The prison is the means that modern positive law has found for punishing crimes. The prison is really *what we have*, the solution that the law has devised for crime, the institution tasked by modern

common sense, both lay and legal, with *resolving the problem of crime*. But considering the case of the convict, we should stick to what jurists have aptly called an "agnostic theory" of crime, one that takes "a suspicious and skeptical position on the aims of punishment," even when these would seem to involve doing justice or enabling rehabilitation or resocialization. If this is the case, because punishment always turns out to entail "the institutionalized exercise of state violence," the only thing left for us to do in studying the case of the convict is adopt an agnostic perspective and seek to reduce the damages of punishment (see Machado and Santos 2018). Likewise, as we study its effects on society as well as on the convict, we should remember that the prison is *what we have*. It has not been proven to have the persuasive power or the discursive capacity to contain the problem of sexual crime. Thus the only real solution involves preventing these crimes from happening. I want to think here about the damage done by sexual assault, and I want to avoid falling into the trap represented by the worst and least effective of all solutions to the problem: the prison as we know it. I proceed by offering a series of statements and claims that, taken together, allow me to build my argument.

Presentation Before the National Senate, April 20, 2017, at the Hearing Called to Assess a Proposal to Impose Harsher Punishments in Response to the Killing of Micaela García on April 1, 2017[2]

1. The rapist is the symptom of a social problem that that affects all of us.

Rape – that is, the act that is typified in law, described in law, as a crime – is the tip of an iceberg made up of many kinds of what I have called symbolic rape, most of them found beneath the surface, constituting the iceberg's base and all of its layers (see Segato 2003a). Most acts of sexual aggression cannot be recognized as crimes, because they constitute the world and the social form in which we live.

To understand this, it is enough to watch the many television programs that feature what a manager for the Argentine Football Association, speaking to a celebrated TV host, called "skirt cutters," which strip women, making them available to exploitation by the media. "We don't need a skirt cutter here," Juan Carlos Crespi said, speaking in his capacity as vice president of Boca Juniors to a

candidate for that club's presidency, Marcelo Tinelli. He thus gave a lapidary and explicit name to what we see on our television screens every day: "You don't play football by cutting skirts."[3] A feminist couldn't have said it better.

We can say, then, that the kind of sexual assault that we manage to define as crime is the tip of an iceberg made up of a set of behaviors that are both widespread and normalized. These behaviors lead to a *spiral of violence* whose innumerable acts and practices, everywhere repeated in everyday routines in all spheres of life, are not criminalized in law because, in fact, they could not be. These thinly disguised oppressive and violent routines are the forms of moral, political, financial, and professional violence that constitute the breeding ground, the incubator, for greater acts of aggression, for the crimes that are recognized as such by law and matters of legal responsibility. This is the only reason, then, that such crimes cannot be stopped, either by the law or by prison. Society itself must change. A law is truly effective only if it has the capacity to change society's ethical sensibilities, that is, if it achieves a degree of rhetorical, discursive, symbolic, and performative efficacy, if it succeeds in persuading and dissuading people, in mobilizing and transforming society.

To want to stop these kinds of crimes by imposing prison sentences is to want to eliminate a symptom without treating the illness that causes it. We have to work the land itself, in other words, not just do some pruning and weeding. The weeds will continue to grow, because they are a social symptom, signs of a social illness, the outbreak of a plague that is much more widespread and that saturates much more of society than we think.

So, what is it that we have to do? We have to work on society.

2. I would add another claim to this one: that it is absurd to put forward a punitivist solution to sexual violence. This kind of simplistic argument sees imprisonment as the only response to rape, when prisons are in fact veritable schools for rapists. My years of fieldwork in prisons, undertaken together with teams of students, have convinced me that both women's prisons and men's prisons, as well as juvenile detention centers, are such schools. It's not only that the rapist is raped in prisons – this kind of punishment is the norm in many carceral communities – but also that these total institutions are spaces for the forced restructuring or reprocessing of gender identities, as Jacobo Shifter, a great scholar of imprisonment, showed in his extraordinary ethnography on men's prisons in Costa

Rica, *Macho Love* (1999). In a totally transparent way, the relations between those who dominate and those who obey within carceral institutions are expressed in terms of sexual domination, including through the rape of the weakest prisoners.

3. Although it is true, as I have argued, that a law is not really effective unless it is symbolically and rhetorically efficacious – unless it has the power to convince, the capacity to persuade and dissuade – it is crucially important to understand that, when we are dealing with crimes of gender, the law is not materially efficacious either. That is, these crimes are not sentenced appropriately by judges. This is owing to the fact that judges cannot make effective decisions because they have not been exposed to reflections on gender, although advances have been made in the legal field, a discipline that is becoming more theoretically productive and sophisticated.

In any case, legal workers do not understand sexual crime. They do not understand what it really is: the exercise of power in and through an act. A lesson in power.

The problem for Judge Carlos Rossi, Judge López,[4] those who follow Raúl Zaffaroni's thesis, and those who, at the other end of the legal spectrum, defend punitivist positions is that none of them understands the problem as a social one, a problem with society. In the first case, scholars and practitioners of law do not avoid the mistake of seeing sexual assault as a form of aggression motivated by sexual desire, driven by libido, that is, as a crime of intimacy with a sexual motive. They do not succeed in grasping the indispensable point that sexual crime is instead crime committed *by sexual means* but whose motive is exhibitionistc, *instructive*, and a matter of war. It seeks to control the victim and to make a spectacle of this control; therefore it belongs not to the domain of intimacy but rather to that of domination. The aggressor and the victim are not intimate in any way. It is not sexual desire that explodes in rape. *The* modus operandi *is sexual, but the motive is not.*

4. It seems paradoxical, but sustained analysis reveals that the aggressor is a moralizer. So too are those who defend a punitivist position on moral grounds.

My claim that the aggressor is the more moral subject causes some of my interlocutors intense discomfort, even pain. But it is the problem of good conscience, of moral superiority, that forms the backdrop and the support for all domination.

The rapist thus sees himself as morally superior to the victim, whom he perceives contemptuously, from his patriarchal position. The rapist punishes and disciplines a disobedient victim. The victim's overt, explicit femininity is what he attacks, challenges, and discounts. This is the rapist's vision, the view of the sexual aggressor.

The aggressor's mentality is narcissistic and self-justifying. He cannot bear to see any chink in the armor of his moral superiority. At bottom, he is convinced that the victim needs to be taught a moral lesson, that she needs to be punished, because he sees in her the supposed evil that he attacks, the femininity that challenges him through its mere existence, in its fullness.

In a not dissimilar way, the punitivists seek to occupy a position of moral superiority and to play the role of enforcing a reigning social morality. Although this might seem surprising, the sexual aggressor is also a subject of this kind, one constituted in this way.

Listening attentively to what a rapist says leaves one perplexed, even shuddering. In the rapist's discourse, the problem or evil resides in the victim. In the same way, for the punitivist, the problem or evil is in the rapist. But the problem, the evil, is in fact social. It has to do with how patriarchal domination is reproduced at a cellular level, how it is the first lesson in domination and violence.

Why does the punitivist school of thought react with such ferocity to my argument that the rapist is a moralizer, that rape is an effort to moralize? Precisely because an unsuspected kinship emerges here, a conflict over who has a monopoly on good, who wields moral power. Both the rapist and the punitivist call for excommunication and for purges; both need an opponent who is conquered, a victim who is defeated, an abject other, in order to accede to a position of power. Both need to attribute evil to the other, and both seek to distance themselves from and cleanse themselves of their own evil. We are dealing, then, with a form of hypocrisy that must be identified and eradicated.

For a Feminist Anti-Punitivism: "Femicide and the Limits of Legal Education"[5]

The following section republishes, with a few stylistic and typographical corrections, my response to the recommendations offered by the distinguished Argentine jurist Eugenio Raúl Zaffaroni, recommendations for how to address the wave of femicides assailing

the country. I include my response here as the second part of this chapter, which seeks to formulate a feminist anti-punitivism. Zaffaroni's article, published in *Página 12* on May 18, 2017, on what he calls the "epidemic of femicides" caused discouragement and consternation among feminists – myself included – who read and respect his work and even assign it in our teaching. Here will I try, once again, to make our position clear to this eminent intellectual. To this end, I will review the mistakes in his argument, with the hope that this distinguished academic and legal scholar, whose writings have been exported from Argentina and found their way into great libraries and seminar rooms throughout the world, will get word of and become familiar with feminist debates that he seems not to know, although he says, referring to feminism, that he has considered "rich arguments" representing a range of theoretical positions. Here, for reasons of space, I will enumerate only some of the problems with Zaffaroni's argument.

1. Consider the definition of femicide that he has chosen in order to address the problem on this basis. By femicide, "I mean those homicides that are *machista* in their motivations"; in these crimes,

> the woman's resistance to the continuation or initiation of a relationship, or her resistance to participation in a sexual act, prompts the "macho" (whose "manhood" is wounded) to kill her or to kill a third party in order to gain vengeance. In the mind of the femicidal criminal, a conviction predominates: that the woman has no right to resist the will of the "alpha male."

And we're off! This characterization of what femicide entails is nothing but a simplistic understanding of the sophisticated debates that feminists have engaged in for nearly a century, debates having to do with the reasons women (or men) are injured or killed by sexual means, whether in a police station, in an attack on the street carried out by a pair or group of young men, or in the context of the new forms of war like those that are spreading today, southward from Mexico. Before venturing an analysis, before broadcasting an opinion on this kind of crime, Zaffaroni has not done the work of engaging in even a brief foray into contemporary debates on the topic. But Dear Judge and Esteemed Professor, these acts of violence by sexual means do not originate in an alpha male's desire for women! What gives rise to them is an alpha male's aspiration

to belong to the masculine corporation! This aspiration can only be satisfied, this goal can only stand achieved, if he is able to prove to his peers that he is capable of carrying out an act of appropriation and domination!

It is the aggressor's narcissistic attraction to the prestige that belonging to the brotherhood of men confers that guides his action and his quest for satisfaction. If there is libido here, this is where it is concentrated. Has the esteemed judge not learned, for example, of the celebrated case of the rape of an old woman, who died immediately after she was raped? She was raped by the Mexican police after she made a complaint related to the repression in San Salvador Atenco?[6] This is a classic case, and it sheds light on this kind of crime. It is essential to know about it before broadcasting an opinion on the matter. There are not male subjects, mad with uncontrollable desire, whose madness is unleashed when they see a woman's body. There are, however, subjects who are mad with greed, who so covet prestige and power that they are prepared to kill, massacre, profane, and conquer – or, rather, show themselves to be conquerors and therefore virile. This is a body blow dealt by power, an effort to control, not a matter of erotic enjoyment. It is war. It is abuse. It is an exercise and declaration of will. It is a matter of competition among men, among rival factions. It is about revenge and conflicts between interest groups or factions. It is about the seizure of territory. Indeed, it is conquest itself. It is a statement of jurisdictional sovereignty, of rule over bodies and territories, a message sung out to the world, and especially to other men. It is driven by lustful aspiration and seeks investiture. It is a question of honor, defined in the corporation's crude sense as belonging to a caste, to an elite that reproduces itself in this way and that seeks to control the world, imposing a structure whose asymmetry and abyssal inequality grows starker every day. Far from fulfilling the false promise of modernity, these forces cause regression. In the end, the big game hunter who was, fortunately, killed in Zimbabwe three days ago, crushed under the weight of an injured elephant, was not Mexican, Guatemalan, Honduran, Salvadoran, Colombian, Brazilian, or Argentine. He was a white Boer hired by North American millionaires who wanted to try their hand at killing in Africa.[7] Although, to be sure, he had more money, he lived within the same structure as our gangsters and assassins: the structure of a power that exists and that needs to stage and restage the spectacle of its own potency in order to reproduce itself. Was there libido in

his life? There was. But was it aimed at the elephant, a vital animal wandering through the landscape? No. It was aimed elsewhere: at the eyes of spectators who were other members of his brotherhood, his corporation.

This is what rape and femicide stage and allegorize every day, every damned day. I wonder, although I know that the law does not cause behaviors except by persuading and dissuading: Can the law not intervene here? Can it not offer an effective discourse, an active declaration that this avalanche of accumulation and power, this exhibitionist excess, is a disgrace?

Can the law not even try to plead with, persuade, and educate society, teaching it to listen to those who are exploited and pillaged, those who are onerously taxed so that this power can reproduce itself? Can the law not understand relations of power and work to contain them, if only performatively, through a kind of conjuration or would-be magic spell? Shouldn't the law express the desires of a society damaged by the shameful spectacle of subjects who are turned on by their own power, a society made to suffer before the cases of Lucía, Micaela, Araceli, and others so numerous that there aren't enough letters in the alphabet to write their initials? The answer to these questions would seem to be, time and again, that the law can express itself only in the terms of a "citizenship" that depends on a fiction of equality it is required to sustain.

As I have argued in chapter 5 above, the law is nothing other than a system for naming, one with the specific power to persuade and dissuade; other than these, it has no causal power over the behavior of people in society. This is why access to inscription within this system of names is more important than the material efficacy of decrees and sentences, and why I have spoken so much of "the right to name suffering in law." The judge's gavel is what maintains, or fails to maintain, the effectiveness and audibility of these names, and not the other way around. *It is not a matter of punishing more, of harsher punishments; rather, it is a matter of redirecting the voice of the law, letting it circulate so that it can be heard by many people. It is a matter of understanding that, unless it serves a pedagogical function, the law cannot affect the acts that impose and reproduce suffering.*

2. Elsewhere in his article, Zaffaroni writes, "Marches and public demonstrations are positive means of struggle that raise awareness against the culture of machismo, but they do not have immediate

effects or preventative power; in fact, what we are seeing is an increase in the frequency of femicides." There are two enormous mistakes in this sentence. I will only note them here. The first has to do with how Zaffaroni unthinkingly approaches an argument that is already familiar to feminists, one that locates the cause of the problem in the victim's behavior: the marches, from this uncomfortable and detached perspective – a perspective we could, without exaggerating, call reactionary – lead to an uproar that is counterproductive; it may even be the motive for the violence that the marchers would abolish. Here again, we see Zaffaroni's lack of familiarity with and his distance from feminist reflection: in fact, the marches promote an *awareness of gender*; they allow women to perceive that there is a place of refuge and above all that there are *other forms of happiness* within reach, even easily within reach, in our way of being, made available in our technologies of sociability and styles of politics, which are now being reborn after a long period of subjugation and lethargy.

Zaffaroni's second mistake here is that he subscribes, seemingly without realizing it, to the kind of short-termism practiced by bad journalists, judges, police officers, and public common sense, because he points to a "preventative power" that should obtain here and now, "immediately." Here a question arises: How would this "immediate" result come to pass? What kind of summary solution would this be? Isn't the scholar here arguing against the great contributions that he himself has made, contributions that suggest that we must make an ongoing effort to understand crime and punishment as they appear throughout history? But those of us who understand the problem know very well that this is a recurring and predictable objection: those who, in their acts in government, show that they care very little about people's individual or collective wellbeing always return to the question of "speed."

3. There is another surprising moment in Zaffaroni's text: he writes, "we must do something different," and I agree. But again he disappoints us when what he conceives of remains limited to an investigation that does not go beyond the field of law, remaining imprisoned within the myopia of the courts, with their imperative to translate everything into their terms, that is, the demand that we sort through the plurality of histories, running them all through the grid of legal terms and categories that governs judicial ritual. Moreover, court dockets are dictated, edited, and transcribed by people who

do not have the slightest education in problems related to gender violence, people working for a judiciary that has repeatedly failed: it cannot think in terms of power, where relations of power are constituted in and through an asymmetry between the feminine and masculine positions in society, and this asymmetry is sustained by a collective imaginary with a long history and is very difficult to destabilize. Zaffaroni is also mistaken when he argues that, in the context of femicides, "obscure cases" – the cases of crimes whose perpetrators are not sentenced – are not a problem, because quantitatively speaking most of these crimes are committed by people who are known and easily identifiable. This claim is mistaken, because the problem is not in any way quantitative but rather qualitative, hermeneutical, a matter of understanding an issue. The problem, moreover, is not the identification of perpetrators, but rather the treatment, resolution, and processing of cases of femicide by judges, prosecutors, and other state agents. And Zaffaroni is mistaken because mass graves, filled with the corpses of those exposed to domination and sexual massacre, are not only found in Colombia, Central America, and Mexico; they can be found in Argentina, in our country, as well, and they were created very recently. Without understanding and connecting public crimes and war crimes, on the one hand, with gender crimes that remain anonymous and unresolved, on the other – the crimes that, according to the illustrious Zaffaroni, cause the numbers of the law's "obscure cases" to swell – we cannot shed light on the role or the meaning of any act of sexual aggression. And vice versa: one field clarifies the other.

This is why I say that no strictly legal solution to the problem is possible. The law can only typify, can only point to the tip of the iceberg; that is, it can only make *some* forms of violence emanating from the structure of gender domination – and of misogynist, homophobic, and transphobic punishment, meted out to those who challenge or flout patriarchal mandates – into punishable crimes. The crux of Zaffaroni's argument, and of the legal perspective in general, with its limited understanding of what can be legislated, points to a misconception, a false understanding of the intimate realm as the space in which all gender violence unfolds. Today, the cutting edge of feminism contests such claims about the libidinal and erotic nature of gender violence, and it classifies these crimes as crimes of power in a complex sense.

As I write, I become more and more disenchanted by the presumptuousness of Zaffaroni, an intellectual whose intelligence cannot be

doubted. I wonder: might it be that the distinguished professor makes more of an effort when he speaks to audiences abroad than when he addresses us, his people? Because we have to pass some kind of verdict on the terrible, misogynist detour taken by someone who has made so many contributions to the field of critical criminology and to the effort to humanize the law. We have to somehow judge and explain the ignorance of a learned academic like Eugenio Raúl Zaffaroni. Perhaps what we can conclude is that he has not made himself available for open and unthreatened dialogue with the sophisticated contributions that feminism has made to this field. It's not advisable to opine without thinking first, and one cannot really think without opening oneself up to what has already been thought, even if this means that one risks learning something explosive.

9

By Way of Conclusion

A Blueprint for Reading Gender Violence in Our Times

I developed this schema or guide for the analysis of gender violence in response to a request from Commissioner Howard Augusto Cotto, the Director General of the National Police of El Salvador, conveyed by Roxana Delgado, the country's Parliamentary Advisor. The text was meant to precede a diagnostic manual on gender. In 2018, I was asked to evaluate the operative capacity of El Salvador's National Civil Police force as well as its ability to cope with crimes against women and people with non-normative sexualities, both within the organization and in Salvadoran society in general. My first step was to formulate the following guidelines, which I now think of as a concluding schema that can tie together and articulate the chapters in this book. I drew on the concepts that my cumulative experience had suggested to me, during the twenty-five years I had spent working both to understand and to stop the stream of gender violence victimizing society. When I say that this violence victimizes all of society, I do so emphatically, because this kind of violence does not target a "minority," as is thought. Ultimately, we have to understand that gender violence is the incubator of all other forms of violence, from theft to war, their hothouse and breeding ground. Violence in all its forms is learned here. The family, the house, the home, are the sites of the first oppressive and violent pedagogy, which is later replicated at all scales.

This blueprint for reading and the categories that make it up were composed after and developed on the basis of my earlier

works, including: *Las estructuras elementales de la violencia* (The Elementary Structures of Violence; Segato 2003a); *La escritura en el cuerpo de las mujeres asesinadas en Ciudad Juárez* (The Writing on the Bodies of Murdered Women in Ciudad Juárez; Segato 2006b, republished as chapter 1 above); *Las nuevas formas de la guerra y el cuerpo de las mujeres* (The New Forms of War and Women's Bodies; Segato 2014b, republished as chapter 2 above); *La crítica de la colonialidad en ocho ensayos y una antropología por demanda* (Segato 2015a; English translation: *The Critique of Coloniality: Eight Essays*; Segato 2022), and *Contra-pedagogías de la crueldad* (Counter-Pedagogies of Cruelty; Segato 2018). The text also draws on various contributions I made in meetings with governmental and non-governmental organizations, written up in the form of reports, rulings, and a survey. Since 2003, I have worked with a range of organizations in both Mexico City and Ciudad Juárez, especially with Nuestras Hijas de Regreso a Casa (May Our Daughters Return Home), in seminars and workshops on femicide. I have also worked with women's organizations in El Salvador, including Las Dignas, Ormusa, Las Mélidas, and the Instituto Salvadoreño para el Desarrollo de la Mujer (Salvadoran Institute for Women's Development); in Guatemala, with a consortium made up of Mujeres Transformando el Mundo (Women Changing the World), the Unión de Mujeres de Guatemala (Women's Union of Guatamala), and the Equipo de Estudios Comunitarios y Acción Psicosocial (Team for Community Studies and Social Action); in Nicaragua, with the organizations Aula Propia (Our Classroom) and La Corriente (The Current); in Honduras, with the Observatorio Nacional de la Violencia (National Observatory on Violence) at the Universidad Nacional Autónoma de Honduras; and in Colombia, with Jurisdicción Especial para la Paz (Special Jurisdiction for Peace). My reflections here also draw on my work as an expert on misogynist violence at the Tribunal de Direitos das Mulheres (Tribunal on Women's Rights) organized by Mugarik Gabe and a meeting of twenty-two organizations in Bilbao in 2013, as well as my work as a judge on the Permanent Peoples' Tribunal, where I worked on the session on Mexico, in particular on a hearing on crimes against women held in Chihuahua in 2014. The chapter also builds on my work serving as an expert witness for the Public Ministry of Guatemala from 2014 to 2016; during these years, I worked on the case of Sepur Zarco in particular, a case that involved the crimes of sexual and domestic slavery, the enslavement

of indigenous Mayan Q'eqchi' by Guatemalan military officials during the authoritarian period. Finally, I also draw here on my work as judge in the Tribunal de Justicia y Defensa de los Derechos de las Mujeres (Tribunal for Justice and the Defense of Women's Rights) during the Foro Social Panamazónico (Pan-Amazonian Social Forum) held in Tarapoto, in the Peruvian Amazon, in 2017.

On the basis of these efforts and the contributions to the field of international activism that I have mentioned, I went about compiling the set of theoretical concepts and categories that I present very succinctly in the next section. These make up a conceptual framework that seeks to shed light on the problem of gender violence in Latin America, on the overwhelming scandal of its frequency and its forms of cruelty.

Conceptual Framework: Gender Asymmetry and What Sustains It

The greatest challenge and impediment to the effort to eliminate the various forms of violence and oppression that women suffer in domestic spaces, in institutions, and on the street is the first, indispensable step on the way to achieving this objective: *moving the question of patriarchy from the margin to the center of the paradigm through which we understand the world and seek solutions.* Without this paradigm shift in our ways of thinking about the "woman question," we will only be capable of making decorative changes, superfluous alterations; we will not be able to resolve the problem of gender inequality. This is because *resolving the problem of gender inequality is not solely and simply resolving a problem for men and women. It is a matter of dismantling structures: (1) the binary asymmetry between problems of general interest that are clearly particular and those seen to be of particular interest and thus the remainder of the general, not fully political; and (2) the masculine mandate that sustains this asymmetry, this binarism that shapes cognition, subjectivity, and the political order.* Being capable of rerouting history means being capable of *taking on the false and damaging system of minoritization* and understanding, for example, that *violence against women is not the problem of a particular group in society, but rather the seedbed, hothouse, and breeding ground of all other forms of violence and domination.*

What hides the centrality of relations of gender in history is precisely the binary character of the structure that makes the public sphere all-encompassing, totalizing, global, on the basis and at the expense of its residual other: the private, personal domain. In other words, what hides the centrality of gender is the relation between political and extra-political life.

This binary determines the *existence of a universe whose truths are assigned universal value and seen as matters of general interest, one whose statements are seen as emanating from a masculine figure pitted against his others, whose concerns are seen as matters of only particular importance, as marginal, minoritarian.* The irreducible gap between the universal and central, on the one hand, and the marginal and residual, on the other, shapes a binary structure that is oppressive and therefore inherently violent in a way other hierarchical orders are not. It is precisely *because of the mechanics of minoritization that operate within and reproduce the binary structure of modernity that crimes against women, like the feminine position in the patriarchal imaginary more generally, are not justly recognized by the law and are never seen as fully public.*

The Two Axes of Gender Aggression and the Masculine Mandate

In all acts of gender aggression, two axes of communication converge. The first is *a vertical axis, from the aggressor to the victim.* Along this axis or within this relation, the aggressor addresses the victim, communicates to her that she is *part of his territory.* He lets her know that he controls her existence, and he *punishes her because he identifies in her, or attributes to her, the ability to take distance from the patriarchal order*; that is, he identifies her disobedience, her refusal of the position assigned to her by the patriarch or authority within a given territory. It is in this sense that I have argued, for instance, that *the rapist is a moralizer*, is moralizing.

Along the horizontal axis of communication, the aggressor is connected to his peers. This axis overdetermines the symbolic economy of aggression, because it is from his peers that the aggressor receives the stimulus to attack, and it is his peers – whether they are physically present on the scene or only in the aggressor's mind – whom he addresses when he displays his taking possession of his victim, his assertion of control over her. *His peers are the source of*

*the masculine mandate and the conferral of "manhood" on those
who comply with this mandate.*

In verbal aggression, in contexts of workplace harassment, for
example, the vertical axis predominates. By contrast, *the horizontal
axis is decisive in rape*, because it is along this horizontal axis that
the aggressor *meets and competes* with those who, in an archaic
imaginary, are understood as *charged with watching over and
protecting this body, keeping it safe.* Here we see a competition or
contest within the masculine order, a challenge to those who are
supposed to be able to offer protection to the body under attack.
This relation of conflict and challenge, which takes place on *the
feminine body understood as a battlefield, in the context of war,
is the matrix or structure that gives meaning to rapes in the new
theater of war, or against the backdrop of the new forms of war.*

Femicide and Femigenocide

It is crucial to distinguish between *intimate femicides*, perpetrated
in the heart of interpersonal relations, and femicides in the context
of war. Despite the fact that both are crimes of gender, they cannot
be approached in the same way in police investigations or legal
proceedings. When I refer to femicides in the context of war, or to
what I also call *femigenocides*, because of their impersonal and fully
public and non-intimate character – and the fact that they cannot be
understood in terms of interpersonal relations between people who
know one another – I presuppose an understanding of the fact that
in Latin America, as in other world regions, an *informal theater of
war* is expanding. Femigenocides are less frequent than intimate
femicides, but the former are clearly spreading throughout Latin
America.

In femigenocides, the proportion between perpetrators and
victims is different than in cases of intimate femicide, when the
aggressor is intimate with his victim. In the latter cases, an aggressor
can come into contact with a limited number of victims: one or
two or at most three acquaintances or former acquaintances, for
example. The nature of interpersonal relations, of acquaintance,
limits this number. In the case of femigenocide, those who give the
orders and the perpetrators themselves, in the context of informal
wars fought by armed corporations, can come into contact with
many more victims, killing and committing femicides in much

greater numbers because their motive is not intimate or interpersonal but military and fully public.

It is important to note here that, although more men are killed in homicides than women, femicides are unjust not least because, as women, we are killed much more than we kill. Women do not kill; data indicate that the numbers of women who murder is very low. However, women are murdered, and this disproportion is unjust.

Two Legal Categories Awaiting Recognition in International Human Rights Law

Two advances in the effort to formulate legal categories in the field of international human rights law remain pending: (1) we have to generate a specific category as well as guarantees and sanctions for the practices associated with the *new forms of war*; that is, we have to recognize and give names to the set of informal conflicts that are leading to the increasing rates of death now characteristic of our continent; and (2) we have to develop a convention against femigenocide.

The international law associated with human rights is different from the laws of states because it has a much greater impact in the mind of people; in other words, it has a symbolic efficacy capable of impacting and transforming people's sensibilities. These rights are much more widely publicized, and this matters because a system of justice without publicity is innocuous.

The guarantees of justice, reparation, and conflict resolution that the state offers seem to me insufficient in all of our countries, because historically the relationship between the state and society in Latin America is very different from the relationship between the state and society in Europe. In Europe, the state–society relationship has a different history, one in which the state is the result of a social history. In our world, this is not the case, and the state is a continuation of the colonial state, translated into our territory. Anyone can see this by knocking at the door of a public office, a state official; everything about the space one then enters is alienating. The population perceives – and is not wrong to perceive – the state order as alien. In fact, it perceives that the history of the state is a colonial history, and that the current state represents the transposition of the overseas metropolitan state, its displacement onto the territories of Latin American nations. But this state served the same purpose as

the colonial state: that of administering people's lives and managing from afar the resources of territories. It has never *not* been external to what it administers; this relationship of exteriority persists to this day. This contradicts the faith in the state characteristic of the world of letters, but until this exteriority is corrected, any such faith will be very hard to sustain.

On the Importance of a Comparative, Transnational Approach

We have to cross borders. A *comparative perspective* and *regional and global approach*, especially when it comes to understanding femigenocides, is essential for understanding the matrix for these crimes. What is their importance? Why are there crimes that reproduce *patterns that, with variations, repeat themselves and remain recognizable* throughout the Latin American region? I am thinking especially of the *triangulation that brings together lethal aggression by sexual means, the targeting of a victim, and the individual or collective antagonist whom the aggressor seeks to address.*

Certain practices like this *triangulation*, or *the destruction of enemy morale in and through the profanation of women's bodies*, recur in the theater of informal war. The regularity of this practice comes into view when we compare different national contexts, and this is why comparative study is fundamental. What do we have to look for in such study? The regularity of certain acts, their systematicity. This is because power's way of agreeing on, deciding on, and devising its strategies cannot be observed directly; only their consequences can. When I refer to "power," I have in mind the various kinds of state, parastate, military, and paramilitary power, legal and illegal; my definition of the term "parastate" includes state agents acting in specific scenarios in a parastate capacity, or redoubling state functions in and through the parastate, as did Latin American militaries during the repressive wars in the region. This fissure in the legal order is even written into the law itself; it is *from the place of this parastate breach, this para-legality anticipated in the law, that a policeman on the street acts as both police officer and judge* and is authorized to commit extrajudicial executions. It is possible to argue that policemen in the street act as judges, as the doubles of state judges, because if their lives or the lives of people around them

are seen to be in danger, they are authorized to process, deliberate, judge, sentence, and summarily shoot the person they consider to be putting others at risk. This gives rise to extrajudicial executions, which in Latin American countries, including Brazil, for example, are very frequent. Another kind of case that involves a state agent with a key or space for acting in a parastate capacity is found in all countries in which police can work two shifts, as it were, one state and the other parastate, spent working as private security guards or in the police forces of corporations.

The regular patterns that can be observed in different national contexts allow us to suggest some protocols for interpreting what is behind the cases in question. And it is therefore possible for the investigation of these cases to draw on the idea of a *modus operandi*, which police investigators use to solve cases involving common crimes as well as cases of serial killing. *In the case of the crimes committed by parastate, armed corporations against the lives and dignity of women – whether these corporations are criminal or paramilitary organizations – the notion of a* modus operandi *proves indispensable for making sense of the regularity and recurrence of certain kinds of crimes, with a recognizable and systematic structure.*

The Parastate, New Forms of War, and Femigenocide

Latin American countries have something in common, namely that in all of them we can see the ease with which *the parastate sphere of control over life* is established, expanded, swollen, and inflated. This parastate sphere implies the existence of an *illegal economy* that produces enormous sums of money – sums so enormous that they allow for the accumulation of capital and the acquisition of purchasing power (over votes, alliances, weapons, and so on) on a scale that brings about *the collapse of institutional controls*. I have called this sphere the *second state* and, later, a *second reality*; in some cases, I refer to the *outsourced state* or *subcontracted state*. This parastate sphere of control over life, which is expanding so easily in Latin America, is characterized by a *non-state economy (income and/or undeclared capital)* and by *a set of laws and armed corporations that do not belong to the state. There are parastates in which state agents act in parastate capacities and criminal parastates*

made up of gangs and mafias engaged in various kinds of business dealings.

It is very difficult for jurists, lawyers, and state administrators to accept the idea that such a parastate sphere of control over life exists. Those who are educated in the field of law canot accept the idea that there is a sphere of such enormous importance where control over life is exercised by forces *other* than the law. But it is important to understand its existence if our goal is to strengthen the law by developing strategies capable of affecting and overpowering the uncontrollable octopus doing so much damage to our countries.

On the Need to De-Libidinize Sexual Aggression and to See Acts of Gender Aggression as Fully Public Crimes

I have been reflecting on violence since the 1990s. This work began in a Brazilian prison, where I started listening to men found guilty of rape on the street. After this work, I moved on to the study of the femicides in Ciudad Juárez, and on the basis of the work I did in that city I began to specialize in femicides committed in the context of war, especially the new forms of war characteristic of Mexico, El Salvador, Colombia, and Guatemala. Along this journey, as I worked through the evidence, I recognized the need to call the category of the libido, or desire, into question. I concluded during my journey that it is crucially important to understand that the act of *raping* a body is not necessarily, as common sense assumes, the result of uncontainable desire; rather it is an *exhibitionist act of domination. It is in this spectacle of potency, staged for the perpetrator's peers, and in the narcissistic satisfaction that the perpetrator takes in the act that we can locate the libido. This is why I argue that rape – from everyday rape to rape committed in the context of war – should not be spoken of as a "sexual crime," but rather as a "crime committed by sexual means," since the motivation for the crime does not derive from the realm of sexuality but from the sphere of domination.*

The idea that sexual assault derives from sexual desire is very difficult to dislodge from the collective imagination; it is extremely difficult to *de-libidinize sexual* assault, because in the world of modernity, which gives rise to and manages modern positive law, everything having to do with women, *everything*

that happens to us, is relegated to the intimate realm. What happened in the case of the femicides in Campo Algodonero, in Ciudad Juárez is a very clear example.[1] In 2009, the Chilean judge Cecilia Medina Quiroga presided over the Inter-American Court of Human Rights in Santiago de Chile and had to issue a separate, concurring opinion in the case of the killings in the cotton field, because the Court would not accept the argument that the case involved torture by sexual means. Why wouldn't the Court accept this? My interpretation is that the other judges would not accept the claim because accepting that these were instances of torture by sexual means would mean accepting that they were public attacks on bodies and not, as we always assume in cases of sexual violence, attacks with their source in an uncontrollable desire to take women's bodies. Already during my first encounters with rapists in a prison in Brasília, where I spent more than a year making many recordings, I began to realize that I was not dealing with what we consider to be sexual desire.

In the theater of war, war itself is being changed into a matter of conflict between armed corporations of various kinds: state armies acting in a parastate capacity in the context of repressive wars; groups of assassins working in gangs and other formations, including mafias; and even competing political factions and parties. This type of conflict affects and challenges the state's capacity to protect the bodies of women and children. The *enemy in war is demoralized in and through a sexual attack on its women.* As is well known, troop morale is something that is cultivated, taught, and promoted in the formation of armies; every army offers training in the skills necessary for the waging of war and training meant to shore up the morale and confidence of the troops, encouraging them. Raping the women associated with an enemy people or faction is a way to defeat this enemy's morale and to lower its self-esteem. *Rape brings about the moral destruction of the corporate group that is supposed to be charged with protecting the bodies now under attack.* This is why scholars specializing in the new forms of war in the Middle East speak today of a form of *feminized war*, one that is registered on the bodies of women. This is a cowardly and very cheap war that destroys the edifice of society in and through the rape and killing of women. This was very clear in Guatemala, and it is what I managed to demonstrate through an anthropological survey on gender: attacking the bodies of the women associated with a community or a faction, attacking these bodies sexually, often to the point of

death, is like planting an unexpected bomb beneath a building, at its very foundation, in order to blow it up cheaply and quickly.

As I have said, we have to cross national borders and compare the situations in various countries in order to perceive the *continental and global diffusion of violent practices and the recurrence of structures*. The feminization of war is one of such recurring tendencies, already noted and named as such by scholars who analyze new forms of war in the Middle East. The tendency is spreading and is a characteristic of the parastatification of Latin America. Today, repressive forces in Guatemala, gangs in El Salvador, organized crime in Mexico, and paramilitaries in Colombia all have acted and continue to act this way. In Guatemala, it was possible to establish that this model of action had found its way into the instruction manuals for waging the repressive wars of the 1980s.

Expressive Violence: The Specificity of the Message, the Capacity for Cruelty, and Territorial Domination

As I have said, it is impossible to see the decisions that power makes, because secrecy is inseparable from the workings of power, a characteristic of the agreements it signs. So what is it that we can see? *We can only see certain recurring epiphenomena.* For example, in various Latin American countries, *systematic sexual attacks on women recur* as a way of dissolving or destroying local autonomy, community, rootedness. In the case of Colombia, in regions where there is still unclaimed land – in other words, in places like the Pacific coast of Colombia, where the land has been occupied for hundreds of years by small farmers or sharecroppers and is protected by the text of the 1991 Constitution – *the way of taking this territory is by cruelly attacking the bodies that are not those of the armed enemy, bodies that, in an archaic imaginary like the imaginary of gender, are not young recruits but rather those of innocent women and children.* It does not matter that in some circumstances there may have been a woman at the scene of the crime, a female torturer or member of private security forces or the army or gangs, because in the archaic imaginary, through which we see the world, a woman is not an armed enemy, not a military antagonist. *This is why cruelty brought to bear on to the bodies of women and children, which is*

not instrumental or directly military cruelty, is different, a message of gratuitous cruelty, of arbitrary will, without purpose. This kind of message can only be sent when one exercises unrestricted territorial control. This is how the parastate and its sovereigns announce their existence.

In other words, *the destruction of a body by sexual means, when this body is not a soldier's, is an expression of sovereign will. I apply my cruelty by destroying such a body through acts of sexual aggression. I profane the body, demoralize the person and her protectors, in order to display my will, my jurisdictional control over territories and lives. I display my impunity.*

Expressive Violence: The Spectacle of Impunity

When I studied the case of Ciudad Juárez, I began to identify this structure, this schema. The violence in the city was not a "problem of impunity" that had to be resolved, but rather something a bit different: it was a matter of displays of impunity, which in fact constituted *a display of power without institutional controls*, that is, an *announcement of the inability of institutions to control the perpetrators, to restrain their power.*

A Watershed in the History of War

What I have written above has led me to conclude that at some point in recent history a transformation in the history of war took place. Some scholars would situate this shift in the war in the former Yugoslavia; apropos of this war, Elizabeth Odio Benito (2001), a judge in the ad hoc tribunal and later the International Criminal Court, suggests in an important essay on war and women that she thought she could perceive in the accounts of witnesses a previously unknown form of cruelty directed against women's bodies. This was an excessive cruelty: it was not enough to rape women; their bodies had to be destroyed through sexual aggression, as was also the case in Guatemala and El Salvador. *We have thus seen a shift in the recent history of wars: as informal wars spread, their purpose comes to involve the annexation of bodies as territories, the taking of territories and of the women who live there. Raping these women or taking them as concubines or sexual slaves – these acts have as*

*their objective a destruction of women's bodies, their moral and
physical murder by sexual means.*

In other wars, throughout the history of armed conflict, *from
tribal wars to wars between states, women have suffered from the
collateral damage of war. In the new forms of war, they come to
be tactical targets* for reaching the aim of destroying the enemy's
cohesion and morale, whether the enemy is an armed corporation,
a faction, or a people. *This is why I say that war today has been
feminized.*

The Masculine Mandate and the Reproduction of Military Labor

Crimes against women committed in the context of informal wars,
whether these are perpetrated by repressive paramilitary groups or
criminal gangs or other groups, are territorial: they seek to enter and
take territories, to destroy or lay claim to property, and to dissolve
communal solidarity and local rootedness. Their aim is always
to appropriate, to pillage. This is why I have insisted on various
occasions that in Latin America the conquest never in fact came to
an end and remains ongoing, fully operational in the current phase
of the historical project of capital, when primitive accumulation
returns. Taking lands for the practice of extractivist agriculture, for
mining, or for exploitation on the real estate market are all ways
to generate wealth today. For this reason, it is crucial to cleanse
territories of their traditional inhabitants. For example, the city of
Buenaventura, on Colombia's Pacific Coast, is one such case. Here
corporate capital's aim is to build three ports to make the city into
the epicenter of trade after the signing of a Trans-Pacific treaty and
into an enormous complex of hotels. To this end, it's necessary to
erase the people who reside there and who are the bearers of recog-
nized constitutional rights. It was precisely here that I was asked a
question that brought about a shift in my way of thinking about
violence in the present. A woman asked me from the audience:

> How is it possible to bring this kind of war to an end when it cannot
> be ended by a peace treaty because it is not a declared war and the
> state plays no role in a war of pillage against us? This isn't a war
> like the FARC's war against the state, right, because it's not a war
> fought by the state? How can there be a peace treaty between gangs

that have been killing and terrorizing people and clearing lands in order to allow for the entry of businesses? How do we end this kind of war?

Until that moment, I had never thought of it, but I managed to offer an answer that continues to guide my research today:

> *By dismantling the masculine mandate, because without obedience to the masculine mandate, no military workforce can be recruited,* and without human resources for serving, this kind of service cannot be carried out.

In order to reach such a longed-for goal, ending the repetition of violence, we urgently need to think how, through what processes, it might be possible to take apart the masculine mandate, which obliges men to surrender their capacity for empathy and instead display their own potency and their capacity for cruelty. In this way, men are turned into cannon fodder, and they die before they should. *It is crucial to convey the message that the first victims of the masculine mandate are men, who fall victim to premature death and who live their lives in states of distress. We are thus faced with the urgent task of discouraging young men and boys from distorting themselves and giving in to the masculine mandate's demands for cruelty, demands that, in many places in Latin America, have become more deadly today than ever before.*

Notes

Foreword

1 Mixed-race indigenous/white, or urbanized indigenous.
2 Recent debates are interrogating this position, not to dismiss the argument about power and domination, but to reassess the role of sex and desire therein (Baaz and Stern 2018). Research shows that the desire for power and violent domination is often sexualized, that is, sexual desire might be strongly linked to the desire to dominate, creating a mix in which violence and sex are not always easy to distinguish (see Boesten and Gavilán 2023). Discourses about men's "innate sexual urges" likewise feed into myths around both sexual desire and power and domination, or what Segato calls the "masculine mandate."
3 Crenshaw speaks of white feminists, referring to the struggles for women's rights of African American women. In the context of Latin America, a similar division is apparent between urban educated feminists of European descent, such as Segato and Lugones, and indigenous women.

Introduction

I am grateful to Gustavo Augusto Gomes de Moura and to Noemí Pérez Axilda for their careful readings of this introduction and the suggestions that helped me to improve it. *Translator's Note*: Parts of this text were published in a revised form as Rita Laura Segato, "Manifiesto en cuatro temas," *Critical Times: Interventions in Global Critical Theory* 1, 1 (2018), pp. 212–25; and in English as "A Manifesto in Four Themes," translated by Ramsey McGlazer, *Critical Times* 1, 1 (2018), pp. 198–211.
1 For a clarifying account of how the category of "gender ideology" was

produced, see Maria das Dores Campos Machado (2016). Her text shows, for example, that the concept was publicized in the title of a book by Jorge Scala, a Catholic conservative from Argentina in 2010, translated into Portuguese the following year.

2 See http://infocatolica.com/?t=noticia&cod=26336.

3 *Translator's Note*: Throughout this book, in keeping with the author's preference and for the sake of clarity, idiom, and flow, I have used "femicide" as a translation for *feminicidio*, the term that Segato uses most often to refer to the killing of women. In Spanish, two terms, *femicidio* and *feminicidio*, both circulate; among some Latin American feminists, choosing one term over the other implies taking a position within ongoing debates. These are not, however, debates in which Segato engages directly or to which she devotes sustained attention. For more on these debates, see chapter 5.

4 I thank Ondina Pena Pereira for the idea that women's politics are topical as opposed to utopian, and I thank my late advisor, John Blacking, for his consistent emphasis on the primacy of process in the making of music as a communal form. The process mattered more, he said, than the product (Blacking 1970).

Chapter 1 The Writing on the Bodies of Murdered Women in Ciudad Juárez: Territory, Sovereignty, and Crimes of the Second State

This chapter was first published in 2006 by the Universidad del Claustro de Sor Juana in Mexico and then in 2013 by the publisher Tinta Limón in Argentina, which included it in the volume *La escritura en el cuerpo de las mujeres asesinadas en Ciudad Juárez*.

1 *Translator's Note*: The phrase "acting out" appears in English in the original.

2 Alma Brisa's remains were found among sunflowers in the same plot of land in the center of the city where Brenda Berenice's body had been found. Brenda, daughter of Juanita, was one of the key collaborators on the project Epikeia.

3 For example, in November 2004, I attended a demonstration organized by victims' mothers and other relatives at the Centro Cívico de Coyoacán in Mexico City. The demonstration's organizers demanded an end to impunity for the real murderers and called for the release of "el Cerillo," a young man held prisoner and, according to the protesters, falsely accused of the crimes. The lawyer Irene Blanco's work is well known by now; this work involved the defense of Latif Sharif, who was falsely accused of the crimes and whose son was attacked. Consider as well the mothers' protests against the imprisonment of members of the gang Los Rebeldes, for the same reason.

4 *Translator's Note*: The word "smokescreen" appears in English in the original.

5 He was beaten and left for dead on a street in Mexico City in 1999, when he was in the middle of researching his book; this attack led to the loss of all of his teeth and forced him to spend more than a month in the hospital.

6 I presented the results of this research in Segato (2003a).

7 *Translator's Note*: In Spanish, one meaning of *autor* is "perpetrator." Segato plays on the word's multiple meanings – agent, cause, author of a text, perpetrator – here and throughout this chapter.

8 This is the argument, for instance, in Radford and Russell (1992).

9 On this contemporary way of "listening" to the text in the work of Bakhtin, Lacan, Levinas, and others, see Patterson (1988).

10 See Koyré (2017 [1945]).

11 Giorgio Agamben (2005) recognizes the notion of a "dual state" as necessary for describing the workings of totalitarian systems like Fascism and Nazism. This notion seeks to account for the fact that these systems had both constitutional frameworks and secondary systems of rules, proper to a "second state," that kept the system functional and cohesive.

12 *Translator's Note*: In Spanish, the word *corporación* has a somewhat broader range of reference than the English cognate "corporation." The Spanish word is used more frequently than the English to refer to groups or organizations that are not necessarily businesses. Throughout this book, I have nevertheless used the word "corporation" to translate *corporación* to underscore the centrality of capitalism and of neoliberal capitalism in particular to Segato's argument.

13 I read this text at an event held on November 29, 2004, featuring Isabel Vericat's book *Ciudad Juárez: De este lado del puente* and the play *Lacrimosa* by Rogelio Sosa, performed by Lorena Glinz, together with the Spanish prosecutor Carlos Castreana and Isabel Vericat.

14 "*Oidipous*, the feet that walk toward knowledge, the famous Oedipus who understood the famous enigma but did not recognize that it is *tuché* [a divine cause that eludes human logic, and a word that refers to the arbitrariness of human destiny and History] that governs everything, as Jocasta uselessly foresees" (Vicentini 1999: 61). For this reason, even after he resolves the riddle, he remains trapped within its terms. In fact, Oedipus and his whole family are engulfed by the question the Sphinx poses: "What is the creature that walks on four legs in the morning, two in the afternoon, and three in the evening?" The deciphering of the riddle's apparent meaning does not lead to the dissolution of the hidden plot that determines belonging to the structure of History.

15 A Mexican journalist murdered on May 30, 1984.

Chapter 2 Women's Bodies and the New Forms of War

This chapter was first published in 2014 by Pez en el Árbol (Mexico City) in the volume *Las nuevas formas de la guerra y el cuerpo de las mujeres*.

1 For another account of this transformation of disciplinary techniques, see Deleuze (1992).
2 *Translator's Note*: The phrase "hidden script" appears in English in the original.
3 See Attorney General Eric Holder's statement to the *New York Times*, published on October 20, 2013. Barry Grey (2013) summed up the newspaper's report this way: "As the *New York Times* wrote on Sunday, 'The government also prefers to settle with big companies rather than indict them, fearing that criminal charges could unnerve the broader economy.' Last March, in testimony before the Senate Judiciary Committee, Holder acknowledged that the failure of the Obama administration to prosecute a single major Wall Street banker was part of a calculated policy. He told the committee that the big banks are so large and powerful that 'if we do bring a criminal charge, it will have a negative impact on the national economy, perhaps even the world economy.'"
4 See the interview with Oslain Santana, published in *Jornal O Globo* on October 19, 2013.

Chapter 3 Patriarchy, from Margin to Center: On Discipline, Territoriality, and Cruelty in Capital's Apocalyptic Phase

Partial versions of this chapter were published as "Patriarchy from Margin to Center: Discipline, Territoriality, and Cruelty in the Apocalyptic Phase of Capital," in *South Atlantic Quarterly* 115, 3 (2016), pp. 615–24.
1 According to Oxfam (2016), in 2010, 288 people had as much wealth as the poorer half of the world's population. This figure was 177 in 2011, 159 in 2012, 92 in 2013, 80 in 2014, and 62 in 2015.

Chapter 4 Coloniality and Modern Patriarchy

The text of this chapter is taken from the essay "Género y colonialidad: en busca de claves de lectura y de un vocabulario estratégico descolonial, " published in Karina Bidaseca and Vanesa Vazquez Laba (eds.), *Feminisimos y poscolonialidad. Descolonizando el feminismo desde y en América Latina* (Buenos Aires: Editorial Godot, 2011), and Aníbal Quijano and Julio Mejía Navarrete (eds.), *La cuestión descolonial* (Lima: Universidad Ricardo Palma-Cátedra América Latina y la Colonialidad del Poder, 2010). *Translator's Note*: For slightly different versions of these pages, see also Rita Laura Segato, *La crítica de la colonialidad en ocho ensayos* (Buenos Aires: Prometeo Libros, 2015), and; *The Critique of Coloniality: Eight Essays*, translated by Ramsey McGlazer (New York: Routledge, 2022).
1 On this experience, see Segato (2003c).

2 For a list of transgender identities in historical and contemporary societies, see Campuzano (2009a: 76).
3 *Translator's Note*: The word "body-snatching" appears in English in the original.
4 On these dynamics, see Benhabib (1992); Cornell (1998); Warner (1990); West (1988).
5 I described this difference between worlds in an article on the communities in Recife practicing the Afro-Brazilian religion of Nagô Yoruba (Segato 2005 [1986]).
6 On the co-emergence of the colony, modernity, and capitalism together with the categories of "Europe," "America," "race," the "Indian," the "white," and the "black," see Quijano (1991; 2000); Quijano and Wallerstein (1992).

Chapter 5 Femigenocide as a Crime Under International Human Rights Law

Published in Rosa Linda Fregoso and Cynthia Bejarano (eds.), *Feminicidio en América Latina* (Mexico City: UNAM-CIIECH/Red de Investigadoras por la Vida y la Libertad de las Mujeres, 2011). This chapter is a significantly expanded version of an article published as "El derecho a nombrar el sufrimiento en el derecho", in Dalila Polack and Leandro Despouy (eds.), *Voces y silencios de la discriminación* (Buenos Aires: Asamblea Permanente por los Derechos Humanos/ Agencia Española de Cooperación Internacional para el Desarrollo/ Relatoria Especial sobre independencia de jueces y abogados, 2010).

1 This preceded and encouraged recent efforts in Latin America, including the amicus brief filed by the Colombian nongovernmental organization Dejusticia with the First Criminal Court of Abancay, arguing that rape should be considered a crime against humanity in the context of the armed conflict in Peru (Uprimny Yepes et al. 2008). See also the important studies in progress by Argentine researchers and their teams. These researchers include María Sondereguer and Violeta Correa, who are working on a project on "Sexual Violence and Gender Violence in State Terroritsm" and Alejandra Oberti, who leads the oral history archive Memoria Abierta (Open Memory). In Colombia, researchers including Viviana Quintero Márquez and Silvia Otero are working on a project led by María Emma Wills, presented to Colcencias (Colombia's Administrative Department of Science, Technology, and Innovation) in 2007; this project is called "'We don't hear what her body says. We don't see what her body shows': The State Removal of Feminine Corpses in the Context of Armed Conflict." See also the work of Karen Quintero and Mirko Fernández, who work with the Gender Unit of the Equipo Colombiano de Investigaciones Antropológico Forenses (Colombian Team for Research in Forensic Anthropology). These last two researchers have worked not only in

Colombia but also in Guatemala and East Timor (see Fernández 2009; Otero Bahamón et al. 2009). All of the researchers I have named seek to make visible what the modern privatization of sexuality and the resulting "shame" of judges and prosecutors has removed from public view, that is, what happens to the bodies of women victimized by the new forms of war.

2 *Translator's Note*: The Minnesota Protocol on the Investigation of Potentially Unlawful Death (2016) was first proposed in 1991 as the Manual on the Effective Prevention and Investigation of Extra-Legal, Arbitrary, and Summary Executions, which became known as simply "the Minnesota Protocol." The "Istanbul Protocol" refers to the Manual on Effective Investigation and Documentation of Torture and Other Cruel, Inhuman or Degrading Treatment or Punishment (1999).

3 See, for example, the denunciation that appears in the *Informe de la Comisión de Expertos Internacionales de la Organización de las Naciones Unidas, Oficina de las Naciones Unidas contra la Droga y el Delito, sobre la Misión en Ciudad Juárez* (Report by the Commission of International Experts of the United Nations, United Nations Office on Drugs and Crime, on the Mission in Ciudad Juárez), presented by Carlos Castresana to the Office on Drugs and Crime in November 2003 (United Nations 2003).

4 Esmeralda Herrera Monreal, Claudia Ivette González, and Laura Berenice Ramos Monárrez were found dead, with their bodies showing signs that they had been subjected to sexual torture, on November 6 and 7, 2001, in the area known as Campo Algodonero (Cotton Field), in Ciudad Juárez, Chihuahua. On November 28, 2009, ten days after the Inter-American Court announced its verdict, Jesús Alfredo Santos Portillo, the son-in-law of Marisela Ortiz, co-founder and co-president of the NGO Nuestras Hijas de Regreso a Casa (May Our Daughters Return Home), was also found murdered in Ciudad Juárez; he was 27 years old. Flor Alicia Gómez López, who was 23 years old and the niece of Alma Gómez Caballero, of the organization Justicia Para Nuestras Hijas (Justice for Our Daughters), suffered the terrible fate of being kidnapped, raped, and tortured in the town of Tomochi, also in the state of Chihuahua. Mentioning this is important because it allows readers to understand the gravity of the problem that I am addressing.

5 *Translator's Note*: See introduction, note 3, on the use of the term "femicide." The debates among some Latin American feminists over the two terms, *femicidio* and *feminicidio*, including the debates between Ana Carcedo and Marcela Lagarde referred to below, are not ones in which Segato herself participates directly, although this chapter attests to her indirect engagement with them.

6 I am grateful to the lawyer and legal scholar César Augusto Baldi for offering clarification of this connection.

Chapter 6 Five Feminist Debates: Arguments for a Dissenting Reflection on Violence Against Women

1 *Translator's Note*: In the area known as Campo Algodonero, outside Ciudad Juárez, the bodies of eight women were found in 2001. In 2007, the Inter-American Commission of Human Rights brought a case before the tribunal, arguing that Mexico was responsible for the deaths of Claudia Ivette González, Esmeralda Herrera Monreal, and Laura Berenice Ramos Monárrez. In 2009, "the Inter-American Court of Human Rights found Mexico in violation of human rights obligations under the American Convention of Human Rights and the Convention of Belém do Pará." See https://cja.org/what-we-do/litigation/amicus -briefs/campo-algodonero-v-the-united-mexican-states/.

2 *Translator's Note*: Here Segato is referring to the killing of Jean Charles da Silva de Menezes by plainclothes members of the London Metropolitan Police Service on July 22, 2005. The police officers mistook de Menezes for a fugitive involved in a failed bomb attempt the previous day.

3 *Translator's Note*: "Our American" refers to José Martí's 1891 essay "Nuestra América" (Our America).

4 *Translator's Note*: For more on this document, see Segato's discussion of the *Manual del Centro de Estudios Militares* in chapter 2 above.

5 *Translator's Note*: Candela Sol Rodríguez Labrador was kidnapped and killed in Greater Buenos Aires in 2011, when she was 11 years old.

6 *Translator's Note*: The Masacre de Salsipuedes or Massacre of Salsipuedes refers to an effort to exterminate the last of the Charrúa people, who were indigenous to Uruguay. The massacre took place in 1831 and was led by Uruguay's president, Fructuoso Rivera.

Chapter 7 Power's New Eloquence: A Conversation with Rita Segato

This chapter is the product of a conversation with the Instituto de Investigación y Experimentación Política (Institute for Political Research and Experimentation), held during the course of 2013 in Buenos Aires, Río Cuarto, and Brasília. The text was included in Rita Laura Segato, *La escritura en el cuerpo de las mujeres asesinadas en Ciudad Juárez* (Buenos Aires: Tinta Limón, 2013); and in Rita Laura Segato, *Las nuevas formas de la guerra y el cuerpo de las mujeres* (Mexico City: Pez en el árbol, 2014).

1 *Translator's Note*: See chapter 6, note 5.

2 *Translator's Note*: Marcos De Palma was killed in 2012, in Greater Buenos Aires, when he was 6 years old.

Chapter 8 From Anti-Punitivist Feminism to Feminist Anti-Punitivism

1 *Translator's Note*: This phrase appears in English in the original.
2 Available online at https://www.youtube.com/watch?v=prUqWHKnUd4.
3 See https://www.elintransigente.com/temas/juan-carlos-crespi-11208 .html, among other articles.
4 These are judges who let rapists go free only for the rapists to then commit more serious crimes: the killing of Micaela García in Judge Rossi's case, and the killing of both Soledad Bargna and Tatiana Kolodziez in the case of Judge López. *Translator's Note*: Micaela García was killed in Gualegay, in the province of Entre Ríos, in 2017, when she was 21 years old. Soledad Bargna was killed in Buenos Aires in 2009, when she was 19 years old, and Tatiana Kolodziez was killed in Fontana, in the province of Chaco, in 2012, when she was 33 years old.
5 Initially published as "Femicidio y los límites de la formación jurídica," in *Suplemento Las 12*, a supplement to the newspaper *Página 12*, on May 26, 2017.
6 *Translator's Note*: In 2006, police attacked a blockade formed by protestors in San Salvador Atenco, in the State of México. Two protestors were killed; dozens were sexually assaulted; and hundreds were subjected to cruel, inhuman, or degrading treatment.
7 "Last Friday, an elephant killed a well-known hunter on a reserve in the region of Gwai, in western Zimbabwe, falling on top of him after he shot it, according to reports by officials and local media on Monday. The hunter was a South African man, Theunis Botha, one of the most experienced professional hunters in the world who specialized in the hunting of big game. Botha organized trophy hunting expeditions for clients, especially from the United States, who were willing to pay thousands of dollars to kill leopards, giraffes, elephants, and other animals." See "La dramática muerte de uno de los cazadores más famosos del mundo," *El País*, May 13, 2017.

Chapter 9 By Way of Conclusion: A Blueprint for Reading Gender Violence in Our Times

1 *Translator's Note:* See chapter 6, note 1.

References

Abbott, Jeff and Julia Hartviksen (2016). "Justice for the Women of Zepur Zarco." *NACLA*, March 11. https://nacla.org/news/2016/03/11/justice -women-sepur-zarco.

Abu-Lughod, Lila (ed.) (1998). *Remaking Women: Feminism and Modernity in the Middle East*. Princeton: Princeton University Press.

Agamben, Giorgio (1998). *Homo Sacer: Sovereign Power and Bare Life*. Translated by Daniel Heller-Roazen. Stanford: Stanford University Press.

Agamben, Giorgio (2005). *State of Exception*. Translated by Kevin Attell. Chicago: University of Chicago Press.

Alvazzi del Frate, Anna (2011). "When the Victim Is a Woman." *Geneva Declaration Secretariat*, pp. 113–44. *Global Burden of Armed Violence*, chapter 4. https://peacewomen.org/system/files/global_study _submissions/GBAV2011_CH4_rev.pdf.

Alverú, Santiago (2021). "'A Kubrick no le gustaban los actores porque no podía controlarlos': Malcolm McDowell desgrana el fenónemo de 'La naranja mecánica' en 'La naranja prohibida.'" *Cinemanía*, December 16. https://www.20minutos.es/cinemania/noticias/malcolm-mcdowell -desgrana-el-fenonemo-de-la-naranja-mecanica-en-la-naranja-prohibida -4923854/.

Amir, Menachem (1971). *Patterns in Forcible Rape*. Chicago: University of Chicago Press.

Arendt, Hannah (1958). *The Origins of Totalitarianism*. Cleveland: Meridian Books.

Assis Climaco, Danilo (2009). *Tráfico de mulheres, negócios de homens. Leituras feministas e anti-coloniais sobre os homens, as masculinidades e/ou o masculino*. Master's Thesis, Florianópolis, Universidade Federal

de Santa Catarina. https://repositorio.ufsc.br/xmlui/handle/123456789/92917.

Atencio, Graciela (2003). "El circuito de la muerte." *Triple Jornada* [supplement of the newspaper *La Jornada*] 61 (September), p. 14.

Azzellini, Dario (2005). *El negocio de la guerra*. Tafalla: Editorial Txalaparta.

Azzellini, Dario (2007). "Mercenarios y nuevas guerras." *Revista Nómada* 2, 8. Universidad Nacional de General San Martín (Argentina). Interview with Darío Azzellini.

Baaz, Maria Eriksson and Maria Stern (2018). "Curious Erasures: The Sexual in Wartime Sexual Violence." *International Feminist Journal of Politics* 20, 3, pp. 295–314.

Baudrillard, Jean (1996). *The Perfect Crime*. Translated by Chris Turner. London: Verso.

Benhabib, Seyla (1992). *Situating the Self: Gender, Community, and Postmodernism, in Contemporary Ethics*. New York: Routledge.

Bhabha, Homi K. (2014). "The Right to Narrate." *Harvard Design Magazine* 38. https://www.harvarddesignmagazine.org/articles/the-right-to-narrate/.

Blacking, John (1970). *Process and Product in Human Society*. Johannesburg: Witwatersrand University Press.

Boesten, Jelke and Lurgio Gavilán (2023). "Military Intimacies: Peruvian Veterans and Narratives About Sex and Violence." *Latin American Research Review* 58, 4, pp. 762–78.

Brownmiller, Susan (1975). *Against Our Will: Men, Women and Rape*. New York: Simon & Schuster.

Cabanillas, Natalia (2009a). *Género y memoria en Sudáfrica postapartheid. La construcción de la noción de víctima en la Comisión de la Verdad y la Reconciliación (1995–1998)*. Master's Thesis, Mexico City, El Colegio de México.

Cabanillas, Natalia (2009b). "La construcción de la categoría mujer a través de la política de derechos humanos en Sudáfrica: la noción jurídica de *víctima* en la Comisión de la Verdad y la Reconciliación." Presentation at *II Coloquio en Estudios de Género Cuerpos, Tráficos y Poder*, Universidad Autónoma de Querétaro.

Campbell, Federico (2004 [1989]). *La memoria de Siascia*. Mexico City: Fondo de Cultura Ecónomica.

Campos Machado, Maria das Dores (2016). "'Ideologia de género': discurso cristão para desqualificar o debate académico e os movimentos sociais." Presented at the Congreso de la Associacáo Brasileira de História das Religiões – ABHR, Florianópolis.

Campuzano, Giuseppe (2006). "Reclaiming Travesti Histories: Sexuality Matters." *IDS Bulletin* 37, 5, pp. 34–9.

Campuzano, Giuseppe (2009a). "Contemporary Travesti Encounters with Gender and Sexuality in Latin America." *Development* 52, 1, pp. 75–83.

Campuzano, Giuseppe (2009b). "Andróginos, hombres vestidos de mujer, maricones . . . el Museo Travesti del Perú." *Bagoas* 4, pp. 79–93.

Carcedo, Ana (ed.) (2010). *No olvidamos ni aceptamos. Femicidio en Centroamérica 2000–2006*. San José de Costa Rica: CEFEMINA y Horizons.

Castells, Manuel (2010). *End of Millennium*. Second edition with a new preface. Chichester: Wiley-Blackwell.

Clastres, Pierre (1987). *Society Against the State: Essays in Political Anthropology*. Translated by Robert Hurley. New York: Zone.

Copelon, Rhonda (2000). "Gender Crimes as War Crimes: Integrating Crimes Against Women into International Criminal Law." *McGill Law Journal* 46, pp. 217–40.

Cornell, Drucilla (1998). *At the Heart of Freedom: Feminism, Sex, and Equality*. Princeton: Princeton University Press.

Crenshaw, Kimberlé (1990). "Mapping the Margins: Intersectionality, Identity Politics, and Violence Against Women of Color." *Stanford Law Review* 43, 6, pp. 1241–99.

Deleuze, Gilles (1992). "Postscript on the Societies of Control." *October* 59, pp. 3–7.

Derrida, Jacques (1982). *Margins of Philosophy*. Translated by Alan Bass. Chicago: University of Chicago Press.

Enríquez, Lourdes (2009). "Eficacia performativa del vocablo feminicidio y legislación penal como estrategia de resistencia," in Ana María Martínez de la Escalera (ed.), *Feminicidio: Actas de denuncia y controversia*. Mexico City: Programa Universitario de Estudios de Género de la Universidad Autónoma de México.

Fernández, Mirko Daniel (2009). *Protocolo sobre violencia sexual contra mujeres asesinadas en masacres perpetuadas por grupos de autodefensa durante el período 1997–2003, y factores que determinan el registro de este tipo de violencia por parte del INML y CF*. Bogotá: Instituto Nacional de Medicina Legal y Cuerpo Forense.

Foucault, Michel (1977). *Discipline and Punish: The Birth of the Prison*. Translated by Alan Sheridan. New York: Vintage.

Foucault, Michel (1983). "The Subject and Power," in Hubert L. Dreyfus and Paul Rabinow (eds.), *Michel Foucault: Beyond Structuralism and Hermeneutics*. Chicago: University of Chicago Press.

Foucault, Michel (2003). "17 March 1976," in *"Society Must Be Defended": Lectures at the Collège de France, 1975–1976*. Edited by Mauro Bertani and Alessandro Fontana; translated by David Macey. New York: Picador.

Foucault, Michel (2007). *Security, Territory, Population: Lectures at the Collège de France, 1977–1978*. Edited by Michael Senellart; translated by Graham Burchell. New York: Picador.

Foucault, Michel (2008). *The Birth of Biopolitics: Lectures at the Collège de France, 1978–1979*. Edited by Michael Senellart; translated by Graham Burchell. New York: Picador.

Fraenkel, Ernst (1941). *The Dual State: A Contribution to the Theory of Dictatorship*. New York: Oxford University Press.

Fregoso, Rosa-Linda and Cynthia Bejarano (eds.) (2010). *Terrorizing Women: Feminicide in the Americas*. Durham, NC: Duke University Press.

Gago, Verónica (2020). *Feminist International: How to Change Everything*. London: Verso.

García-Villegas, Mauricio (1993). *La eficacia simbólica del derecho. Examen de situaciones colombianas*. Bogotá: Uniandes.

Gautier, Arlette (2005). "Mujeres y colonialismo," in Marc Ferro (ed.), *El libro negro del colonialismo. Siglos XVI al XXI: Del exterminio al arrepentimiento*. Madrid: La esfera de los libros.

González, Lélia (1988). "A categoría político-cultural de amefricanidade." *Tempo Brasileiro* 92/93, pp. 69–82.

González Rodríguez, Sergio (2002). *Huesos en el desierto*. Barcelona: Editorial Anagrama.

Gorbach, Frida and Mario Rufer (eds.) (2016). *(In)disciplinar la investigación. Archivo, trabajo de campo y escritura*. Mexico City: Siglo XXI/ Universidad Autónoma Metropolitana.

Gott, Gil (2002). "Imperial Humanitarianism: History of an Arrested Dialectic," in Berta Esperanza Hernández-Truyol (ed.), *Moral Imperialism: A Critical Anthology*. New York: New York University Press.

Grey, Barry (2013). "Justice and Financial Fraud: The Blanket Settlement with J.P. Morgan: A \$13-Billion Cover-up." *Global Research*, 21 October.

Gutiérrez, Margarita and Nelly Palomo (1999). "Autonomía con mirada de mujer," in Aracely Burguete Cal y Mayor (ed.), *México: Experiencias de Autonomía Indígena*. Guatemala and Copenhagen: IWGIA/Grupo Internacional de Trabajo sobre Asuntos Indígenas.

Habermas, Jürgen (1988). "Historical Consciousness and Post-Traditional Identity: Remarks on the Federal Republic's Orientation to the West." *Acta Sociologica* 31, 1, pp. 3–13.

Hernández Castillo, Rosalva Aída (2003). "Re-pensar el multiculturalismo desde el género: las luchas por el reconocimiento cultural y los feminismos de la diversidad." *La Ventana. Revista de estudios de género* 18, pp. 7–39.

Hernández Castillo, Rosalva Aída and María Teresa Sierra (2005). "Repensar los derechos colectivos desde el género: aportes de las mujeres indígenas al debate de la autonomía," in Martha Sánchez (ed.), *La Doble Mirada. Luchas y experiencias de las mujeres indígenas de América Latina*. Mexico City: UNIFEM/ILSB.

Hirsi Ali, Ayaan (2006). "Ayaan Hirsi Ali Speaks on International Women's Day, 2006." AHA Foundation. https://www.theahafoundation.org /ayaan-hirsi-ali-speaks-on-international-womens-day-2006/.

Kaldor, Mary (2012). *New and Old Wars: Organized Violence in a Global Era*. Cambridge: Polity.

Koyré, Alexandre (2017 [1945]). "The Political Function of the Modern Lie." *October* 160, pp. 143–51.

Lagarde y de los Ríos, Marcela (2010). "Preface: Feminist Keys for Understanding Feminicide: Theoretical, Political, and Legal Construction," in Rosa-Linda Fregoso and Cynthia Bejarano (eds.), *Terrorizing Women: Feminicide in the Americas*. Durham, NC: Duke University Press.

Lemaitre Ripoll, Julieta (2009). *El Derecho como conjuro*. Bogotá: Universidad de los Andes.

Lugones, María (2007). "Heterosexualism and the Colonial/Modern Gender System." *Hypatia* 22, 1, pp. 186–209.

Lugones, María (2020). "Revisiting Gender: A Decolonial Approach," in Andrea J. Pitts, Mariana Ortega, and José Medina (eds.), *Theories of the Flesh: Latinx and Latin American Feminisms, Transformation, and Resistance*. Oxford: Oxford University Press.

Machado, Bruno Amaral and Rafael Seixas Santos (2018). "Constituição, STF e a política penitenciária no Brasil: uma abordagem agnóstica da execução das penas," in Antonio Henrique Graciano Suxberger and Bruno Amaral Machado (eds.), *Revista Brasileira de Políticas Públicas*. Special section on *Políticas públicas eboas práticas para o sistema penal*. Brasília: Editora UNICEUB.

MacKinnon, Catharine (1993). "Crimes of War, Crimes of Peace," in Stephen Shute and Susan Hurley (eds.), *On Human Rights: The Oxford Amnesty Lectures 1993*. New York: Basic Books.

Maia, Claudia de Jesús (2010). *A invenção da "solteirona." Conjugalidade moderna e terror. Moral. Minas Gerais (1890–1948)*. Florianópolis: Editora das Mulheres.

Mario, Silvia and Edith Alejandra Pantelides (2008). "Estimación de la magnitud del aborto inducido en la Argentina." *Notas de Población* 87, pp. 95–120.

Mato Nunpa, Chris (2008). "Minnesota's Genocide and Concentration Camps." *Censored News*. https://censored-news.blogspot.com/2008/08/chris-mato-numpa-minnesotas-genocide.html.

Matos Menezes, Elisa (2009). *O inimputável. Crimes do estado contra a juventude criminalizada*. Brasília: Universidade de Brasília/Departamento de Antropologia.

Mignolo, Walter (2000). *Local Histories, Global Designs: Coloniality, Subaltern Knowledges, and Border Thinking*. Princeton: Princeton University Press.

Monárrez Fragoso, Julia Estela (2006). "Las diversas representaciones del feminicidio y los asesinatos de mujeres en Ciudad Juárez, 1993–2005," in *Sistema socioeconómico y georeferencial sobre la violencia de género en Ciudad Juárez*, vol. II, Ciudad Juárez (Chihuahua), El Colegio de la Frontera Norte and Comisión para Prevenir y Erradicar la Violencia Contra las Mujeres en Ciudad Juárez. https://catedraunescodh.unam.mx/catedra/mujeres/menu_superior/Feminicidio/5_Otros_textos/9/6/vii.pdf.

Monárrez Fragoso, Julia Estela (2010). "The Victims of Ciudad Juárez Feminicide: Sexually Fetishized Commodities," in Rosa-Linda Fregoso

and Cynthia Bejarano (eds.), *Terrorizing Women: Feminicide in the Americas*. Durham, NC: Duke University Press.

Münkler, Herfried (2003). "The Wars of the Twenty-First Century." *International Review of the Red Cross* 85, 849, pp. 7–22.

Münkler, Herfried (2005). *The New Wars*. Cambridge: Polity.

Muñoz, Lily (2013). *Mujeres mayas. Genocidio y delitos contra los deberes de la humanidad*. Guatemala: Centro de Acción Legal en Derechos Humanos (CALDH).

Neves, Marcelo (2022). *Symbolic Constitutionalization*. Translated by Kevin Mundy. Oxford: Oxford University Press.

Odio Benito, Elizabeth (2001). "De la violación y otras graves agresiones a la integridad sexual como crímenes sancionados por el derecho internacional humanitario (crímenes de guerra)." *Órgano Informativo de la Comisión de Derechos Humanos del Estado de México (CODHEM)*, pp. 98–112.

Otero Bahamón, Silvia, Viviana Quintero Márquez, and Ingrid Bolívar (2009). "Las barreras invisibles del registro de la violencia sexual en el conflicto armado colombiano." *Forensis: Datos para la vida*, pp. 335–49.

Oxfam (2016). "62 People Own the Same as Half the World, Reveals Oxfam Davos Report," January 18. https://www.oxfam.org/en/press-releases/62-people-own-same-half-world-reveals-oxfam-davos-report.

Oyěwùmí, Oyèrónké (1997). *The Invention of Women: Making an African Sense of Western Gender Discourses*. Minneapolis: University of Minnesota Press.

Paixáo, Marcelo and Luiz Marcelo (2008). *Relatório anual das desigualdades raciais no Brasil 2007–2008*. Río de Janeiro: Garamont.

Paredes, Julieta (2010). *Hilando fino desde el feminismo comunitario*. La Paz: CEDEC y Mujeres Creando Comunidad.

Passos, Tiago Eli de Lima (2008). *Terror de estado: uma crítica à perspectiva excepcionalista*. Master's Thesis, Brasília, Universidade de Brasília.

Pateman, Carole (1988). *The Sexual Contract*. Stanford: Stanford University Press.

Patterson, David (1988). *Literature and Spirit: Essays on Bakhtin and his Contemporaries*. Lexington: The University Press of Kentucky.

Quijano, Aníbal (1991). "La modernidad, el capital y América Latina nacen el mismo día." *ILLA. Revista del Centro de Educación y Cultura* 10, pp. 44–56.

Quijano, Aníbal (1992). "Colonialidad y modernidad-racionalidad," in Heraclio Bonilla (ed.), *Los conquistados. 1492 y la población indígena de las Américas*. Quito: Tercer Mundo/Libri Mundi/FLACSO-Ecuador.

Quijano, Aníbal (2000). "Coloniality of Power, Eurocentrism, and Latin America." Translated by Michael Ennis. *Nepantla: Views from South* 1, 3, pp. 533–80.

Quijano, Aníbal and Immanuel Wallerstein (1992). "Americanity as a Concept, or the Americas in the Modern World-System." *International Social Sciences Journal* 134, pp. 549–57.

Radford, Jill and Diana E.H. Russell (eds.) (1992). *Femicide: The Politics of Woman Killing*. New York: Twayne Publishers.

Reguillo, Rossana (2015). "La turbulencia en el paisaje: de jóvenes, necropolítica y 43 esperanzas," in José Manuel Valenzuela Arce (ed.), *Juvenicidio. Ayotzinapa y las vidas precarias en América Latina y España*. Guadalajara, ITESO/El Colegio de la Frontera Norte/ Ned Ediciones.

Rufer, Mario (2009). *La nación en escenas. Memoria pública y usos del pasado en contextos poscoloniales*. Mexico City: El Colegio de México.

Sahlins, Marshall (1972). *Stone Age Economics*. Chicago: Aldine Atherton.

Said, Edward W. (1978). *Orientalism*. New York: Pantheon Books.

Said, Edward W. (2000 [1984]). "Permission to Narrate," in Moustafa Bayoumi and Andrew Rubin (eds.), *The Edward Said Reader*. New York, Vintage Books.

Schmitt, Carl (1986 [1922]). *Political Theology: Four Chapters on the Concept of Sovereignty*. Translated by George Schwab. Cambridge, MA: MIT Press.

Segato, Rita Laura (1995). *Santos e daimones. O politeísmo afro-brasileiro e a tradicáo arquetipal*. Brasília: Editora da Universidade de Brasília. (Second edition, 2005.)

Segato, Rita Laura (2001). *The Factor of Gender in the Yoruba Transnational Gender World*. Série Antropologia 289, Brasília, Dpto. de Antropologia da Universidade de Brasília. http://www.dan2.unb.br /images/doc/Serie289empdf.pdf.

Segato, Rita Laura (2003a). *Las estructuras elementales de la violencia. Ensayos sobre género entre la antropología, el psicoanálisis y los derechos humanos*. Buenos Aires: Prometo Libros/Universidad Nacional de Quilmes. (Second edition, 2013.)

Segato, Rita Laura (2003b). "La célula violenta que Lacan no vio: un diálogo (tenso) entre la antropología y el psicoanálisis," in *Las estructuras elementales de la violencia. Ensayos sobre género entre la antropología, el psicoanálisis y los derechos humanos*. Buenos Aires: Prometo Libros/ Universidad Nacional de Quilmes. (Second edition, 2013.)

Segato, Rita Laura (2003c). *Uma agenda de ações afirmativas para as mulheres indígenas do Brasil*. Brasília: Universidade de Brasília.

Segato, Rita Laura (2005 [1986]). "Inventando a natureza. Familia, sexo e género no Xangó de Recife," in *Santos e daimones. O politeísmo afro-brasileiro e a tradicáo arquetipal*. Second edition. Brasília: Editora da Universidade de Brasília.

Segato, Rita Laura (2006a). "Antropologia e direitos humanos: alteridade e ética no movimento de expansão dos direitos universais." *Mana: Estudos de Antropolgia Social* 12, 1, pp. 207–36.

Segato, Rita Laura (2006b). *La escritura en el cuerpo de las mujeres asesinadas en Ciudad Juárez. Territorio, soberanía y crímenes de Segundo Estado*. Mexico City: Ediciones de la Universidad del Claustro de Sor Juana.

Segato, Rita Laura (2007a). *La nación y sus otros*. Buenos Aires: Prometeo Libros.

Segato, Rita Laura (2007b). "Cambio religioso y des-etnificación: la expansión evangélica en los Andes Centrales de Argentina," in *La nación y sus otros*. Buenos Aires: Prometeo Libros.

Segato, Rita Laura (2007c). "La faccionalización de la República y el paisaje religioso como índice de una nueva territorialidad," in *La nación y sus otros*. Buenos Aires: Prometeo Libros.

Segato, Rita Laura (2007d). "En busca de un léxico para teorizar la experiencia territorial contemporánea", in *La nación y sus otros*. Buenos Aires: Prometeo Libros.

Segato, Rita Laura (2007e). "Identidades políticas/alteridades históricas. Una crítica a las certezas del pluralismo global," in *La nación y sus otros*. Buenos Aires: Prometeo Libros.

Segato, Rita Laura (2007f). "El color de la cárcel en América Latina: apuntes sobre la colonialidad de la justicia en un continente en deconstrucción." *Revista Nueva Sociedad* 208, pp. 142–61.

Segato, Rita Laura (2007g). "Qué es un feminicidio. Notas para un debate emergente," in Marisa Belausteguigoitia and Lucía Melgar (eds.), *Fronteras, violencia, justicia: nuevos discursos*. Mexico City: PUEG/UNIFEM.

Segato, Rita Laura (2008). "Closing Ranks: Religion, Society and Politics Today." *Social Compass* 55, 2, pp. 203–15.

Segato, Rita Laura (2009). "Qué cada pueblo teja los hilos de su historia: el argumento del pluralismo jurídico en diálogo didáctico con legisladores," in Victoria Chenaut, Magdalena Gómez, Héctor Ortiz, and María Teresa Sierra (eds.), *Justicia y diversidad en tiempos de globalización*. Mexico City: RELAJU.

Segato, Rita Laura (2011a). "Género y colonialidad: en busca de claves de lectura y de un vocabulario estratégico descolonial," in Karina Bidaseca and V. Vázquez Laba (eds.), *Feminismos y poscolonialidad*. Buenos Aires: Editoria Godot.

Segato, Rita Laura (2011b). "Femi-geno-cidio como crimen en el fuero internacional de los derechos humanos: el derecho a nombrar el sufrimiento en el derecho," in Rosa-Linda Fregoso and Cynthia Bejarano (eds.), *Feminicidio en América Latina*. Mexico City: Centro de Investigaciones de Ciencias Sociales y Humanidades y Universidad Nacional Autónoma de México.

Segato, Rita Laura (2012). "Femigenocidio y feminicidio: una propuesta de tipificación." *Revista Herramienta* 49. https://www.herramienta.com.ar/?id=1687.

Segato, Rita Laura (2013). "La nueva elocuencia del poder", in *La escritura en el cuerpo de las mujeres asesinadas en Ciudad Juárez*. Buenos Aires: Tinta Limón, 2013.

Segato, Rita Laura (2014a). "La norma y el sexo: frente estatal, desposesión, patriarcado y colonialidad," in Marisa Belausteguigoitia and Josie Saldaña (eds.), *Des/posesión. Género, territorio y luchas por la naturaleza*. Mexico City: PUEG-UNAM.

Segato, Rita Laura (2014b). *Las nuevas formas de la guerra y el cuerpo de las mujeres*. Puebla: Pez en el árbol.

Segato, Rita Laura (2015a). *La crítica de la colonialidad en ocho ensayos y una antropología por demanda*. Buenos Aires: Prometeo Libros.

Segato, Rita Laura (2015b). "Aníbal Quijano y la perspectiva de la colonialidad del poder," in *La crítica de la colonialidad en ocho ensayos y una antropología por demanda*. Buenos Aires: Prometeo Libros.

Segato, Rita Laura (2015c). "El sexo y la norma: frente estatal-empresarial-mediático-cristiano," in *La crítica de la colonialidad en ocho ensayos y una antropología por demanda*. Buenos Aires: Prometeo Libros.

Segato, Rita Laura (2015d). "Los cauces profundos de la raza latinoamericana: una relectura del mestizaje," in *La crítica de la colonialidad en ocho ensayos y una antropología por demanda*. Buenos Aires: Prometeo Libros.

Segato, Rita Laura (2015e). "Qué cada pueblo teja los hilos de su historia: el pluralismo jurídico en diálogo didáctico con legisladores," in *La crítica de la colonialidad en ocho ensayos y una antropología por demanda*. Buenos Aires: Prometeo Libros.

Segato, Rita Laura (2015f). "Género y colonialidad: del patriarcado comunitario de baja intensidad al patriarcardo colonial moderno de alta intensidad," in *La crítica de la colonialidad en ocho ensayos y una antropología por demanda*. Buenos Aires: Prometeo Libros.

Segato, Rita Laura (2016). *Juicio Sepur Zarco: peritaje antropológico cultural de género*, parts 1, 2, and 3. http://www.ivoox.com/juiciosepurzarco-partel-peritaje-antropologico-cultural-genero_rf_10549052_1.html; http://www.ivoox.com/juiciosepurzarco-parte2-peritajeantropologico-cultural-genero_rf_10548803_l.html; http://www.ivoox.com/juiciosepurzarco-parte3-peritaje-antropologico-cultural-genero_rf_10491443_1.html.

Segato, Rita Laura (2018). *Contra-pedagogías de la crueldad*. Buenos Aires: Prometo Libris.

Segato, Rita (2022). *The Critique of Coloniality: Eight Essays*. Translated by Ramsey McGlazer. New York: Routledge.

Segato, Rita Laura and José Jorge de Carvalho (2002). *Uma proposta de cotas para estudantes negros na Universidade de Brasília*. Série Antropologia 314. Brasília, Dpto. de Antropologia da Universidade de Brasília. http://www.dan2.unb.br/images/doc/Serie314empdf.pdf.

Segato, Rita Laura and Marlene Libardone (2013). *Derecho a una vida libre de violencia. Informe de las expertas para el Tribunal Internacional de Derechos de las Mujeres Viena +20*, organized by Mugarik Gabe in Bilbao, Euskalherria, Spain, 7–8 June. https://www.feministas.org/IMG/pdf/tribunal_internacional_de_derechos_de_las_mujeres.pdf.

Sen, Amartya (1990). "More than 100 Million Women Are Missing." *The New York Review of Books*, December 20.

Shifter, Jacobo (1999). *Macho Love: Sex Behind Bars in Central America*. Translated by Christina E. Feeny. New York: The Hawthorn Hispanic/Latino Press.

Sondereguer, María (ed.) (2012). *Género y poder. Violencias de género en contextos de represión política y conflictos armados.* Buenos Aires: Editorial de la Universidad Nacional de Quilmes.

Theidon, Kimberly (2004). *Entre prójimos. El conflicto armado interno y la política de la reconciliación en el Perú.* Lima: Instituto de Estudios Peruanos.

Toledo Vásquez, Patsilí (2009). *Feminicidio.* Mexico City: Consultoría para la Oficina en México del Alto Comisionado de las Naciones Unidas para los Derechos Humanos/OACNUDH.

United Nations (2003). *Informe de la Comisión de Expertos Internacionales sobre la Misión en Ciudad Juárez, Chihuahua.* Mexico City: Oficina de las Naciones Unidas contra la Droga y el Delito. https://catedraunescodh .unam.mx/catedra/mujeres_ORIGINAL/menu_superior/Feminicidio /1_Info_inter/4.pdf.

UNODC (United Nations Office on Drugs and Crime) (2014). *Global Study on Homicide 2013.* Vienna: UNODC Research and Trend Analysis Branch, Division for Policy Analysis and Public Affairs. https://www .unodc.org/documents/gsh/pdfs/2014_GLOBAL_HOMICIDE_BOOK _web.pdf.

Uprimny Yepes, Rodrigo, Diana Esther Guzmán Rodríguez, and Julissa Mantilla Falcón (2008). *Violación sexual como crimen de lesa humanidad.* Lima: Asociación Pro Derechos Humanos – APRODEH.

Valenzuela Arce, José Manuel (ed.) (2015). *Juvenicidio. Ayotzinapa y las vidas precarias en América Latina y España.* Guadalajara: ITESO/El Colegio de la Frontera Norte/Ned Ediciones.

Vicentini, Ana (1999). "Entre týche e autómaton: o próprio nome de Édipo." *Percurso* 23, p. 61.

von Ihering, Rudolf (1915 [1872]). *The Struggle for Law.* Translated by John Lalor. Chicago: Callaghan and Company.

Warner, Michael (1990). *The Letters of the Republic: Publication and the Public Sphere in Eighteenth-Century America.* Cambridge, MA: Harvard University Press.

Washington Valdez, Diana (2006). *The Killing Fields: Harvest of Women. The Truth About Mexico's Bloody Border Legacy.* Burbank, CA: Peace at the Border.

West, Robin (1988). "Jurisprudence and Gender." *The University of Chicago Law Review* 55, 1, pp. 1–72.

Williams, Brackette F. and Pauline Pierce (1996). "And Your Prayers Shall Be Answered through the Womb of a Woman: Insurgent Masculine Redemption and the Nation of Islam," in Brackette F. Williams (ed.), *Women Out of Place: The Gender of Agency and the Race of Nationality.* New York: Routledge.

Zaffaroni, Eugenio Raúl (1993) *En busca de las penas perdidas. Deslegitimación y dogmática jurídico-penal.* Bogotá: Temis.

Zaffaroni, Eugenio Raúl (2006) *El enemigo en el derecho penal.* Buenos Aires: Editorial Dykinson.

Index